**Dalí**  Robert Radford

ART&IDEAS

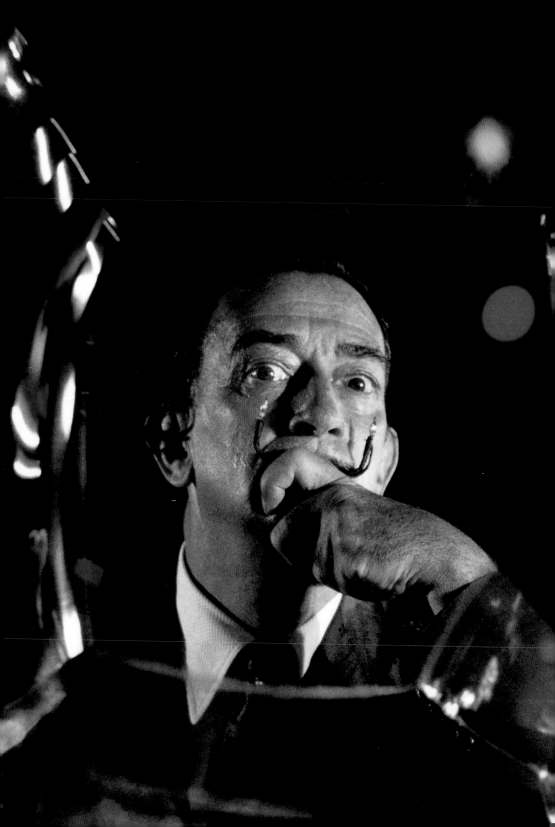

Dalí

Opposite
Dalí
photographed
by Enrico
Sarcini

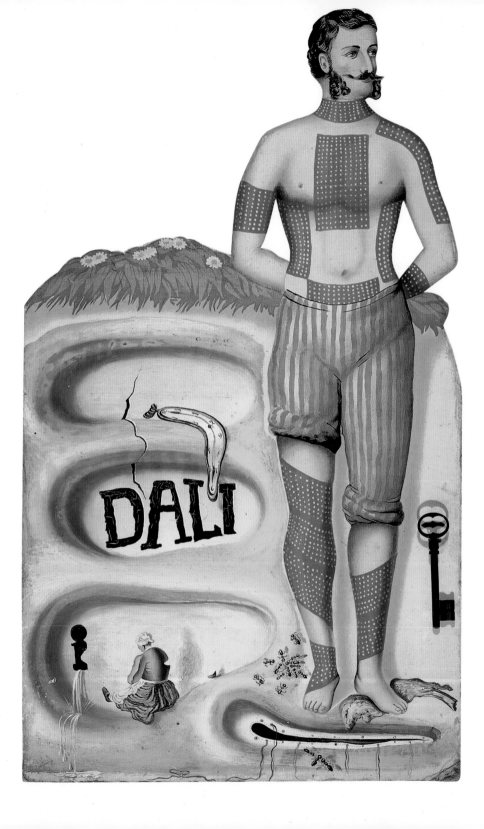

The popularity of the work of Salvador Dalí is immense; his images are recognized and provoke a response across the world. They continue to appeal to new generations, for whom the startling, the disquieting, yet intensely absorbing and brilliant nature of his pictures are as new and unforgettable as ever. The purpose of this book is to suggest some reasons for the lasting power to impress that his work holds.

Dalí considered his childhood and adolescence to be absolutely crucial in shaping his formation as an artist, since he regarded the unbridled passions, the unclouded perceptions and guilt-free fantasies (especially of childhood years) as the ideal basis for the state of Surrealist awareness. On the other hand, his was also a typical bourgeois upbringing in a family replete with maternal love and paternal authority. The region of Catalunya in northern Spain, where he was born and grew up, enjoyed a confident prosperity and an established artistic culture of its own, more open than the rest of Spain to the new ideas that were shaping Modernism in the major European art centres, and especially Paris.

1
Surrealist
Poster, 1934.
Oil on card-
board with
key;
69 × 46 cm,
27 $\frac{1}{8}$ × 18 $\frac{1}{8}$ in.
Private
collection, on
loan to the
Salvador Dalí
Museum, St
Petersburg,
Florida

His training as an art student was spent in Madrid but his real education came from his personal researches and from the friendships he made there with a vital generation of young intellectuals. Two men in particular, the poet Federico García Lorca and the film-maker Luis Buñuel, were to make a significant personal and creative impression on his life. Although Dalí's painting of the mid-1920s is only gradually becoming better known today, in fact his early promise was noted by Joan Miró and Pablo Picasso, who were both helpful to him when in 1929 he came to Paris, in order to make the first Surrealist film, *Un Chien andalou* (*An Andalucian Dog*).

His very special vision and his energetic imagination quickly won him a place at the Surrealists' table. He was at first regarded by them as much for his writing and the extension of Surrealist activity as for

his painting. It was at this point that the most significant encounter of Dalí's life occurred, at least according to his own account, when he met Gala Éluard. She was to remain his companion, and later his wife, for the next fifty years; but more than this, she fulfilled the role of model, muse and ideal woman which was to influence and shape much of his succeeding work. It is from his painting of the 1930s that Dalí's particularly memorable images, such as the soft watches and the supporting crutches, have emerged into widespread popular recognition.

Despite his avowed dedication to a life of complete egoism and his disdain for political involvement, the intractable historical tensions of Europe, erupting in the divisive horrors of the Spanish Civil War, inevitably marked his life; later, as the invading German troops occupied France, Dalí took flight to the United States. There, the next major adventure of his life took place as he encountered the freshness and energy of the New World with its own culture of Hollywood film, the popular press and advertising. In America he discovered the joys and rewards of personal publicity which he was to orchestrate with consummate success thereafter. This was also the period in which his full gifts as a writer were revealed by the publication of his autobiography, *The Secret Life of Salvador Dalí*, and his novel, *Hidden Faces*.

By the end of the 1940s he had abandoned the ideas and methods of Surrealism and had also opposed the new directions of American abstract painting. Instead he embarked on a return to Renaissance ideals, but transformed in a characteristically Dalínian manner into something far removed from what Raphael would ever have understood, for now Dalí was applying his understanding of quantum physics to produce a dynamic synthesis of traditional and modern imagery. These highly inventive pictorial solutions often paralleled the emerging imagery of the Pop Art of the 1960s.

As his personal reputation expanded into world-wide recognition, he assiduously promoted his role as showman and jester with moustache and bulging eyes and, above all, enjoyment of his celebrity status. But all this time he continued to explore his long-term obsession with the

task of the artist as illusionist. Drawing his inspiration from Diego Velázquez and Jan Vermeer, he experimented with stereoscopic and holographic processes in search of a modern version of the perfect illusion. The record of his later years is particularly manifest in the appropriately termed Theatre-Museum which he established in his home town of Figueres, dedicated to the idea that art should be dramatic, exciting and directed to securing the immediate imaginative response of the viewer.

It is now high time to review and reassess the contribution to the art of the twentieth century by an artist who managed to earn the disaffection of most of his fellow artists and many critics and commentators – in direct proportion to the popular regard in which he was held by the public at large. Now that irony and appropriation of former styles are increasingly recognized strategies of current art practice, now that adherence to a narrowly defined direction of progressive art has been rejected and now that the celebrity status of the artist is no longer automatically derided, it is fitting to look again at the art of Salvador Dalí.

However, the task of getting closer to the subject and disentangling fact from fiction is by no means straightforward. There are, for example, at least three accounts of Dalí's childhood and youth available: the version based on the dispassionate voice of official records, then the highly impassioned and creative version coming from Dalí himself, constantly evolving in its retelling in the manner of some ancient myth, and finally the idealized picture of unblemished family harmony portrayed by his sister. This should not cause too much dismay, however, since it is rarely possible to say with any certainty that we possess the one and only 'truth' about anyone's life; clearly, identical circumstances will be experienced, remembered and related by all the parties involved – parents, siblings, outside observers – in often dramatically different ways. Nevertheless, so successful was the web of mystification that Dalí and Gala spun, and the façade of public performance that they erected for the outside world, that their private lives remained virtually unrecorded and resistant to re-creation.

The problem becomes more complicated when the subject under scrutiny is an artist. Since the emergence of the figure of the 'artist' in Classical Greece, the public has always been eager to create a mythic presence, to allow a special licence of behaviour and to expect astonishing and abnormal things in respect of this being. Perhaps this was due to some sense of awe that the community felt when confronted with the artist's capacity to create, a capacity that dangerously rivalled the powers of the gods themselves. It was a tendency always exploited by artists, as we can see in the case of the Renaissance painter Giorgio Vasari in his *Lives of the Artists*. This process of myth-making reached its apogee in the Romantic movement, with the artist taking on the role of heroic victim; by the time of the invention of the 'bohemian', the artist was habitually condemned as social outcast to a life of poverty, rejection and suicide, in return for the freedom to flout the conventional moral restrictions of bourgeois society. Following Nietzsche's declaration at the end of the nineteenth century that 'God is dead', and the general decline in society's resort to established religion, the artist was invited to take on more of the role of prophet or shaman, the one who cures the anxieties of a people by entering into a state of mental separation from the world. This was the ideological inheritance of the generation of avant-garde artists that emerged in the early twentieth century. Dalí was only outstanding in this company in the extent to which he understood and made use of the myth of the artist. Later on, he also proved to be advanced in his recognition of that peculiar creation of the twentieth century, the myth of the celebrity. He worked hard at creating an image of his personality and life in such a way that these aspects should become indistinguishable in the public mind from his creative work as an artist. So when he calculated, in 1942, that he was in a position to become a major figure in the art of his times, he brought out his autobiography, *The Secret Life of Salvador Dalí*, which presented to the world his preferred orchestration of his own myth: the story of the creation of a 'genius'. When the material was further elaborated in 1976 with the publication of *The Unspeakable Confessions of Salvador Dalí*, the reader was frankly reminded that 'this is a Dalínian novel'.

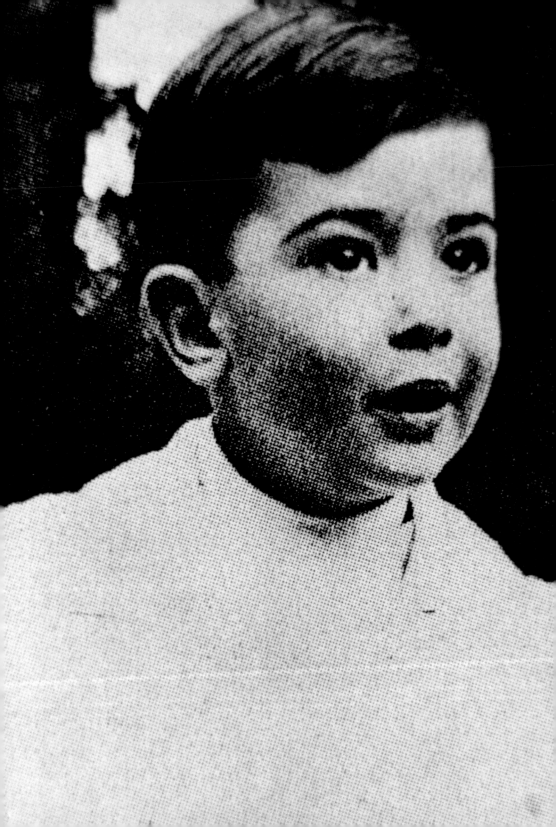

Before considering Dalí as a Spanish artist, or a Parisian artist, or a world artist, it is important to take account of the Dalí who was a Catalan artist. He always made it clear how much he valued his identity as a Catalan as distinct from being simply Spanish. He had never travelled beyond Figueres and Barcelona until his student years took him to Madrid; and Catalan (which is a separate Romance language rather than a dialect of Spanish) was the language he spoke at home and among friends. When he wrote his first articles and manifestos for the art press in Barcelona in the 1920s, these were published in Catalan. In later years, he would often wear the *barretina*, the traditional red cap of the country people of Catalunya, which we also see depicted in a number of works by Miró.

2
Dali aged three in Güell Park, Barcelona

Catalunya is a region at the northeastern corner of Spain, bounded by a long stretch of Mediterranean coast and forming boundaries with France and Andorra along the line of the Pyrenees (see map on p. 343). Its chief city is Barcelona, which rivals Madrid in size and international recognition. The 'principality' of Catalunya had a long history of independence in the past, and during Dalí's youth it was the scene of political campaigns for greater autonomy from the central control exercised by the Spanish capital. In the Middle Ages its boundaries were extended to include an area of southern France around Perpignan, and its powerful fleet secured it colonial influence around the Mediterranean, from Athens to Sicily and from Sardinia to Mallorca. It had created an early form of representational parliament known as the Generalitat, and this ancient sense of democratic rights had always been fiercely defended. However, during the periods of the succeeding Hapsburg and Bourbon regimes in Spain, most of these democratic rights had been eroded and the region had become fully integrated within the larger Spanish state; moreover its language and universities had been subjected to political suppression.

In the later part of the nineteenth century there was a gradual revival in the public use of the language and a new recognition of the region's cultural identity. In a movement which became known as 'La Renaixença' (the renaissance), newspapers and literary magazines, published in Catalan, began to revive an interest in all aspects of the region's long artistic, architectural, literary and folkloric traditions. Catalunya had always been economically expansive in comparison to the rest of Spain and the area around Barcelona had experienced a considerable level of industrial development from the end of the eighteenth century, which, coupled with the banking and trading prowess of its entrepreneurs, had made the region the most prosperous and 'European' part of Spain. Such achievements were felt to reflect the typical Catalan characteristics of sound common sense and thrift.

This was the world into which Dalí was born, on 11 May 1904, and given the name Salvador Felipe Jacinto Dalí Domènech. His father, also called Salvador, aged forty-one, was a public notary (a legal official concerned with certifying documents) in Figueres, the main town in Alt Empordà, the most northerly district of Catalunya, about 100 km (62 miles) north of Barcelona. His mother, Felipa, was eleven years younger than her husband and came from a prosperous trading family in Barcelona. A sister, Ana María, was born three years later and the two children appear to have been close companions throughout their early life. The family would have enjoyed the comfortable lifestyle, status and security appropriate to the father's public position, and the mother would have been free, with the support of domestic servants, to concentrate her attentions on the well-being of the family. The young Salvador (2) appears to have enjoyed a highly indulged, if not to say downright spoilt, childhood; certainly in his reminiscences he relishes his exploitation of his parents' concern about his well-being. A holiday photograph (4) from around 1910 of the family group, complete with aunts and grandmother, illustrates the female ambience which must have pervaded domestic life. They lived in an apartment in the centre of the town, in a street named after the town's previously most famed figure, Narcis Monturiol, who had invented a man-powered submarine in the 1850s. Ana María

**3 Above left**
Study for *My Family*, 1920.
Pencil and ink on paper; 22 × 16·5 cm, 8⅝ × 6½ in.
Private collection

**4 Above right**
The Dalí family at Cadaqués, c.1910

**5 Below**
The Dalí family at their beachfront home, c.1918.
Pencil and ink on paper; 14·5 × 21·5 cm, 5¾ × 8½ in.
Fundació Gala-Salvador Dalí, Figueres

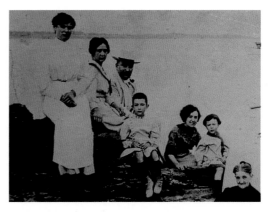

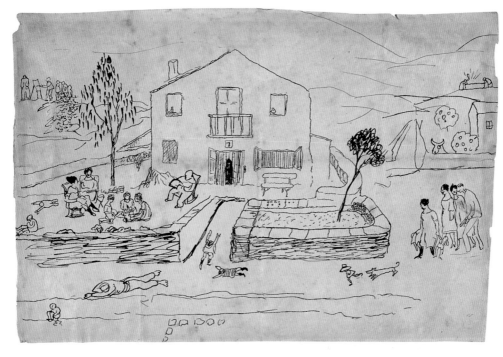

depicts Figueres as an attractively bustling and varied place, with its literary and musical societies, its colourful market days, military bands on Sundays and picturesque local characters. The family owned a holiday home, 'El Llaner', in the nearby fishing village of Cadaqués, before it was to become a popular holiday resort, and the children spent much of their summers and weekends exploring the beaches and rocky coastline of the vicinity. An early drawing by Dalí has survived, which depicts the leisurely activity around the beach-front house (5), with the mother and aunt sewing, the father reading, the gardener stretched out by the sea, the neighbours paying a visit and the fearsome cow which kept the children away from the orange trees. In a sketch of the family at Cadaqués done a few years later, when Dalí was about sixteen, his identity as an artist is clearly established (3).

This attachment to the area of Cadaqués was to prove one of the most constant features of Dalí's later life; he was to set up his first home with Gala Éluard, his muse and companion, nearby at Port Lligat which, after he had expanded it into a studio, was to provide the necessary oasis of order and calm to allow him to maintain his highly concentrated output of painting. Not only the general contours of the coastline but specific, identifiable rocks and bays from the headland of Cabo Creus (6) form the backdrop to many of his classic paintings.

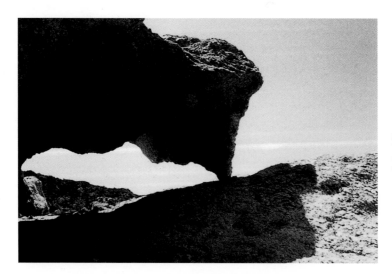

6
The granite
rocks at
Cadaqués

His father was a free-thinker, that is to say he opposed the moral authority and the political influence of the established Roman Catholic church. He was an atheist, a republican and a supporter of Catalan autonomy; Salvador's first taste of the excitement of the world of ideas came from browsing through his father's library, which included works by Voltaire, Kant and Nietzsche that undoubtedly shaped his early appetite for theoretical speculation. One consequence of his father's views was that Dalí's first school was not a church school, more fitting to the family's social position, but the local primary school which provided for children from a lower social order, and it is quite likely that his keen sense of snobbery had its origins in this experience, when, dressed in his neat sailor suit, he first encountered the ragged, barefoot boys from the poorer streets. Between the ages of six and twelve he attended the school run by the Christian Brothers, a French Catholic sect, and it was from these days that Dalí acquired his familiarity with the French language and his appreciation of its literature, since the teaching there was conducted in that language. The next hurdle in his educational career was having to study for his *bachillerato* examinations, which were needed for entry to university level study, so between the ages of thirteen and eighteen he went to the Figueres Institute high school; he also took extra classes at a college run by another religious body, the Marist Brothers, as well as classes at the municipal School of Drawing. When he was fourteen he started to contribute illustrations and art-historical articles to a school magazine called *Studium*. Despite the claims made in *The Secret Life* about his cavalier attitude to schoolwork, his record cards would suggest that he worked hard and did well in most subjects; on the other hand, the evidence of his surviving textbooks, highly ornamented with doodled drawings, show a predictable difficulty in maintaining concentration during lessons. There is also the testimony from his school friend, Jaume Miratvilles, that it was only a miracle and his tuition that got Dalí through his algebra exam.

A teenage diary survives from this period in which he sets out his ambitious life plans, which include the unabashed intention of winning recognition as a genius. They also indicate the interest with

7 Overleaf
*USSR - Long Live Russia - Death to Wars*, c.1920.
Wash on paper; 9 × 14·1 cm, 3½ × 5½ in.
Fundació Gala-Salvador Dalí, Figueres

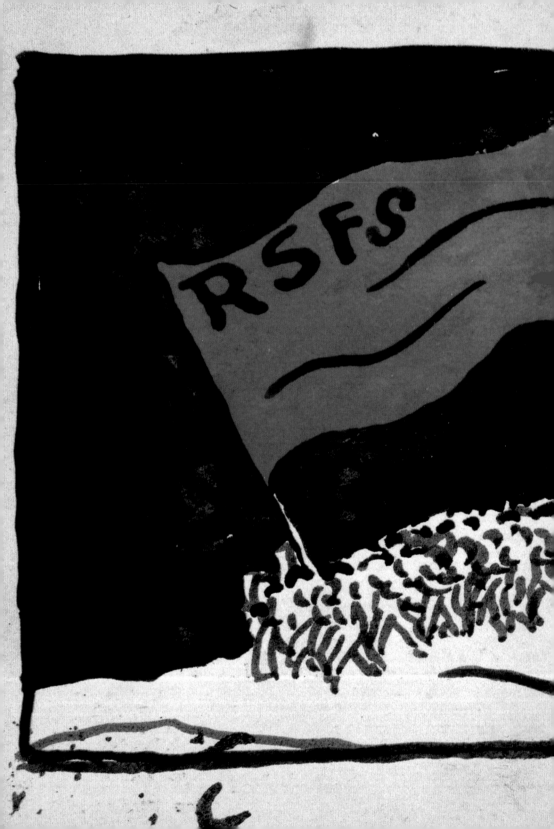

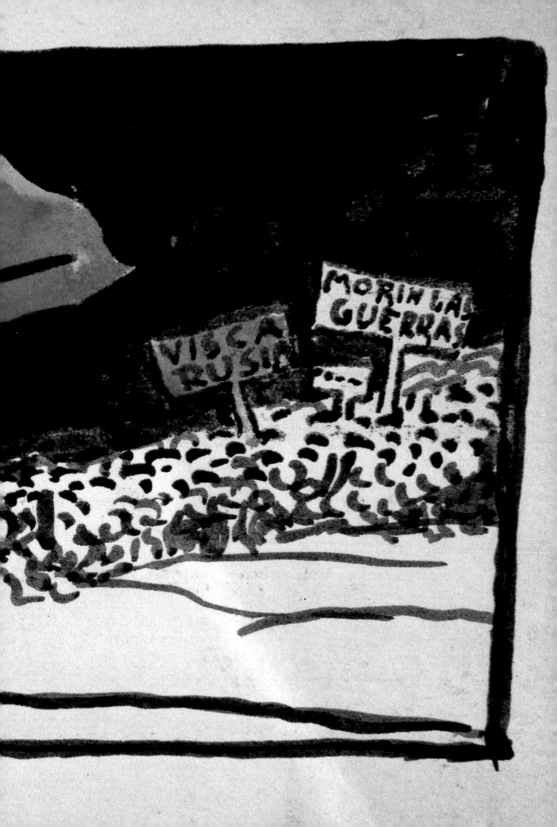

which he followed world events and local politics in the news, assert-
ing his support for the revolution in Russia (7), and for Catalan inde-
pendence. In 1917 the October Revolution, the successful uprising of
the Bolsheviks in Russia, sent shock waves throughout Europe. Until
then, the possibility of a workers' revolution had remained only a
powerful theoretical ideal, based on the economic and political wri-
tings of Karl Marx, fuelling radical political movements across all the
developing industrial nations. Now, under the guidance of Lenin, the
historical reality of revolution had been achieved and the new
people's state of the Union of Soviet Socialist Republics was born.
Furthermore, the idea of the global spread of the revolution was
fundamental to Marxist teaching, and the dislocation of political and
economic structures which followed in the wake of the First World
War encouraged a spate of revolutionary activity and reactionary
reprisals, which ensured another two decades of civil unrest and
political instability in Europe. Spain was not exempted from this tide
of disruption, though it did have its own particular features.

Inevitably, increasing demands for greater political autonomy were
closely linked to the cultural revival in Catalunya, but pressure for
political change also came from the new class of industrial workers in
Barcelona. The harsh factory conditions of these workers led to the
formation of radical political movements, adopting the ideas of Marx
as well as those of the French political philosopher Pierre-Joseph
Proudhon and the Russian anarchist Mikhail Bakunin. Workers were
urged to bring about revolution through exercising their power to
organize in trade unions and to effect a general strike. Thus at the
turn of the century political agitation took an increasingly revolu-
tionary direction with a series of large-scale strikes, mass demonstra-
tions and terrorist bombings. In 1893 a blast killed twenty people in
the Liceu Opera House. Anarchists tried in connection with the bomb-
ing were sketched by the Catalan artist Santiago Rusiñol (8). Three
years later, twelve people died in a bomb attack on a Corpus Christi
procession which was followed by the incarceration of 400 known
militants. An attempt was made on the life of the king in 1906, and
in the 'Tragic Week' of 1909 eighty churches, schools and convents in
the city were burned; the uprising was finally put down by the

8
Santiago
Rusiñol,
*Heads of
Anarchists
Tried in
Connection
with the Liceu
Bomb*,
1893–4.
Conté crayon
on paper;
20·5×27 cm,
8×10⅝ in.
Museo del
Cau Ferrat,
Sitges

military with the deaths of 116 people. The particular case of Barcelona can be taken to exemplify a widespread sense of insecurity underlying the calm face of prosperity and order which civic society presented to the world, an insecurity that encouraged the revolutionary rhetoric and the general will for change shared by so many of the avant-garde art movements in Europe in the first decades of the twentieth century.

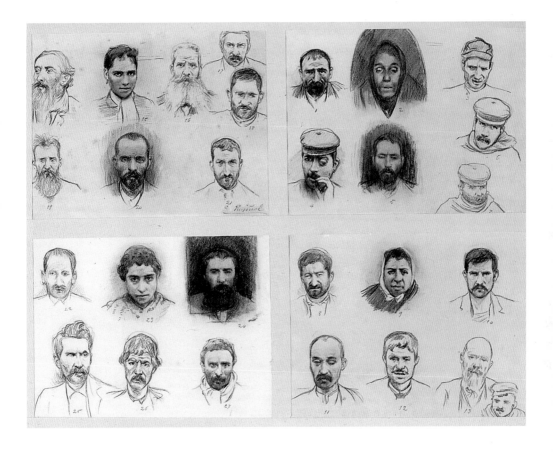

Dalí recalls an incident when, as a schoolboy, he had been invited by the local student activists to address a meeting in Figueres which had been called to mark the end of the First World War. His description of the event sought to turn it into an anticipation of his Surrealist tactic of causing maximum public confusion; totally panicked by his obligation to make a public speech, he confined himself to simply shouting out, 'Long live Germany! Long live Russia!' This was afterwards analysed by his anarchist comrades as a masterful political gesture.

The diary also reveals his unashamed celebration of egotism: 'I am madly in love with myself,' he writes, clearly enjoying his assumed role as poseur. He devised a suitable appearance to match this role, a version of the degenerate dandy which owed not a little to Oscar Wilde and which can be seen in a number of self-portraits (9). First he borrowed his mother's face powder and make-up to produce the required dissolute complexion; then he grew sideburns and shoulder-length hair before putting on his sporting jacket, muffler and cape. Of one thing he was certain, and that was that in order to succeed as an artist he had to develop the persona of the truculent eccentric. Even in these early days he was keenly aware of the pleasures of

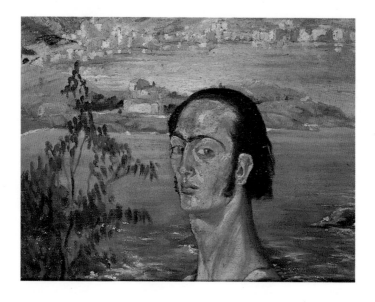

9
*Self-portrait with Raphaelesque Neck*, 1921–2. Oil on canvas; 41·5 × 53 cm, 16³⁄₈ × 20⁷⁄₈ in. Fundació Gala-Salvador Dalí, Figueres

publicity in its own right; during a political demonstration in which the Spanish flag was burned, he found himself among those who were apprehended by the police, 'which made a deep impression on public opinion'.

The account of his life appearing in *The Secret Life of Salvador Dalí*, written while in America some thirty years after the events which it covers, can only sensibly be understood as a fictionalized biography, serving a number of possible purposes. It was undoubtedly an opportunity to exercise his prolific and entertaining talents as a writer; secondly, it allowed him to take control of his own history, to confuse

and spoil the market for future biographers who might endanger the carefully wrought fabric of his genius myth; but the main purpose appears to have been to compose a version of his early life which would allow a Freudian, psychoanalytic reading of his Surrealist work. Certainly he wished to emphasize the significance of his infantile and adolescent experiences, since he regarded that state of extremity of emotion, at the edge of psychological balance, those surges of sexual passion, confused by guilt and fear, which are associated with adolescence, as the primary creative force behind his work. Indeed the personal philosophy which seemed to direct all aspects of his life, well into his later years, was firmly based on the autocratic egotism of perpetual adolescence. But for all the obviously retouched appearance of his early recollections and anecdotes, they do at least convince us of a vividly experienced childhood, retaining all the details of sight, smell and taste.

Under the warning sign of the chapter heading 'False Memories', we encounter an example of his delight in causing parental embarrassment and asserting his obstinacy: 'When I was seven years old, my father decided to take me to school. He had to resort to force; with great effort he dragged me all the way by the hand, while I screamed and raised such a commotion that all the shopkeepers in the streets we passed through came out on their doorsteps to watch us.' Dalí was, of course, keen to create the impression of a competitive relationship with his father, both to comply with Freudian theory and to provide evidence for an autobiographical reading of certain paintings, such as those which allude to the fable of William Tell, the legendary national hero of Switzerland, who was forced to attempt to shoot an arrow through an apple placed on his son's head (95 and 97). As if to demonstrate his transcendence of the laws of conventional morality, which the rights of genius bestowed on him, he recounts some outrageous stories with considerable glee. At the age of five, for example, in the middle of playing with a small boy 'who had very blond, curly hair', he suddenly pushed him off a bridge, cracking his head open on the rocks below. 'That evening,' he concludes, 'while taking my usual solitary walk, I remembered savouring the beauty of each blade of grass.'

Dalí explains that the difference between false and true memories is the same as for jewels: 'It is always the false ones which look the most real, the most brilliant.' This merging of actual and imagined realities and reluctance to commit himself to making definite distinctions between these states of mind is already present in a revealing diary entry from his teenage years, where he reflects on the particular intensity of vision he experienced in front of a reproduction in one of his art books: 'Many times things would get confused in my memories between real things and reproductions. In turning over these pages again and again, it seemed to me that I had known these people from a long time ago very intimately. It seemed to me that I had picnicked one day in this shady corner with Watteau [Antoine Watteau].' His absorbed study of reproductions of the Old Masters at this early age surely provided the basis for the memory bank of images, from Leonardo da Vinci to Francisco de Zurbarán, from Velázquez to Jean-François Millet, from which he was able to draw so knowledgeably in his post-Surrealist work.

He returns again in *The Secret Life* to the theme of adolescent erotic confusion and anxiety in his anecdote of a date with a girlfriend which starts off in the familiar tones of teenage lust but soon diverts into an incident of particularly Dalínian perverse sensuality. He derives little apparent pleasure from the poor girl's fervent kisses until he notices that she has a cold and was 'constantly sniffing up her mucus ... so fluid, colourless and runny that it rather resembled tears'; then, after taking particular pleasure in breathing in 'the sublime fragrance compounded of heliotrope and lamb to which a few burnt coffee beans might have been added' which emanated from her armpit, he promptly tells her that he does not love her and that he would never love any woman; he concludes the story by claiming that he kept this girl in a state of sadistic, emotional subjection for the next five years. Can this be the same fair-skinned girl with the enigmatic smile whom his sister tells us about, the object of a chaste, romantic love, and for whom he composed decorous love letters? The answer is probably 'yes', but it is for the reader to decide where, if anywhere, the truth lies, or rather, which truth they prefer.

One of the most blatantly 'false' or 'adjusted' memories concerns his parents' first child, who died in infancy before Dalí's own birth. By the time he was writing *The Secret Life*, he had come to the conclusion that this dead brother, who had also been named Salvador, had exercised a powerful and distressing presence over his early life. He tells of a seven-year-old, who had died three years before he himself was born and who had 'displayed the unmistakable facial morphology of a genius', whose intelligence was masked by a veil of melancholy, who represented the too perfect ideal in his parents' minds for him, the 'replacement' Salvador, to ever live up to. Thus, in compliance with Freudian theory, he had to 'kill' the competing brother to gain his own immortality. The reality was that the first child died as a baby of twenty-one months less than a year before his own birth, and thus could hardly have had time to display any obvious signs of exceptional intellectual gifts. So persistent was this private myth that he painted a *Portrait of My Dead Brother* (178) in 1963, using the face of an unknown man in his twenties.

Even while recognizing Dalí's success in creating an enthralling but fictionalized autobiography, there is no denying the abnormality of much of his personality traits and the social behaviour which he displayed from an early age. The following account, skilfully narrated, no doubt, and perhaps embroidered in its detailing, nevertheless conveys that particular strength of feeling associated with phobias and other irrational fears, with which we can all associate and which are at the core of his success as a creator of imagery commanding such a universal response. The young Dalí has rescued a wounded bat and placed it with due ceremony in a bucket for protection:

The next morning a frightful spectacle awaited me. When I reached the back of the wash-house I found the glass overturned. The ladybugs gone and the bat, though still half alive, bristling with frenzied ants, its tortured little face exposing tiny little teeth like an old woman's. Just then I caught sight of the young woman [a chance caller at the house] in a veil passing within ten feet of me ... Suddenly I committed an incomprehensible act that drew a shrill cry of horror from the young woman. With a lightning movement, I picked up the bat, crawling with ants, and lifted it to my

mouth, moved by an insurmountable feeling of pity; but instead of kissing it, as I thought I was going to, I gave it such a vigorous bite with my jaws that it seemed to me that I almost split it in two.

Ana María was so distressed by what she read in *The Secret Life* that, convinced that her brother had been led into wickedness and perversity through the malevolent influence of Surrealism in general, and Gala Éluard in particular, she determined to set the record straight with her own account of their early life. In *Salvador Dalí visto por su hermana* (*Salvador Dalí Seen by his Sister*), published in 1949, she paints a picture of Figueres as an integrated community at peace with itself, not narrow-mindedly provincial but open to liberal ideas through its proximity to France and the rest of Europe. We get intimate glimpses of the Dalí household with the family enjoying magic lantern shows, the grandmother silently sewing and the mother singing to the children. She does not deny her brother's more irritating characteristics, for example how he would yell and complain if his mother left him to sleep alone at night, or his pleasure in squashing his plastic ducks with a hammer, or how he would frequently behave like an 'obstinate little maniac' when he could not get satisfaction for his often impossible demands. She also records how the warmth and protection of this family life tragically ended when their mother died of cancer in 1921; Ana María was thirteen and Salvador seventeen.

The musical and artistic Pichot family, who were friends of his parents and who also had a summer house at Cadaqués, were to prove highly influential in shaping Dalí's ambitions to become an artist, in particular Ramon Pichot, who was a progressive artist and a friend of Picasso – it is not at all unlikely that the twenty-nine-year-old Picasso was a fellow house guest of the Pichots at the same time as the six-year-old Dalí – and 'Pepito' Pichot seem to have taken a special interest in the young Salvador (10). It was undoubtedly their encouragement and advice which reconciled his father to the idea that he should pursue his art education. His visits to the country home, El Molí de la Torre, belonging to another member of the family, the opera singer María Gay, were to feature strongly in the first stirrings of his erotic fantasies as recounted in *The Secret Life*.

10
Dalí and
Pepito Pichot
at an air show,
1912

The presence and the work of Pichot introduced the young Dalí to
that magnificent surge of activity in the arts, especially in architec-
ture and the decorative arts, which was later identified as a move-
ment called Modernisme. The term was originally used in connection
with a modernizing tendency in theology, and was then applied to
philosophy and literature; it has achieved most resonance, however,
when associated with the work of such architects as Puig i Cadafalch,
Domènech i Montaner and, above all, Antonio Gaudí, between c.1888
and c.1908. Although Modernisme coincided with the supremacy of
Art Nouveau in other parts of Europe, it is not especially helpful to
see this movement as simply the local variant of Art Nouveau. The
designs of these architects seem to give substantial, symbolic form to
the intentions of the 'Renaixença' by resurrecting historical stylistic
features and the craft skills of local artisans but also by looking for a
new synthesis with current materials and techniques to meet the
functional needs of modern life. It was the style which had trans-
formed turn-of-the-century Barcelona, and Dalí remembered his
childhood visits to Gaudí's Güell Park, with its tree-like columns, its
ceramic decorations and its guardian dragon. Gaudí would have hated
to be described as a modernist since he despaired of his godless times:
the Sagrada Familia (Holy Family) church, to which he devoted the
last decades of his life, was called the Expiatory Temple as a mark of

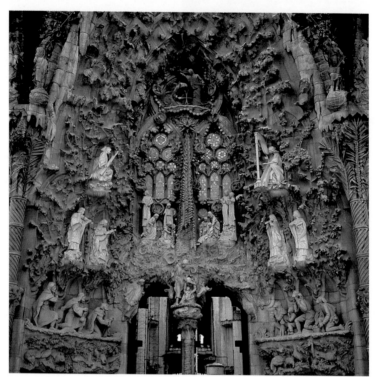

**11–12**
**Antonio Gaudí,**
Expiatory
Church of the
Sagrada Familia
(Holy Family),
Barcelona,
begun 1882
(unfinished)
**Left**
'Passion' façade
**Right**
Spiral staircase
in the tower

atonement for the anarchists' church burnings in Barcelona. Dalí had
a particular empathy for Gaudí's language of organic form (11, 12),
seeing in it a latent eroticism, which he presented as a Surrealist
discovery in the 1930s, at a time when Modernisme was considered
the worst possible architectural taste.

We can also identify a Modernista movement in painting, represented
by two generations of artists, though Pichot bridged them both.
Rusiñol and Ramón Casas were the principal figures of the 1890s
generation. They lived and worked mostly in Paris and depicted the
realism of street and café life (13) with rather more of a sense of
human involvement than their French Impressionist contemporaries.
Casas's representation of current events on the streets of Barcelona
mark him out as an impressive history painter of his own times.
Rusiñol was also attracted to the ideas of Aestheticism and designed
his house at Sitges, the Cau Ferrat (or 'Den of Iron' in reference to his
collection of antique ironwork), as a house for the 'art lover' where,
surrounded by carefully selected objects and paintings, guests would

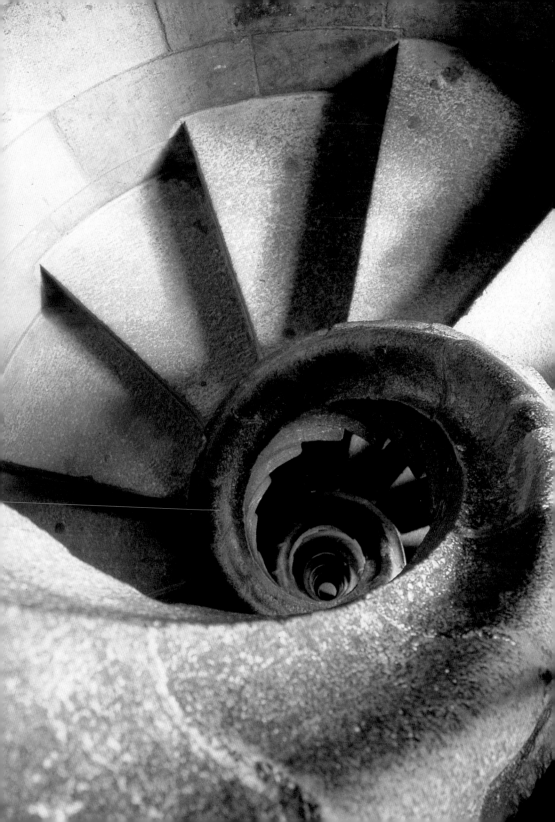

assemble to enjoy musical recitals and poetry readings. This represented the 'artistic' aspect of Catalan culture which Dalí was later to ridicule so vociferously in the *Yellow Manifesto*. A rather more boisterous ambience, modelled on the Parisian artists' café, was to be found at Els Quatre Gats – The Four Cats (14) – which opened in Barcelona in 1897 and became associated with the younger generation of Modernista artists, Isidore Nonell, Miguel Utrillo, Pere Romeu and Dalí's mentor, Pichot. The young artist who was to become its most famous *habitué* was Picasso (15), who was at this time portraying the blind beggars and melancholic drinkers of his Blue Period. The Quatre Gats circle exemplifies the flow of ideas and people between Paris and Barcelona and it provided a model to Dalí of the artist as bohemian dandy, in revolt against bourgeois values and moral restraint.

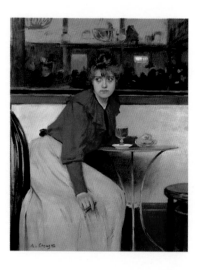

13 Left
Ramón Casas,
*Madeleine*,
1892.
Oil on canvas;
117×90 cm,
46×35½ in.
Museo de
Montserrat,
Catalunya

14
Opposite left
Pablo Picasso,
Menu Cover
from 'Els
Quatre Gats',
1899–1900.
Printed card;
21·8×32·8 cm,
8½×12⅞ in.
Museo Picasso,
Barcelona

15
Opposite right
Ramón Casas,
*Portait of
Pablo Picasso*,
1901.
Charcoal and
conté crayon
heightened
with pastel on
paper;
69×44·5 cm,
27⅛×17½ in.
Museu d'Art
Modern,
Barcelona

With the outbreak of the First World War in 1914, and Spain's neutrality, Barcelona found itself home to a group of avant-garde artists exiled from Paris. They included the Cubists Serge Charchoune, Sonia Terk, Robert Delaunay, Albert Gleizes and Marie Laurencin, and the Dadaists Francis Picabia, who published a number of issues of the journal *391* from there, and Arthur Cravan, who promoted his notorious boxing match with the world champion Jack Johnson. Sergei Diaghilev's modern ballet *Parade* was performed there in 1917.

Further, the city's leading modern art gallery, the Dalmau Gallery, mounted regular exhibitions. So Barcelona was exposed to much exciting new art.

There is no doubt that at an early age the young Salvador had already decided on his future career and, contrary to the popular myth of the struggling artist, he received support and encouragement from his parents towards achieving this goal. He was allowed to use a vacant laundry room on the roof terrace of their apartment as his first studio and, when he won a drawing prize at the age of thirteen, his father gave a party and opened up a room at home for his first exhibition. Art books and the best quality materials were bought for him through an uncle who owned a bookshop in Barcelona, and he subscribed to several Spanish and French art magazines. He acquired local recogni-

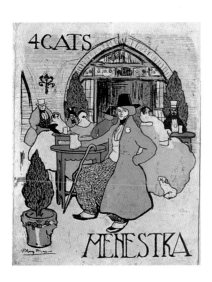

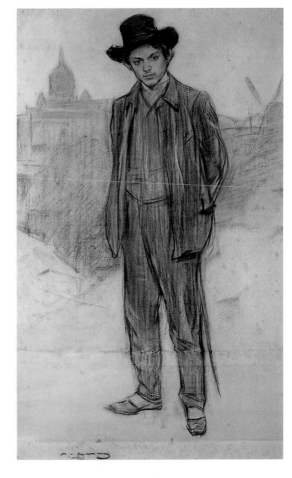

tion while still at school, having drawings published in magazines and an exhibition in 1918 at the town theatre, which was the very same building he was to take over when he established his Theatre-Museum in 1974 (see Chapter 7). The show was reviewed by a Figueres journalist in glowing terms: 'We welcome the new artist and express our belief that at some point in the future our humble words will prove to be prophetic. Salvador Dalí Domènech will be a great painter.' On one occasion the local council asked him and a friend to decorate a float, in the form of an Egyptian temple, for the annual Epiphany parade, and he also designed posters and the programme for the local festival of the Holy Cross.

On his visits to the Pichot household he encountered the painterly seascapes of Ramón which introduced him to the freedom of brush-stroke of late Impressionist painting, and in studies such as *The Sick Child* (16) we see him expertly tackling these directly painted,

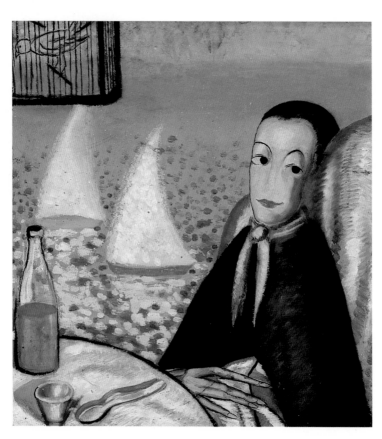

**16 Left**
*The Sick Child*,
c.1922.
Oil and
gouache on
cardboard;
57 × 51 cm,
22¹⁄₂ × 20 in.
Salvador Dalí
Museum, St
Petersburg,
Florida

**17 Right**
*The Artist at
the Rudder of
'El Son'*,
1919.
Oil on
cardboard;
24 × 19 cm,
9¹⁄₂ × 7¹⁄₂ in.
Fundació
Gala-Salvador
Dalí, Figueres

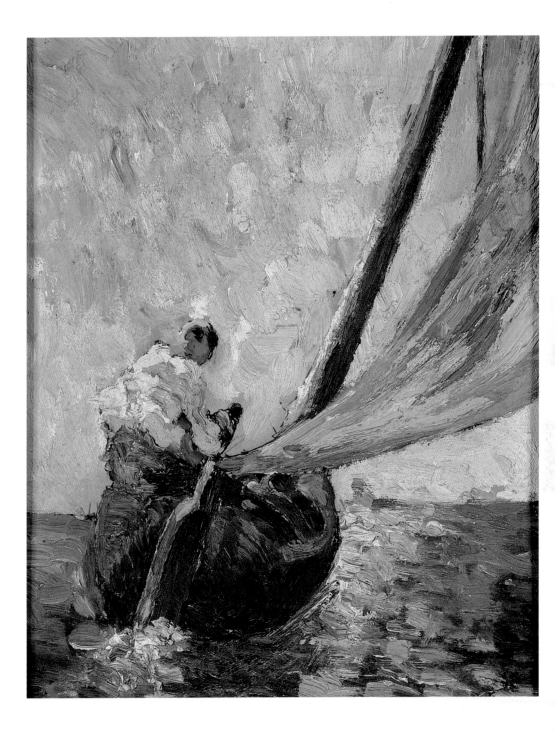

brightly hued subjects for himself. Bearing in mind what we know about the miniaturist technique typical of his mature work, we might be surprised by the richness of texture of such paintings as *The Artist at the Rudder of 'El Son'* (in which the artist depicts himself at the helm of a sailing boat), where the paint handling takes on an almost Vincent van Gogh-like impasto (17). In fact this relates more directly to his enthusiasm at this time for the work of the Catalan colourist Joaquim Mir. Dalí took over Pichot's studio in the upper room of a fisherman's house in Cadaqués and a number of studies of the rocky coast, the dappled sea and sailing ships survive from the period 1919 to 1921, such as *The Llané Beach in Cadaqués* (18). Like most young artists at this stage in their development, he was ready to experiment with a range of different styles and methods.

From around 1908, the movement known as Noucentisme (Twentieth-Centuryism), effectively promoted by the critic and writer Eugeni

**18 Left**
*The Llané Beach in Cadaqués*, 1921.
Oil on canvas; 63 × 89 cm, 24⅞ × 35 in.
Private collection

**19 Right**
Joaquin Sunyer, *Forn Bay*, 1917.
Oil on canvas; 120 × 140 cm, 47¼ × 55⅛ in.
Museu d'Art Modern, Barcelona

d'Ors, rejected the eclecticism of Modernista architecture and the Romanticism of the period's painting in favour of a Neoclassicism, a 'return to order' which predates the comparable tendencies that emerged throughout the rest of Europe during the 1920s. It would be a mistake to read this impulse as simple, backward-looking conservatism: painters such as Joaquin Sunyer, for example (19), took their starting point from Paul Cézanne, and the manner of Cézanne is well understood in Dalí's landscape studies of the period.

Other types of subject demanded more complexity of detail or a two-dimensional quality of design, and here Dalí chose to work with gouache – as in the *Fair of the Holy Cross – the Circus* (20) or the orgiastic *The Picnic* (21). The explicitly entitled *Man Holding up a Baby as though He Were Drinking from a Bottle* (22) reveals that particular taste for 'bodily function' humour which he continued to enjoy throughout his life.

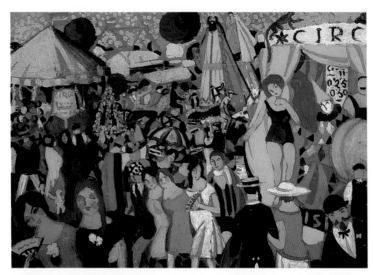

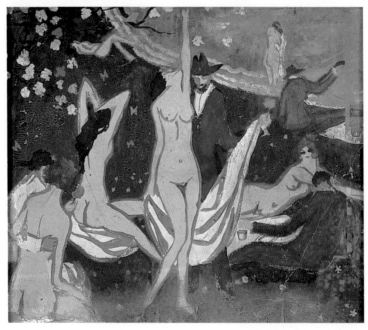

**20 Above**
*Fair of the
Holy Cross –
the Circus,*
1921.
Gouache on
cardboard;
52 × 75 cm,
20½ × 29½ in.
Fundació Gala-
Salvador Dalí,
Figueres

**21 Below**
*The Picnic,*
1921.
Gouache on
cardboard;
44·2 × 52·3 cm,
17⅜ × 20⅝ in.
Fundació Gala-
Salvador Dalí,
Figueres

**22 Opposite**
*Man Holding
up a Baby as
though He
Were Drinking
from a Bottle,*
c.1921.
Gouache on
cardboard;
52·8 × 35·5 cm,
20¾ × 14 in.
Fundació Gala-
Salvador Dalí,
Figueres

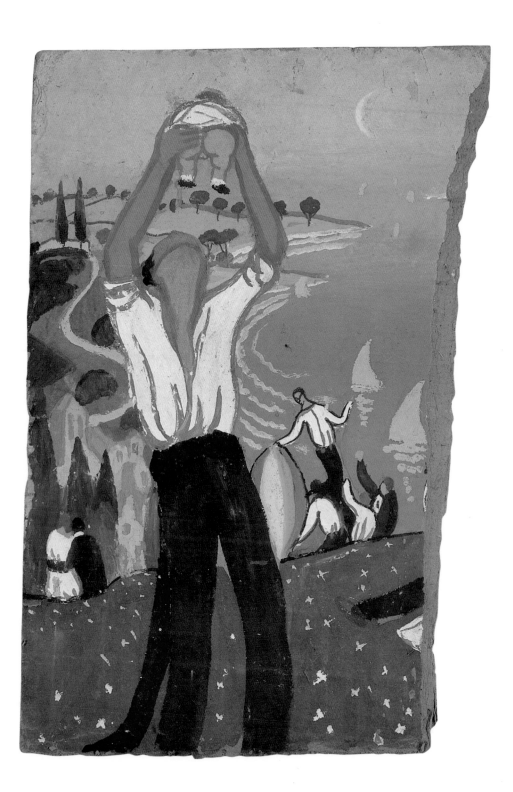

**23 Left**
*The Artist's Father at Llané Beach,* 1920.
Oil on canvas; Dimensions unknown.
Private collection

**24 Right**
*Portrait of my Father,* 1920–1.
Oil on canvas; 90·5 × 66 cm, 35⅝ × 26 in.
Fundació Gala-Salvador Dalí, Figueres

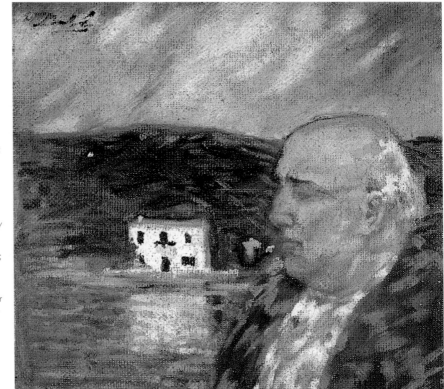

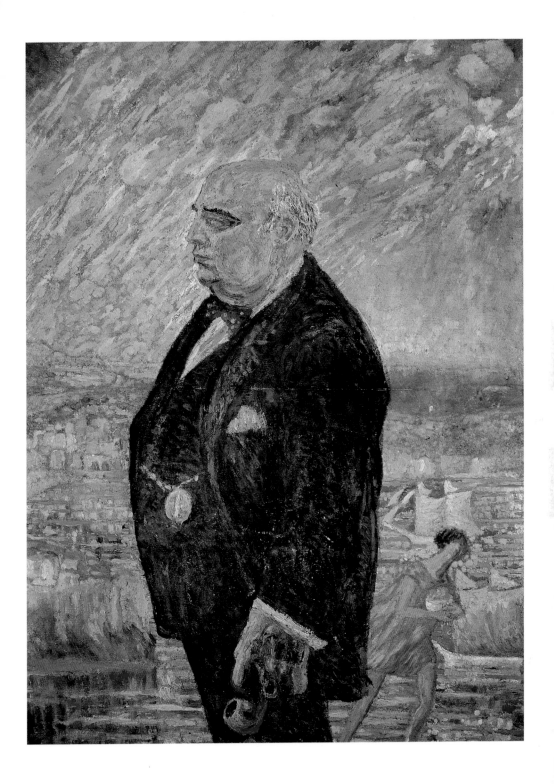

Perhaps the most memorable images from the closing months of the period of security in Cadaqués, surrounded by the support and adulation of his family, are two paintings of his father. *The Artist's Father at Llané Beach* (23), done in 1920, is equally a portrait of their holiday home; *Portrait of my Father* (24), from the following year, with the formidable bulk of the father-figure, complete with pipe and gold watch, dominating the seascape, provides all the evidence needed for a Freudian reading of Dalí's relationship with his parent which he would develop at length in the Surrealist period. In contrast, he depicts himself at the same time, with a 'Raphaelesque neck' (9), as a rather vulnerable, 'aesthetic' youth, about to bid farewell to the idyllic environment of his long summer holidays before starting the next episode of his life as a serious art student in Madrid.

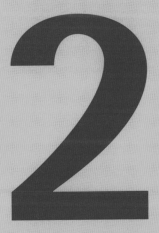

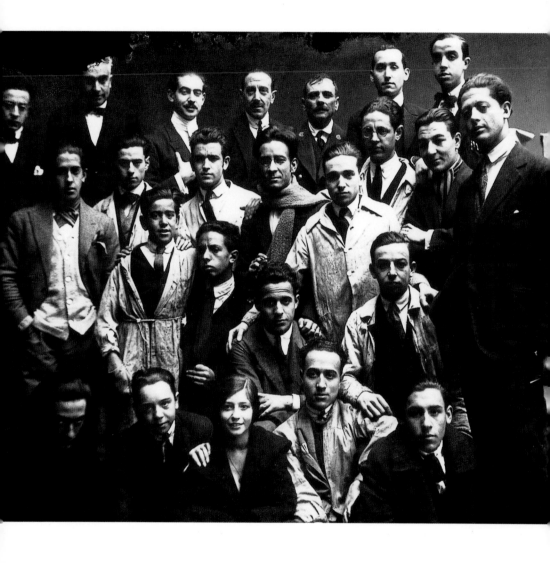

It was decided that Dalí should attend the Special School of
Sculpture, Painting and Engraving at the Royal Academy of San
Fernando in Madrid. There was a highly reputable art school closer
in Barcelona but the academy in the capital city probably seemed to
father and son to carry a higher status and, more importantly, it
allowed students to graduate with a teaching qualification. His father
had insisted on the need to have a reliable source of income to fall
back on, since he considered that his friend Pichot had irresponsibly
squandered his inheritance in supporting himself as an artist.

But first Dalí had to be accepted into the school on the basis of an
entrance examination, which consisted of a week-long, detailed
drawing 'from the antique'. There was an established set of conven-
tions governing the techniques and presentation of these drawings,
which aimed to achieve a balance between such elements as a clear
definition of outline, the suggestion of form, good proportion and
accurate observation. Dalí had been well initiated into these methods
at the Figueres School of Drawing under the direction of a draughts-
man and engraver who had been awarded the Prix de Rome and so, in
normal circumstances, such a test would have been well within his
capabilities. However, by his own account of the event, corroborated
by Ana María, he managed to extract the maximum drama from the
situation. It is of course likely that he was extremely nervous about
the examination, as he was about any situation which threatened to
test the reality of his accomplishment against his own, elevated
claims. It is indicative of the prevailing family relations that father
and daughter considered it necessary to accompany the seventeen-
year-old Dalí to Madrid, and highly predictable that he should have
displaced his own anxiety on to them. Six days were allotted for the
drawing, in this case from a cast of the Renaissance sculptor Jacopo
Sansovino's *Bacchus*, and Dalí senior would constantly pester the
academy's attendant with technical questions about his son's

25
Dalí at the
Royal
Academy of
San Fernando,
Madrid,
1922–3
(Dalí is on the
bottom left)

41    The Student Years

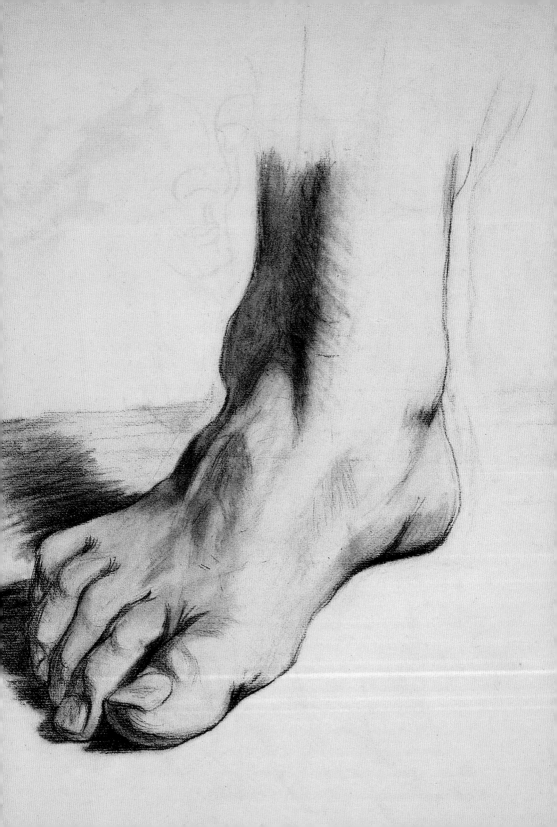

progress, only to be told that the drawing was too small for the regulations. Dalí extracted as much parental anguish as he could by twice abandoning the drawing before, so he claimed, completing it to perfection on the very last day. Further embarrassment ensued for the father, when his attempts to relax by evening visits to the cinema had to be curtailed due to the public's dismay at Dalí's appearance, with his long hair, voluminous scarf, black, shaggy hat and a cloak reaching down to the ground.

Whatever the truth about the drawing for his entrance test, he was duly enrolled for the 1922 session. The first weeks of the course at the academy revealed Dalí as a quiet, hard-working student, living off one peseta a day, with no time for youthful recreation after his classes (25). At weekends he visited the Prado, copying from its collection of Old Masters, and in the evenings he was occupied with his private work, experimenting with the new art forms of Cubism and Futurism. It gradually became clear to him, however, that the course did not offer the kind of direction and teaching for which he had been hoping. There was a mismatch of perception between his teachers and himself about what should constitute contemporary art and, consequently, about how it should be taught. The Royal Academy of San Fernando was founded in 1752 and operated within a general consensus of principles and methods shared among similar institutions in the art centres of Europe during the eighteenth and nineteenth centuries. The idea of 'the academy' was based on the belief that the greatest achievements of art were the products of Classical Greece and Rome – of which, prior to the discovery of Pompeii and Herculaneum, only sculptural examples had survived. These artistic achievements were acknowledged to have been matched by a few outstanding artists of the Renaissance such as Raphael, Leonardo and Michelangelo; gradually, more recent figures from the Baroque period, such as Peter Paul Rubens and Nicolas Poussin, were admitted as exemplary models. The academy was dedicated to propounding the Classical ideal and the teaching programme did not allow the student to paint before he had mastered drawing, nor to work from a life model until Classical taste had been fully absorbed by means of copying from figure sculpture or Old Master drawings (26).

26
*Study of a Foot*, 1922.
Pencil on paper;
47 × 31·5 cm,
18¹₂ × 123⅜ in.
Fundació Gala-Salvador Dalí, Figueres

By the 1920s, even in artistically conservative Spain, this ideal and curriculum were rapidly losing their remaining conviction. The persuasive influence of 'modern', anti-academic approaches to painting, deriving from Realism, Impressionism and Post-Impressionism, which had come to represent the dominant practice in Paris, was now filtering through to Madrid. The work of Joaquín Sorolla now seemed to represent the academy's ideal, with its *plein air*, light toned, freely painted treatment of picturesque, Spanish themes – *tipicismo*, as Dalí called it derisively. Accordingly, instead of an initiation into the mysteries and esoteric formulas of the old tradition of painting that Dalí had hoped for, the only kind of advice he was offered on matters of technique followed the modern idea of painting according to the artist's own feelings rather than according to rules. While these reforms might have been mildly liberating to most of his fellow students, they were irritatingly unhelpful to Dalí who had already explored this territory of painterly freedom while working under Pichot's influence. His respect was reserved for the one master who continued the old ways and who arrived at work in his top hat and corrected the students' drawings wearing white gloves. Dalí's frustration was aggravated by his more advanced knowledge than those around him, not only of the radical movements of Cubism and Futurism of the pre-war years, but also of the contemporary Neoclassical approaches which were being followed in France and Italy, obtained through reading such journals as *L'Esprit nouveau* and *Valori plastici*. He recalls bringing in to the academy a catalogue of an exhibition by the Cubist Georges Braque and the revelatory affect this had on the professor of anatomy to whom he showed it.

However, his formal art training represented only part of his student experience; he was admitted to the Residencia d'Estudiantes, and this contact with the varied and stimulating university environment was to make a more lasting impression on his future development. Far more than simply a student hostel, the Residencia was modelled on the colleges at the English universities of Oxford and Cambridge, with the object of providing an ideal learning community for young people studying a whole range of professional and intellectual disciplines. It was founded in 1910 by Jiménez Fraud with the intention of creating

a new, liberal élite who could take on the political and administrative tasks of modernizing Spain. Fraud invited visiting speakers of the highest international importance to lecture at the Residencia, including the scientists Marie Curie and Albert Einstein, the composers Francis Poulenc and Igor Stravinsky, the writer and social reformer H G Wells, the economist John Maynard Keynes and the Surrealist poets Louis Aragon and Paul Éluard – though it must be said that there is no record of Dalí ever attending these lectures. He certainly missed the fiery provocation of Aragon's address to the students there in 1925, since he had been suspended from his courses at the time. Aragon declaimed: 'We shall triumph over everything. And first of all we shall destroy this civilization which is so dear to you, in which you are caught like fossils in shale ... Rise, O world! See how dry the earth is, and ready, like so much straw, for every conflagration.'

Dalí seems to have remained a rather private person during his first weeks at the Residencia, keeping to his room, either to get on with his work or to cover up his timidity and awareness of his social standing among the bright and confident young men from wealthy and influential families. However, he was shortly taken up by a group of fellow residents who were to contribute substantially to his intellectual maturity and extra-curricular activities. Two of these in particular, Luis Buñuel and Federico García Lorca, were each to be involved in crucial periods of collaboration with Dalí in later years. The circle also included the poet Rafael Alberti; Rafael Barradas, an avant-garde painter from Uruguay who was to exert a brief influence on Dalí; and José (Pepín) Bello, a medical student who was to remain a friend and correspondent for a number of years. In reaction to the limitations of his course at the academy, Dalí was working on experimental approaches in his hostel room and the group were impressed to discover what was, to their eyes, the advanced Cubo-Futurist drawings and paintings he was producing. Pepito Pichot had brought back from Paris a copy of Umberto Boccioni's book *Pittura scultura futurista (dinamismo plastico)* (1914); this he gave to Dalí and we can see Dalí's pencilled notation on it of the faceted planes of a typical Futurist work by Carlo Carrà entitled *Simultaneity* (27). He deploys this Futurist idea of depicting simultaneous events within a freely

structured, dynamic composition in a series of ink wash and water-colour drawings based on his nocturnal adventuring in Madrid (28). Two early student exercises on cardboard survive from around 1923 which reveal his attempts to make use of Cubist and Futurist formal language. *Self-portrait with 'L'Humanité'* (29) reduces the frontal image of his face to a simplified schema and the newspaper title is a collaged piece of 'actuality' rather than a painted representation (he was Figueres's sole subscriber to this French socialist paper and was obviously keen to register his radicalism in this image). In *Self-portrait with 'La Publicitat'* (30) a rather more sophisticated technique of fractured planes is attempted.

As in most student groups, the time that the Residencia students actually devoted to serious discussion of the pressing philosophical and political issues of the day was probably rather limited; according to Dalí, they generally adopted a public display of dandified cynicism. His own political views at this stage favoured either anarchism or

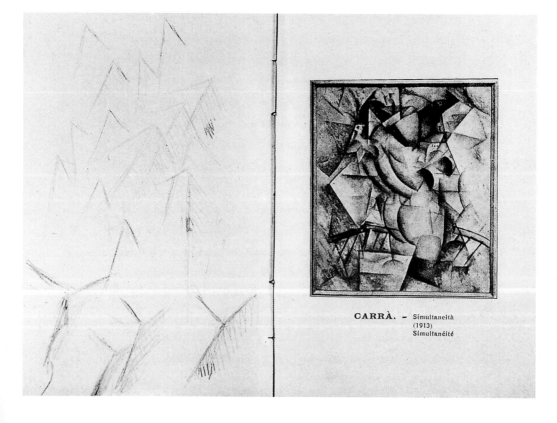

CARRÀ. – Simultaneità (1913) Simultanéité

authoritarian rule, without making much distinction between them. This was based on a somewhat perverse idea that either state of affairs would lead to a sense of 'collective danger by total, systematic disintegration, in order to enhance the possibility of anguish'. His objective, therefore, was not to bring about some new state of harmony and order following world revolution, which was the ultimate aspiration of utopian anarchism, but to institute a sense of permanent, delirious anxiety as a preferred state of mind in its own right.

Before he was allowed to join the fashionable set of young intellectuals at the Residencia, a change of personal style was called for; the general style of the group tended towards English tweeds and precise tailoring but Dalí's variant owed more to the style of the Italian film star Rudolph Valentino. His decadent locks were dispensed with, to be replaced by hair now cut close to the head and given the maximum shine. On this particular detail he recommended adding egg-white to

**27 Opposite**
Dalí's copy of Umberto Boccioni's book *Pittura scultura futurista (dinamismo plastico),* Milan, 1914, with his own drawings next to Carlo Carrà's *Simultaneity* of 1913, c.1922. Private collection

**28 Right**
*Madrid Scenes,* 1922. Ink and wash; 22 × 15 cm, 8²⁄₃ × 5⁷⁄₈ in. Fundació Gala-Salvador Dalí, Figueres

**29 Far right**
*Self-portrait with 'L'Humanité',* 1923. Oil, gouache and collage on cardboard; 104·9 × 75·4 cm, 41¹⁄₄ × 29³⁄₄ in. Fundació Gala-Salvador Dalí, Figueres

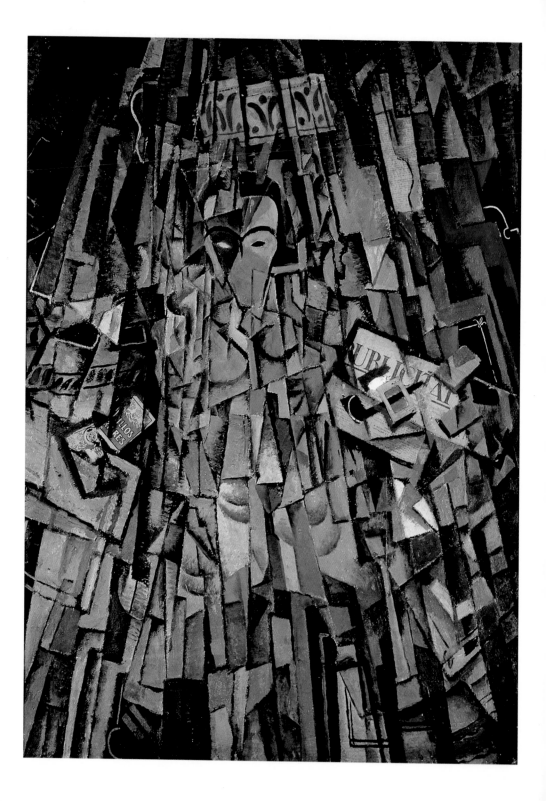

the hair-slick rather than picture varnish, which proved awkward to remove! His tastes for the pleasures of public notoriety and the high life were already emerging:

On coming out of the School of Fine Art, I ecstatically savoured the homage of that street, so intelligent and full of wit ... I stopped to buy a very flexible bamboo cane from whose leather-sheathed handle dangled a shiny strap of folded leather. After which, sitting down at the terrace of the Café-bar Regina, and drinking three Cinzano Vermouths with olives, I contemplated in the compact crowd of my spectators passing before me, the whole future that the anonymous crowd held in reserve for me.

Now he was ready to cruise the literary cafés, to experiment with cocktails, to spend other people's money and to hang around night-clubs in search for elegant women. He defined an elegant woman as 'a woman who despises you and who has no hair under her arms'. He was far too shy and inexperienced to approach them socially but reacted to their presence by ostentatious acts of cocktail-bar performance. These included dissolving peseta bills in glasses of whisky and creating a new cocktail by adding to the drink the blood that had poured from his finger when he had mistakenly attempted to remove a hair from the glass, which in fact turned out to be a crack. The cocktail was then topped off with a decorative cherry from a woman customer's hat, into which he had delicately bitten.

He soon began to realize that his reputation in the group for absurd and unpredictable behaviour had its limitations and was not sufficient to resist the growing dominance of Lorca, who would 'shine like a mad and fiery diamond'. His frankly admitted jealousy of the poet's charisma reveals one of the elements in the complex relationship between the two men.

Hardly surprisingly Dalí's art school career was not to remain trouble-free, and at the beginning of his second year he was suspended for indiscipline. His version of events was that, on the occasion of the inauguration of a new professor, whose work was disapproved of by the students, he had quietly walked out of the room, after which the body of students had voiced their protest with increasing fervour and

30
*Self-portrait with 'La Publicitat',* 1923.
Oil and collage on cardboard mounted on wood;
104·9 × 74·2 cm, 41³⁄₈ × 29¹⁄₄ in.
Museo Nacional Centro de Arte Reina Sofía, Madrid

the police had had to be brought in; subsequently, he claims, he was unjustly identified as one of the ringleaders.

His clashes with authority did not end there, for some time later, when he had returned to Figueres, he was detained under suspicion of unspecified acts of political subversion. It would appear that this action was taken as a means of reprisal against his father, who was opposed to the new, right-wing regime of General Miguel Primo de Rivera. The tensions which had surfaced in the civil life of Spain in 1917, between the forces of tradition and modernization, privilege and democracy, agriculture and industry, remained largely unresolved during the post-war period. Although Spain was at this time a constitutional monarchy, with Alfonso XIII as head of state, there was neither sufficient unanimity among politicians, nor faith among the people in the conduct of the parliamentary system, to sustain a workable party process. Consequently, Primo de Rivera was able in 1923 to suspend the constitution and establish a 'temporary' military dictatorship, which soon after received the endorsement of the king. Although Primo de Rivera admired much of the state efficiency and patriotic nationalism of Mussolini's Italy, his regime was not specifically Fascist in ideology, and he won a considerable level of popular support for his modernizing reforms. On the other hand, he was particularly concerned to repress Catalanism and banned the language from any official usage. It was his attempts to effect changes in the institutional life of the army and the universities which led ultimately to the formation of centres of opposition to his regime, forcing him to resign in 1929.

We might reasonably suppose that Dalí's experience of his month-long incarceration would have been traumatic but, on the contrary, he looked back on it as a kind of 'retreat', getting on with his writing and sketching, drinking the local *cava* (champagne) and relaxing at night in the congenial company of fellow detainees, added to which was the bonus of the status of local hero awaiting him on his release.

Although he returned in the next session to his course at the academy, his true apprenticeship as an artist is better reflected in his growing record of exhibiting and the critical appreciation awarded

him. He contributed to the first major show of Modernist art in Spain, organized by the Society of Iberian Artists in Madrid in 1925, and in the same year the leading modern gallery in Barcelona, the Dalmau, gave him his first solo exhibition.

He did not remain at the academy in Madrid to complete his formal studies and we may well accept his explanation that he got himself expelled from the course – by refusing to acknowledge the authority of his examiners in the theory of fine art – as a strategic device to return all the quicker to Figueres in order to concentrate on the kind of painting that was important to him.

From Cubism to Classicism, a book written in 1921 by Gino Severini, the former Futurist painter, probably came to Dalí's notice, and its title serves to chart the evolution of his work between 1922 and 1926. A much more resolved use of the late Cubist manner of Picasso or Braque than he had previously shown is found in Watermelon of 1924, which achieves an uncharacteristic decorativeness (31). Dalí made a nod in recognition of a classic Cubist work from 1912 by Juan Gris, The Bottle of Rum, with his own Still Life with Bottle of Rum (32 and 33). Here a much tighter, geometrical structure is set up, which can also be closely related to the sparsity and stillness of Giorgio Morandi in his 'Metaphysical' subjects. Dalí would have come across Morandi's paintings reproduced in the pages of Valori plastici, to which he subscribed. To some extent Still Life with Bottle of Rum also reflects the taste for rigorous measurement extolled by Charles-Édouard Jeanneret (more commonly known as Le Corbusier) and Amédée Ozenfant, the theorists of 'Purism'. Writing in the French magazine L'Esprit nouveau, they affirmed: 'The highest level of this hierarchy [of aesthetic sensations] seems to us to be that special state of a mathematical sort to which we are raised, for example, by the clear perception of a great general law (the state of mathematical lyricism one might say); it is superior to the brute pleasure of the senses.'

The origins of Dalí's first mature style are beginning to emerge from his synthesis of the positions of Purism and Metaphysical art. He was attracted to the philosophy of objectivity and anti-emotionalism

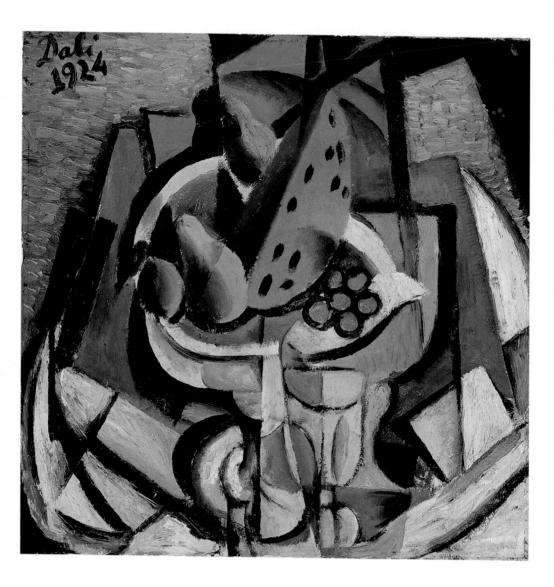

**31**
*Watermelon*,
1924.
Oil on canvas;
49·5 × 49·5 cm,
19 ½ × 19 ½ in.
Salvador Dalí
Museum, St
Petersburg,
Florida

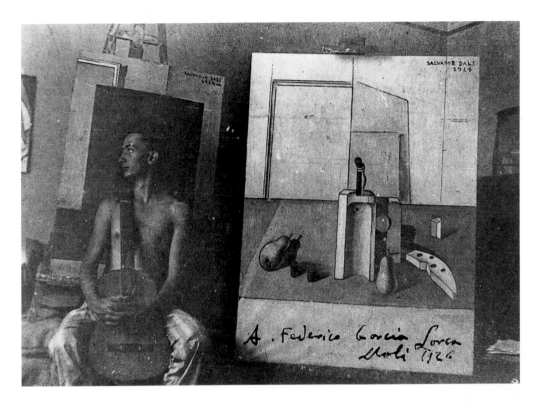

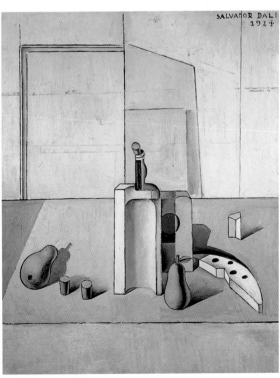

**32 Above**
Dalí in his
Figueres
studio with
*Still Life with
Bottle of
Rum,*
1926.
Fundación
Federico
García Lorca,
Madrid

**33 Below**
*Still Life with
Bottle of
Rum,*
1924.
Oil on canvas;
125×99 cm,
49¼×39 in.
Fundación
Federico
García Lorca,
Madrid

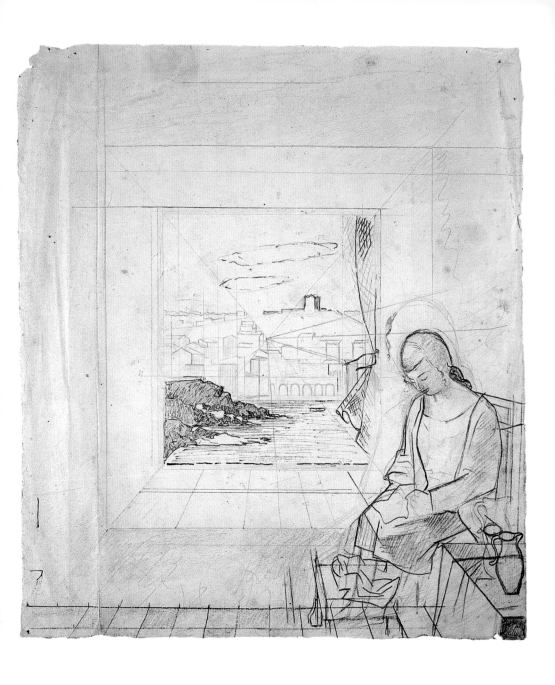

**34**
Study for *Girl
Sewing*, 1926.
Pencil and ink
on paper;
31·5 × 27·8 cm,
12⅜ × 11 in.
Fundació
Gala-Salvador
Dalí, Figueres

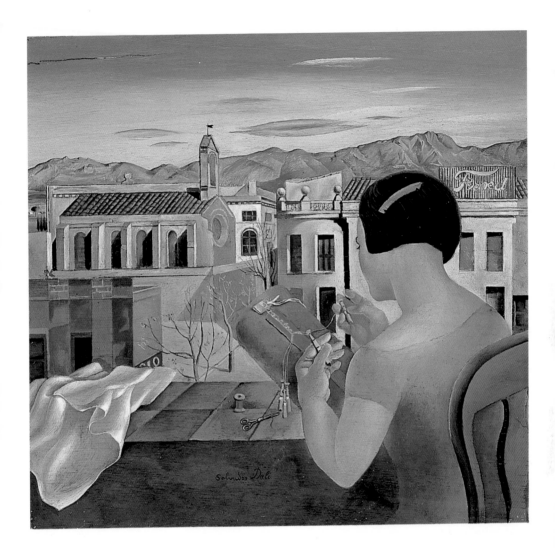

**35**
*Woman at the
Window in
Figueres,*
c.1926.
Oil on board;
24 × 25 cm,
9½ × 9⅞ in.
Fundació
Gala-Salvador
Dalí, Figueres

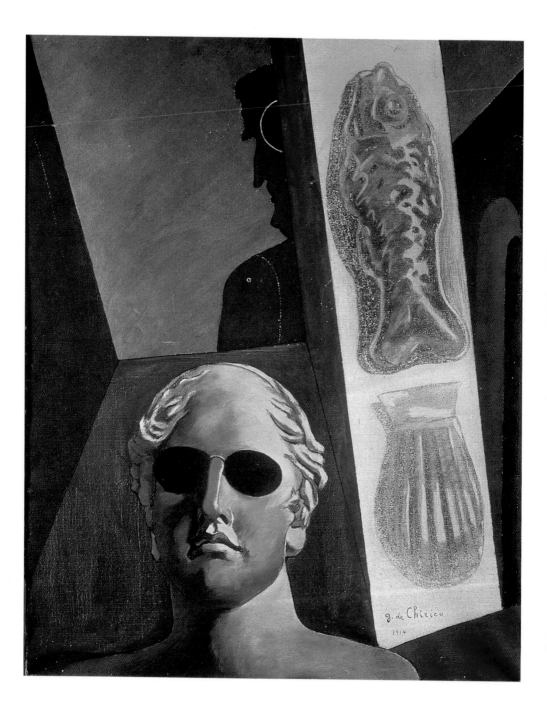

proclaimed by the Purists, as is apparent in the dialogue of artistic ideas recorded in his correspondence with Lorca. It is also evident in his use of a measured, systematic drawing technique, as in the perspective study of 1926 for *Girl Sewing* (34) and *Woman at the Window in Figueres* (35). He recognized in both Purism and Metaphysical art the search for a more profound sense of reality which lay behind the superficiality and the incidental detail of appearance. The Purists maintained that, by focusing intently on the abstracted forms of simple objects like bottles, jugs and musical instruments, the mind could engage in a more meditative conception of reality; it was a philosophical position which was ultimately derived from the idealism of Plato. The Metaphysical artists, such as Giorgio de Chirico (36), maintained that an intensified, visual encounter with objects, located in unpredictable situations and placed in disrupted relations, could induce a troubling sense of 'enigma', of the mystery and melancholy of everyday things. Dalí was clearly attracted to both Purist and Metaphysical viewpoints and, along with many of his contemporaries, he explored them through the language of classicism. Of course this arch-individualist was never interested in following another artist's style very closely. 'Everything influences me,' he once proclaimed, 'nothing modifies me,' and on another occasion, 'the important thing is not what one takes from others but how one differs from them.'

One further tendency had been gaining ground in various forms and locations throughout Europe since the end of the First World War and this was towards a classical realism, usually referred to as Neo-classicism. Rather than seeing twentieth-century Neoclassicism as some reactionary movement running directly counter to Modernism, it is more helpful to consider it as an ebb-tide running for a certain time within the larger movement of Modernism. Certainly, some explanation for the rise of Neoclassicism must be found in the feeling that the headlong rush of avant-garde activity that took place in the first two decades of the century could no longer be sustained. Under the general banner of a 'Return to Order', a number of national schools evolved, particularly in the Mediterranean countries, each displaying local dialects within the language of the Classical ideal. As

36
Giorgio de Chirico,
*Guillaume Apollinaire*,
1914.
Oil on canvas;
89 × 69 cm,
35 × 27⅛ in.
Musée National d'Art Moderne, Centre Georges Pompidou, Paris

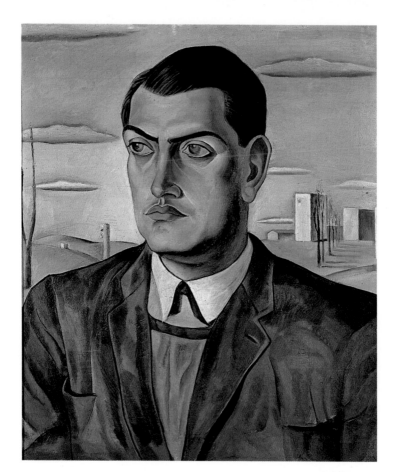

**37 Left**
*Portrait of
Luis Buñuel*,
1924.
Oil on canvas;
70 × 60 cm,
27¹⁄₂ × 23⁵⁄₈ in.
Museo
Nacional
Centro de
Arte Reina
Sofía, Madrid

**38 Right**
*Portrait of my
Father*,
1925.
Oil on canvas;
100 × 100 cm,
39³⁄₈ × 39³⁄₈ in.
Museu d'Art
Modern,
Barcelona

we have seen, Catalunya had already developed its Noucentisme
movement, André Derain was at the heart of such tendencies in Paris
and the Novecento group in Italy – Mario Sironi, Felice Casorati and
others – were revisiting the pictorial language of the Renaissance.
Around 1925, Dalí was becoming particularly susceptible to this style
of Neoclassical realism. The splendidly grave and heroic portrait of his
college friend, the twenty-five-year-old Buñuel as a modern man of
action (37), was recognized by critics as reflecting very effectively the
then current Noucentista taste, shared with other Spanish artists such
as José de Togores and Sunyer. His typical reduced palette at this
stage, of sienna brown, olive green, black and white, is also apparent
in the 1925 work *Portrait of my Father* (38). It is tempting to see here
a much more relaxed figure than in the earlier depictions, seated and
in his leisure clothes, in a posture which reflects the twin notes of

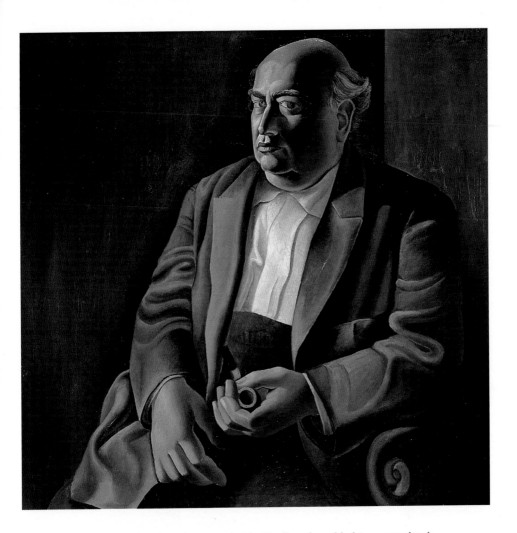

**pride and resignation revealed in the lines he added to a scrapbook that he kept of his son's achievements:**

After twenty-one years of cares, anxieties and great efforts I am at last almost able to see my son in a position to face life's necessities and to provide for himself ... We his parents did not wish our son to dedicate himself to art, a calling for which he seems to have shown great aptitude since his childhood. We know the bitterness, the despair and the sorrow of those who fail ... the passion which he feels for painting distracts him from his official studies.

I should not be telling the truth if I should deny that my son's present successes displease me, for if it should happen that my son were not able

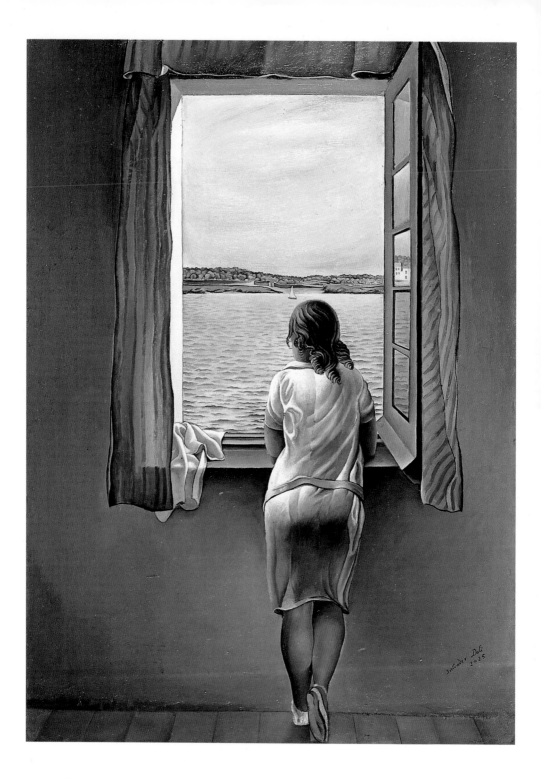

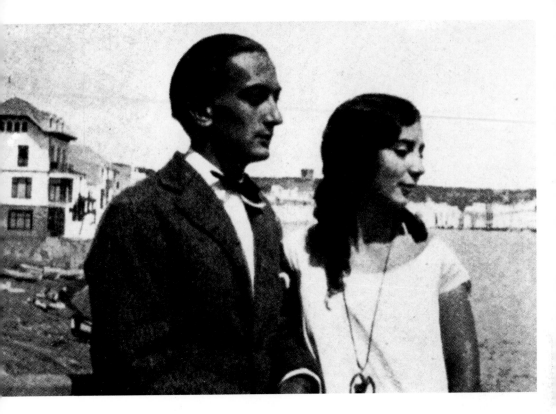

**39 Left**
*Figure at a
Window,*
1925.
Oil on
cardboard;
105 × 74·5 cm,
41⅜ × 29⅜ in.
Museo
Nacional
Centro de Arte
Reina Sofía,
Madrid

**40 Above**
Dalí and Ana
María in
Cadaqués,
1925-6.
Fundació Gala-
Salvador Dalí,
Figueres

to win an appointment to a professorship, I am told that the artistic orientation he is following is not completely erroneous.

The *Figure at a Window* is perhaps the best known of Dalí's pre-Surrealist works (39). At one level, it has the familiar look of much Neoclassical painting of its day, using the pictorial device of a figure in repose in conjunction with a 'framed' landscape seen through a window – a picture within a picture – which is typical of Italian Novecento art. What is not typical is that the model, in this case Dalí's sister (40), is seen from behind, and the rules of the genre are decidedly breached when the ideal mood of tranquillity and the harmony of form and composition are disturbed by an undeniable air of suppressed eroticism, a feature which indicates much of the future development of his work.

A companion piece of the same format, *Seated Girl from the Back* (41), was also shown in his first solo exhibition in Barcelona and was used for the catalogue's title page. It manages to retain more of the

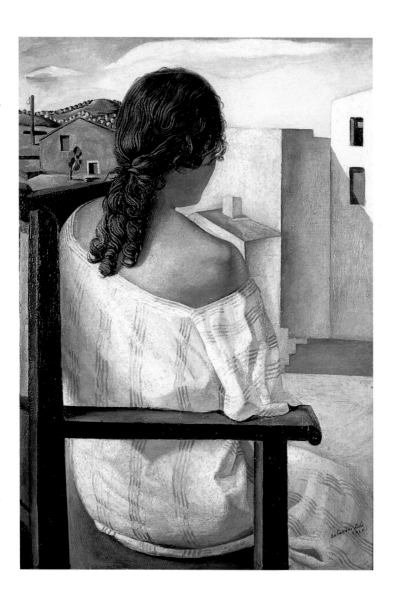

**41 Left**
*Seated Girl
from the Back,*
1925.
Oil on canvas;
103 × 73·5 cm,
40¹₂ × 29 in.
Museo
Nacional
Centro de Arte
Reina Sofía,
Madrid

**42 Right**
*Portrait of
María
Carbona,*
1925.
Oil on
cardboard;
52 × 39·2 cm,
20¹₂ × 15¹₂ in.
Museum of
Fine Arts,
Montreal

classical mood, with the braided hair and simple dress achieving a
certain timeless quality and with its highly formalized pictorial
structure, allowing distinct areas for sections of landscape and town-
scape. Dalí's particular touch, however, is revealed in the visual
rhyming of the line of the shoulder with the slope of the roof and the
highlighted contrast of light and shade which results from this.

In the spirit of the current Classical revival, the catalogue is prefaced
with a number of maxims from the nineteenth-century French
Neoclassical painter Jean-Auguste-Dominique Ingres, such as,

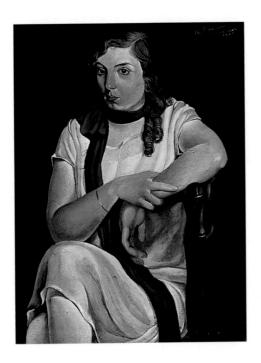

'Beautiful form consists of even surfaces with curvatures. Form is
beautiful when it is both firm and full, and when the details do not
harm the overall impact of the full shape', and, 'Drawing is the
probity of art.' This respect for the clarity of outline drawing and
lightness of shading, which had recently been revisited by Picasso, is
reminiscent of Ingres, and is vividly apparent in Dalí's linear style of
this time (42). The exhibition was very successful, most of the work
was sold and he was hailed by critics as an impressive new talent –
though he was discussed only in terms of Noucentisme.

In 1926 Dalí left Spain for the first time, as a young man in his early twenties, to visit France and Belgium, accompanied by his aunt (who was now married to his father) and sister. His activities there reflect, even at this early stage, his ambivalent attitudes to Modernist art and to the art of the museums. He was able to visit Picasso in his studio, which he describes in the awed tones of a papal audience; this is understandable: Picasso was both a heroic figure in the history of avant-garde art and a role model for Dalí as an honorary Catalan (although born in Malaga) who had achieved international recognition. His fame and financial success imposed a necessary distance of access and Dalí required a letter of introduction (which was then a normal social convention) from Manuel Angeles Ortiz, a Cubist artist from Granada and a friend of Lorca. Dalí delivered the well-rehearsed line on meeting Picasso, 'I have come to see you before visiting the Louvre,' and took a couple of examples of his current work to show him. Picasso seems to have been pleased to help the young artist and, later the same year, after seeing his work on show in Barcelona he recommended Dalí to his dealer, Paul Rosenberg.

43
*Basket of Bread,*
1926.
Oil on panel;
31·5×31·5 cm,
12³⁄₈×12³⁄₈ in.
Salvador Dalí
Museum, St
Petersburg,
Florida

Of course Dalí visited the Louvre as well as Versailles and the Musée Grevin waxworks; more unusual was his visit to Millet's studio/museum, which marks the first instance of his long-term obsession with the Barbizon painter. There is no doubt that in his visits to the Louvre and then the Musées Royaux in Brussels, he further whetted his appetite for the Dutch and Flemish artists such as Vermeer and Pieter Bruegel to whom he had been introduced in the art books of his childhood. Perhaps as a result of this experience, in 1926 he painted in a newly precise technique the *Basket of Bread* (43). The black background reminds us, though, more directly of the work of the seventeenth-century Spanish artist Zurbarán, and indeed the subject itself must be seen in the long Spanish tradition of the still-life depiction of food known as the *bodegón*. These subjects usually have some moral or even religious significance beyond their decorative value, and we know that bread always held a particularly rich level of symbolism for Dalí. The *Basket of Bread* celebrates a sense of the marvellous within the ordinary, with associations which range from the widespread Mediterranean custom of serving bread at

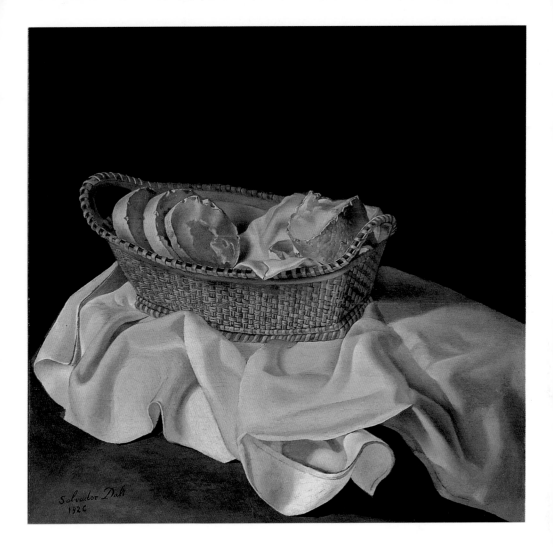

the start of the meal to all the biblical references to 'breaking bread', culminating, of course, in the profound Roman Catholic symbol of the Host. The painting is also of interest as being the first work by Dalí to be exhibited in the United States, at the Carnegie Institute International Exhibition in Pittsburgh, where it was purchased.

But Dalí was far from resigning any claim to work in a more advanced manner; he coined the useful term 'Neocubist' to refer to his own efforts to apply the particular emphasis and montage, the selection of certain details and the freedom from the restrictions of conventional pictorial language which Cubism had won. He was particularly

attracted to the ways in which Picasso applied this language to traditional figure subjects such as the Harlequin and Pierrot from *commedia dell'arte* theatre and Classical figures derived from statuary, and he had a reproduction of Picasso's 1922 study for the Ballets Russes production of *Train bleu*, called *The Race* (44) pinned up on his studio wall. His *Venus and a Sailor* (46) light-heartedly montages together emblematic images of ancient and modern characters. The *Figure on the Rocks* (45) of 1926 is only partially inspired by Picasso, in that it displays his current interest in intense highlighting of form; it also reveals Dalí's unwillingness to take the Classical allusions very seriously, for he is surely mocking the undignified and erotic abandon of the sunbathers who disported themselves outside his Cadaqués studio. The major work in this synthesis of Cubism and classicism, the *Neocubist Academy* (47), is now in the unlikely location of the monastery of Montserrat. Painted on a grand scale (200 cm or some 79 in

44
Pablo Picasso,
*The Race*,
1922.
Gouache on
wood;
32·7 × 41·3 cm,
12⁷⁄₈ × 16¹⁄₄ in.
Musée Picasso,
Paris

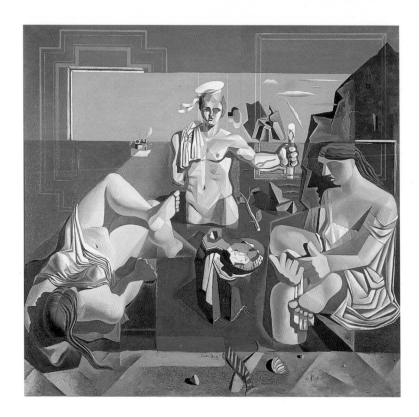

square), it may well have been conceived in the spirit of a riposte
to the academy which had finally expelled him. Dalí connects its
iconography with the theme of St Sebastian, a topic which he also
treated in a prose piece later published in *L'Amic de les arts*. The
theme was developed in the correspondence between Lorca and Dalí,
and represented the complexity of their relationship. It is possible
to see the features of both Dalí and Lorca in the classic head of the
central figure, who, as St Sebastian, has survived the wounding barbs
of critics and detractors and now stands, poised between figures
representing 'luxury' and 'virtue', in search of the way ahead. The
playful details, such as the sailor's cap and crossed, phallic signs of
the tie and the fish look forward to the Surrealist explorations of
the coming years.

'I met Lorca and our friendship, based on complete antagonism,
began,' Dalí perceptively confided to his friend Sebastià Gasch. What
initially attracted them to each other was probably the mutual

**47 Left**
*Neocubist
Academy,*
1926.
Oil on canvas;
200 × 200 cm,
78¾ × 78¾ in.
Museo de
Montserrat,
Barcelona

**48 Right**
Lorca and Dalí
at Cadaqués,
March 1925

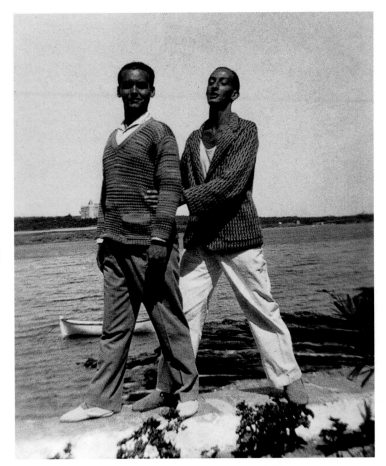

recognition of their marginality within the student group at the
Residencia; they soon realized that each had the ambition and the
promise to revolutionize their respective fields of poetry and painting
in Spain. Suffusing all this was a highly charged atmosphere of erotic
attraction (48). There is no doubt that the years between 1923, when
they met at the Residencia, and 1929, when they parted, not only
from each other's company but also from their native country, with
Dalí travelling to Paris and Lorca to New York, proved enormously
fruitful in the mutual development of their artistic ideas.

Lorca, who was six years older than Dalí, was born at Fuente Vaqueros
(where a dedicated museum has since been set up) near Granada, the
child of a prosperous farming family. He was a talented pianist and
might well have pursued a musical career. He worked with Manuel de

Falla in drawing attention to the magnificent tradition of flamenco music among the gypsies of Andalucia and helping to organize a festival and competition of *cante jondo* (deep song). Andalucia and Catalunya represent diametrically contrasting aspects of Spanish life and values; Andalucia is almost African in climate and its customs and architecture reflect the 800 years of Islamic rule there before the sixteenth century. Lorca's subjects are suffused with the tragedy of life, the constant presence of love and death, and the mysterious force of expressive passion, 'the hidden spirit of suffering Spain', which he called *duende*. Although he lived at the Residencia in Madrid, he was actually registered to read law at Granada University. He has, of course, achieved world-wide recognition as poet and playwright; what has only more recently been recognized is his output as a visual artist. His drawings, which have a direct, folk-art quality about them, were described as 'involuntary' (though not automatic in the Surrealist sense) when exhibited at the Dalmau Gallery, and Lorca used drawing as an adjunct to his writing: 'When a subject is too long or has a tricky poetic content, I resolve it with pencils.'

In 1925 Lorca was invited to the Dalí family home for the Easter holiday, where he gave a private reading for them of his new play, *Mariana Pineda*, which was later to be performed in Barcelona with sets and costumes designed by Dalí. In return Dalí's father organized a Sardana (regional dance) in honour of the poet, who seems to have been entranced by the scenery of the Empordà plain and the Cadaqués coast. His growing fascination with Dalí the artist and Dalí the young man was made manifest in the publication the following year of his 'Ode to Salvador Dalí', which was favourably reviewed as far away as Paris. This poem in twenty-eight verses marks a new development in Lorca's language, with the use of 'object phrases', tightly montaged together, in a manner which can be described as Cubist. In it he celebrates the objectivity of perception and the clear precision of imagery which he admired in Dalí, as representative of the ideals of the modern artist, and which he himself would only later be able to achieve after he had shed the clinging romanticism of Andalucia when he discovered the modern drama of New York. Here are some verses from the opening section, in the translation by

Merryn Williams, which offer an effective commentary on the painter's pictures of this period:

A rose in the high garden that you desire.
A wheel in steel's pure syntax.
Naked is the mountain of Impressionist mist.
The grey looks down upon their last balustrades.

Modern painters, in their white studios,
cut the square root's aseptic flower.
In the waters of the Seine, a marble ice-berg
cools the windows and dispels the ivy ...

Sailors who ignore the wine and the half-light
behead mermaids on seas of lead.
The night, black statue of wisdom,
is holding the moon's round mirror.

A desire for forms and limits overcomes us.
The man who thinks with the yellow ruler is coming.
Venus is a white still-life
and the butterfly collectors flee.

Dalí had adopted this posture of 'the man who thinks with the yellow ruler' in his first encounters with Lorca in the Residencia group as his only defence against the magnetically influential charm of the poet: 'I would say nothing that was indefinable, nothing of which a "contour" or a "law" could not be established ... when I felt the incendiary and communicative fire of the great Federico rise in wild, dishevelled flames.'

For a couple of years this interaction profoundly affected Dalí's art and thought; they shared a common arena of concern, exploring the rich power of the material world to provide a symbolic imagery, heightened through disturbingly unpredictable juxtaposition, even though they approached that material world from opposing direc-tions, with Lorca disposed to the lyric charm of folk–myth and Dalí to an unemotional objectivity. This sense of a shared venture appears in their joint ownership of a number of complex symbols, seeing them-

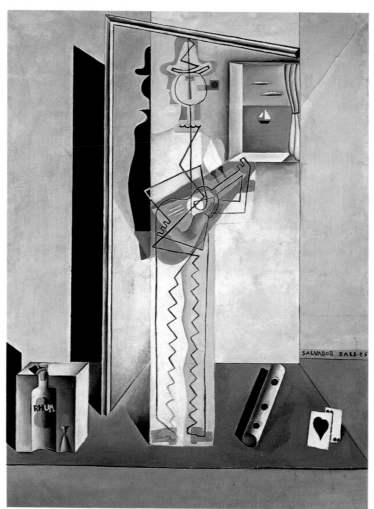

**49**
*Pierrot Playing
the Guitar,*
1925.
Oil on canvas;
198 × 149 cm,
78 × 58⅝ in.
Museo
Nacional
Centro de Arte
Reina Sofía,
Madrid

selves, for example, as modern-day martyrs in their use of the St
Sebastian theme. Their derisive name for the bourgeois philistine was
the *putrefacto*, and Dalí employed the image of a 'rotting donkey' in
a number of pictures, culminating in one of the most extraordinary
scenes in the film *Un Chien andalou*. Their self-perception as almost a
twinned personality is also evident in the various double portrait
images of Lorca and himself, for example, *Pierrot Playing the Guitar*,
from 1925 (49). Although it is arguable which one of the pair is
represented by the schematically drawn Pierrot and which by the
deeply shadowed Harlequin, the significant point is that they are joint
but contrasting aspects of a shared personage.

The letters that survive between the two indicate an intensity of personal affection as well as a shared delight in the excitement of their artistic debate. Dalí sent Lorca a drawing – dedicated 'with all the tenderness of his little son' – and Lorca made it clear how much he missed Dalí when they were separated for a long time. On the balance of evidence, it would seem that the relationship was not physically consummated but, in any case, the level of social disapproval of homosexuality in Spain at the time was such that it would have been very difficult, even dangerous, to have openly admitted it if it were. It is probable that homophobia was a major element in the local circumstances that led to Lorca's assassination in 1936.

For Dalí the main gain from this intense experience of interaction between word and image was the discovery of a new route out of both Cubism and classicism and a number of paintings from around 1927 show this development. In works such as *Apparatus and Hand* (50) we can see the breakthrough into that kind of randomized pictorial space, with its disconnected and freely floating fantasy images, which will shortly provide the facility for his Surrealist ideas to emerge. In *Little Cinders* (51) this sense of the uncensored and non-sequential drama of the dreamed experience is further developed; dominated by a bloated, fleshy torso of unspecified gender, a world of invented, fetishistic objects and body parts, including a grimacing head of Lorca, is created.

50 Overleaf
*Apparatus and Hand,* 1927.
Oil on panel;
62·2 × 47·6 cm,
24½ × 18¾ in.
Salvador Dalí
Museum, St
Petersburg,
Florida

It soon became clear that the essentially antagonistic artistic positions of the two could not remain undeclared for long; Dalí had already suggested in a letter to Lorca that his poetry should acknowledge the fact that in the twentieth century trams ran through the streets of Granada and planes flew overhead, that today people listened to jazz records, not the songs of troubadours strumming their mandolins. He attached to another letter a photograph of himself animatedly dancing the Charleston of which he was reportedly a great exponent. By 1928, following the publication and popular reception of Lorca's work *The Gypsy Ballads*, Dalí could no longer restrain his serious disapproval of what he regarded as sentimental 'flamenco dramas'.

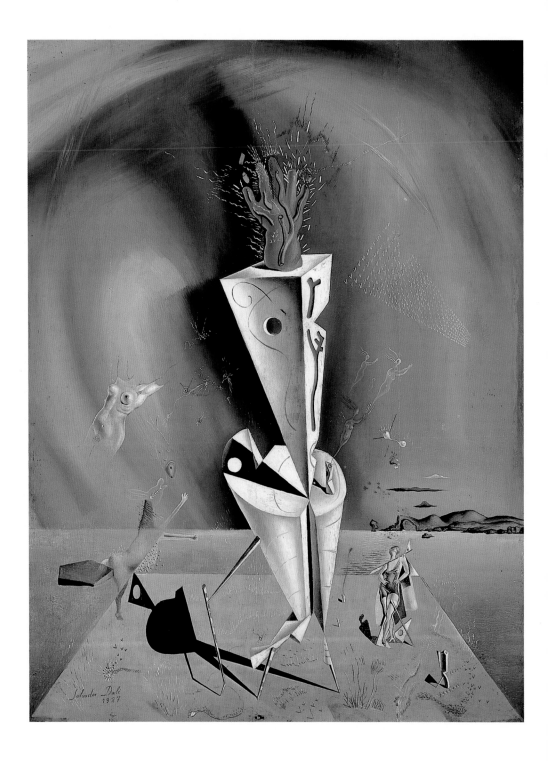

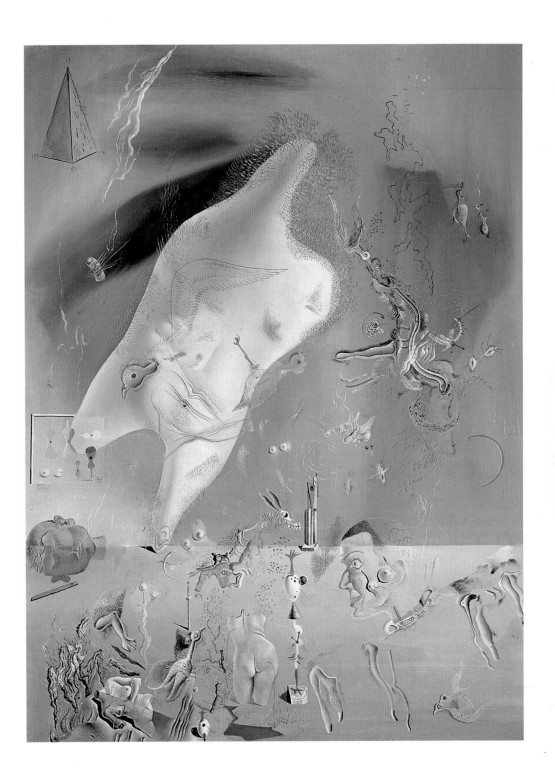

Dalí is consistently remembered by those who first encountered him in the 1920s as possessing a clear and precise intellect. For a long time the clowning and showmanship that coloured Dalí's later years have diverted attention from the vitality and originality of his critical and experimental writing in this period. This situation is gradually being remedied as his work is translated and becoming available in English. The impressive contributions that he made to the literature of art first appear in a series of articles he wrote for the Catalan public in *L'Amic de les arts* between 1926 and 1929. They reflect the passionate evolution of his ideas during the period of his transition towards Surrealism and demonstrate his awareness while still a young and developing artist in Spain of current debates in Paris and elsewhere in Europe.

His essay 'St Sebastian' approvingly quotes the Metaphysical artist and writer Alberto Savinio, and the piece goes on to describe an

object or a painting conceived in the imagination, which seems to possess some of the attributes of one of De Chirico's humanoid mannequins. The language is experimental and evocative as if to support his claim that 'today, poetry belongs to the painter.' This metaphysical St Sebastian is equipped with devices for the 'measurement of apparent distances between pure aesthetic values' and is dedicated to 'holy objectivity'. Dalí's reference here is to what Fernand Léger called the machine aesthetic, that prevailing spirit of optimistic association with the speed and efficiency of the modern world that was shared by the younger generation which thrived in it. As if setting out the scenario for an unrealized painting in this mode of modern classicism 'St Sebastian' espies: 'On the deck of a white mail boat, a breastless girl taught sailors sated with the west wind to dance the black bottom ... On the racing track in Portland, the blue Bugattis, seen from an aeroplane, take on a sleepy movement of hydroida which spiral down to the bottom of the aquarium.' When the saint (who on other occasions corresponds to the hybrid figure of Dalí/Lorca) turns his instrument in the opposite direction, he sees 'putrefaction' and 'the blubbering, transcendental artists, far removed from all clarity'.

Dalí's main argument, then, is with the aesthete, the mystic and the sentimentalist – the 'art lover' who relies on academic theory and inherited notions of taste; the new art, by contrast, is accessible to children and all those without educated culture – he points to the clear understanding of his own work that was displayed by the fishermen at Cadaqués. In a famous essay of 1925, 'The Dehumanization of Art', the Spanish philosopher and art historian Ortega y Gasset addresses the same phenomenon of objectivity: 'There is one feature of great significance which seems to symbolize all that modern art stands for – the fact that it is stripped of all spiritual content.' However, he differs from Dalí in holding out no hope that the essentially dehumanized modern art will ever win the acceptance of the masses.

Dalí's theoretical thirst for pure objectivity leads him logically to consider the role of the camera in 'Photography: Pure Creation of the Mind', an essay which appears to have been informed by László Moholy-Nagy's book *Painting, Photography, Film* published by the experimental German school of design, the Bauhaus. On a later occasion he was to state that his ideal was to paint 'hand-made colour photographs' and the essay provides some explanation why this approach is particularly appropriate for the Surrealist vision. His point is that, while the painter must inevitably select objects to be seen, and appoint specific and limited symbolic meanings to them, the camera lens 'glides with continual imagination over new events'; it does not impose its own selection but allows the viewer the inventive act of identifying meaning; above all, it allows transformation from one order of meaning to another without hindrance of logic, in the way that the dream works – a way he would soon set out to reproduce in such paintings as *The Accommodations of Desire* (82). He offers a clear example of such a sequence: 'A clear portrait of an orchid poetically merges with the photographed inside of a tiger's mouth, where the sun plays in a thousand shadows with the physiological architecture of the larynx.'

The logic of this argument for the particular suitability of photography as a Surrealist medium is carried to its next stage when he writes

**52**
*The Bather*
1928.
Oil, sand and
gravel on
panel;
52 × 71·7 cm,
20¹⁄₂ × 28¹⁄₄ in.
Salvador Dali
Museum, St
Petersburg,
Florida

about film. (It is apparent that his next major venture – making a film with Buñuel – came at a precise point in the development of his creative ideas.) In 'Art Films and Anti-Artistic Films' he criticizes artistically inclined film-makers for bringing to the medium the worst affectations of the old lyrical or literary culture and for showing no awareness of the inherent technical qualities of the medium. He believes that even modern artists such as Léger and Man Ray get it wrong, by making the mistake of creating a world of invented images, directed at the eyes alone. Instead it is the 'anti-artistic' Hollywood producer who, in working like a 'naïve' artist, reflects the subconscious fantasies behind the popular imagination: 'He films in a pure way, obeying only the technical necessities of his equipment and the infantile and strikingly joyful instinct of his sporting physiology.' What Dalí recognizes is that a whole new culture, particular to the medium of film, has evolved, founded on an anonymous collective system of production and speaking directly to the popular mass audience. In just the same way, the audiences for ancient Greek tragedy demanded stereotypical plots, but were entertained by the unexpected ways in which these were played out.

Dalí's 'anti-artistic' impulse revealed itself in a number of deliberately provocative paintings and art objects, as well as writings, during 1928. *The Bather* (52) offers the viewer a strange headless torso, of neither sex in particular or, rather, of both sexes, since this is the first of his several images which deal with the theme of masturbation, its outstretched hand, with repellently wrinkled fingers, also simulating the form of a vulva. A group of paintings from the late 1920s, including *The Bather*, incorporate sand as an anti-aesthetic painting material. *The Bird* (53) employs both sand and gravel. At about the same time Miró was using almost Dadaist techniques expressly in order to 'assassinate' painting, with the use of rough, displeasing materials, and Dalí responded to this example with a number of objects made from cork fishing floats, such as *Anthropomorphic Beach* (54), which recall the ambiguous forms of Hans Arp. There is no doubt that Dalí at this time is looking much more closely at Surrealist painters such as Yves Tanguy (55), with his ambiguous pictorial space, at Max Ernst and above all at Miró, adopting his bright blue backdrop in such

**53 Above**
*The Bird,*
1928.
Oil, sand and gravel on panel;
49 × 60 cm,
19¹⁄₄ × 23⁵⁄₈ in.
Private collection

**54 Below**
*Anthropomorphic Beach*
(fragment of first version),
1928.
Oil, cork, stone, red sponge and carved polychrome, wooden finger on canvas;
47·5 × 27·7 cm,
18⁵⁄₈ × 10⁷⁄₈ in.
Salvador Dalí Museum, St Petersburg, Florida

pictures as *Little Cinders* (51) and *Apparatus and Hand* (50). Miró was also Catalan, was some eleven years older than Dalí, and had been living in Paris since 1920. He much admired these paintings of Dalí's when he came to Figueres in 1927, bringing with him his Parisian dealer, Pierre Loeb. Although a contract was not yet forthcoming, Miró wrote to Dalí and to his father encouragingly and advised Dalí to get himself established in Paris, where it mattered. The picture which emerges of Dalí, the young artist in his mid-twenties, during the years between his student life in Madrid and his immersion into the world of Surrealism in Paris, is one of tremendous mental energy and of eagerness to pick up, sample and try out the visual and theoretical ideas that were current in the circles of advanced art during the 1920s.

It has been noted that Dalí's more pictorially conventional works had been well received by reviewers but these more recent, dream-inspired pictures, Surrealist in all but name, had certainly not; the local critics were confused and outraged. Dalí took the opportunity in an article entitled 'My Pictures at the Autumn Salon' in 1927 to reply to these *putrefactos*, insisting on the 'anti-artistic and direct' effects of his work and ending with a statement of belief in his work and his confidence in the judgement of the general public, which fittingly rebuts much of the criticism that he was going to receive over the years to come from various sections of the art establishment: 'What is certain is that people were glued in front of my pictures like flies on Tanglefoot paper, despite finding risible and stupid the things they could not restrain themselves from looking at. Why? Because the poetic fact held them, moved them subconsciously, despite the violent protests from their culture and their intellect.'

Dalí's taste for provocation was increasing. He sensed that his early success in Barcelona and Madrid was too easily won and that a move to Paris was imminent; knowing the Catalans' sentimental pride in their local culture, at a public lecture in Barcelona he even called for the clearance of the historic Gothic quarter of the city and the banning of the national dance, the Sardana. Finally, along with two friends from the *L'Amic de les arts* circle, Sebastià Gasch and Luis

55
Yves Tanguy,
*Shadow
Country,*
1927.
Oil on canvas;
99 × 80·3 cm,
39 × 31⅝ in.
Institute of
Arts, Detroit

Montanyà, he published the *Yellow Manifesto*, which denounced the cosiness and torpor of Catalan culture. It is actually a consistent and evenly tempered declaration, in line with the general tone of then current Modernist optimism associated with the ideas of Léger and the Purists. Essentially it voices the derision and frustration experienced by a youthful generation rebelling against the cultural establishment of its elders:

WE DENOUNCE the total lack of decision and audacity

WE DENOUNCE the fear of new events, of new words,
of the risk of the ridiculous

WE DENOUNCE the torpor of the putrid atmosphere of
clubs and egos mingled with art

WE DENOUNCE the total unawareness of critics
with regard to the art of the present and the past

Contemporary artists of whom they did approve included Picasso and De Chirico, Miró and Gris, the Purists and most of the Surrealists. This latter movement held great creative promise for Dalí and his *Yellow Manifesto* colleagues.

Early in 1929 Dalí began to work with Luis Buñuel, his friend from
student days in Barcelona, on a project for a film script. Eventually
the filming brought Dalí to Paris. He was now ready for a new phase
in his life at the heart of the Surrealist movement.

Surrealism was the last of the major tendencies to emerge within the
Modernist movement. It has proved one of Modernism's most resilient
ideas; continuing to influence many areas of contemporary art, it
has entered into our general language and has spread beyond the
confines of art and into unexpected corners of everyday life such as
advertising and product design. However this 'quiet revolution' would
have been a sad disappointment to its original advocates for whom
the ultimate prize was – following the poet Arthur Rimbaud – 'to
transform life', and – following Marx – 'to transform the world'.

Many of the early members (57) had been associated with the Dada
movement and, clearly, much of that movement's taste for insult,
disruption and irony were taken over into Surrealism, but there were
also emphatic points of departure. Dada was nihilistic and anarchic,
having no faith in any future system of social organization; its
preferred medium was performance; it embraced no philosophical
position, whereas Surrealism was idealistic and Marxist, maintaining
a belief in the promise of revolution; its original mode of expression
was primarily literary; and it avidly adopted the therapeutic methods
of Freudian psychoanalysis as the basis for creative living. Surrealism
was also different in that it acknowledged a line of inheritance,
reaching back into Europe's Romantic tradition, to the German
Romantic writers, the English 'Gothic' novelists and especially to such
nineteenth-century French poets as Charles Baudelaire, Rimbaud and
Stéphane Mallarmé, who probed the limits of imaginative expression.
A particular place of honour was reserved for the Comte de
Lautréamont (the pseudonym of Isidore Ducasse), whose frequently

56
Hand with
ants from the
film Un Chien
andalou,
directed by
Dalí and Luis
Buñuel, 1929

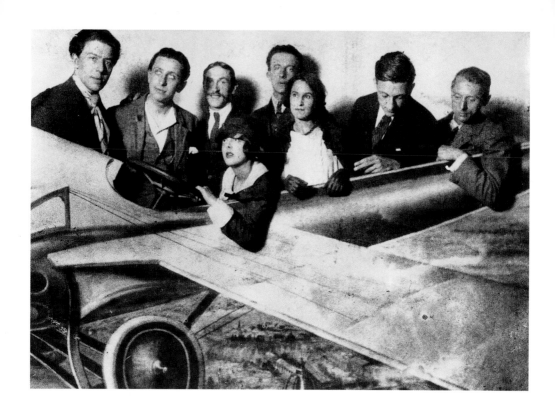

quoted line 'as beautiful as the chance encounter of a sewing machine and an umbrella on a dissecting table' was revered as a kind of talisman by the Surrealists, representing their ideal of a memorable, poetic image which had the potential to suggest a complex of symbolic associations, largely by the surprising and irrational juxtaposition of objects.

So, what was Surrealism? For Dalí it was 'the systemization of confusion' designed to destroy 'the shackles limiting our vision'; for the actor and dramatist Antonin Artaud it was 'a state of mind'; but for the more philosophically inclined André Breton, who provided an impressive dictionary definition, Surrealism was: 'Pure psychic automatism, by which it is intended to express, either verbally or in writing, the true function of thought. Thought dictated in the absence of all control exerted by reason, and outside all aesthetic or moral considerations.' Its founders were the group of young men – notably Philippe Soupault, Louis Aragon and Breton – who wrote for the Parisian journal *Littérature* between 1919 and 1923. By 1922

**57 Left**
Surrealists in
an aeroplane
(from left to
right: André
Breton, Robert
Desnos, Joseph
Delteil,
Simonne
Breton, Paul
and Gala
Éluard,
Jacques Baron
and Max
Ernst), c.1930

**58 Right**
Francis
Picabia,
Cover for
'Littérature',
1922

Breton had taken over the editorship and steered it clearly away from
its earlier associations with Dadaism, although making good use of
the graphic wit of the unreformed Dadaist Picabia for its cover
designs (58). A joint work by Soupault and Breton, *The Magnetic
Fields*, is generally considered the first categorically Surrealist work,
but perhaps the movement's formal inauguration was marked by the
publication in 1924 of *The Surrealist Manifesto*.

In the manifesto, Breton diagnoses the pervasive discontent of
contemporary man (and it is written from a restrictively male
perspective) as the result of his chronic separation from the imagina-
tive world of the dream and the fantasy. He reminds the reader of
those privileged states of mental freedom, like that of children who
'set off each day without a worry in the world', or of the insane,
whose 'profound indifference to the way in which we judge them, and
even to the various punishments meted out to them, allow us to
suppose that they derive a great deal of comfort and consolation
from their imagination'. The problem is that 'we are living under the

reign of logic' and that rationalism is quite inadequate to answer the needs of our actual experience of life. But now, with the guidance offered by Sigmund Freud, 'the imagination is perhaps on the point of reasserting itself, of reclaiming its rights. If the depths of our mind contains within it strange forces capable of augmenting those on the surface, or of waging a victorious battle against them, there is every reason to seize them.' Breton argues that, in opposition to common-sense opinion, we should see the dream state as registering reality, to which our waking moments are but confusing interference. He goes on to explain the release of creative activity that Surrealist writers induce by using techniques which facilitate 'a monologue spoken as rapidly as possible without any intervention on the part of the critical faculties ... akin to spoken thought', a process which he called 'automatism'.

Dalí and Buñuel shared an enthusiasm for film as a medium ripe for Surrealist exploitation. Film had not, like the older expressive media, become 'putrefied' under layers of tradition and aesthetic pretension; its development, both in terms of its technical sophistication and its form of narrative language, had been shaped largely through the dynamics of commercial pressure; and it was a popular art form, considered to be in poor taste by the respectable, cultured classes and therefore most eligible for the formation of a modern mythology in touch with the subconscious sensibilities of its contemporary audience.

Buñuel had been living in Paris since 1925, intent on developing his career as a film-maker, latterly working as an assistant to Jean Epstein on the production of *The Fall of the House of Usher* as well as writing on film for *Cahiers d'art*. He had kept in touch with Dalí, meeting him and showing him round Paris on his visit in 1926, and, as Dalí found it harder to suppress his artistic differences with Lorca, Buñuel's influence began to replace that of the poet (see Chapter 2).

Buñuel and Dalí's film was going to be very different from anything that had been made before. Buñuel visited Figueres in January 1929 with a scenario of his own which, however, they soon rejected. Instead the screenplay was allowed to develop out of two dreams, which were to ferment into some of the film's more unforgettable images:

Buñuel's dream was about a tapering cloud, slicing the moon in two, like a razor blade slicing through an eye, and Dalí's was of a hand, out of which emerged a swarm of crawling ants. In his autobiography (*My Last Sigh*) Buñuel recounts the intensive and effective week of Surrealist interaction that followed:

We soon found ourselves hard at work and in less than a week we had a script. Our only rule was very simple: no idea or image which might lend itself to a rational explanation of any kind would be accepted. We had to open all doors to the irrational and keep only those images which surprised us, without trying to explain why. The amazing thing was that we never had the slightest disagreement; we spent a week of total identification.

As *Un Chien andalou*, it has entered film history as one of the most memorable and unconventional films ever made. There had been a number of previous attempts by Surrealist writers to produce film-scripts, but before this Buñuel/Dalí collaboration there had never been an adequately sympathetic director, nor enough funds, to bring them to successful fruition. Buñuel had obtained a sizeable sum of family money to finance the project (half of which he boasts of having spent in night-clubs); he hired the Billancourt Studios in Paris and employed a cameraman and two professional actors, Simone Mareuil and Pierre Batcheff. Dalí came to Paris for the shooting – which took just two weeks – but, according to Buñuel, spent most of the time in loving preparation of the corpses of the two donkeys, covering them with a treacly glue, gouging out their eye sockets and exposing the teeth for extra effect (59).

As Buñuel described, any hint of conventional narrative was excluded, and although there was a chronological sequence of events it was only of a very general nature: the film was composed essentially of a series of scenes based on highly insistent images, separate and concrete in themselves, switching quickly from one to the next. The only logic they followed was analogous to that experienced in dreams: it was the special cinematic techniques of editing cuts, of montage and adjustment of speed, which rendered the medium of film so amenable to the Surrealists' objective of evoking the mental

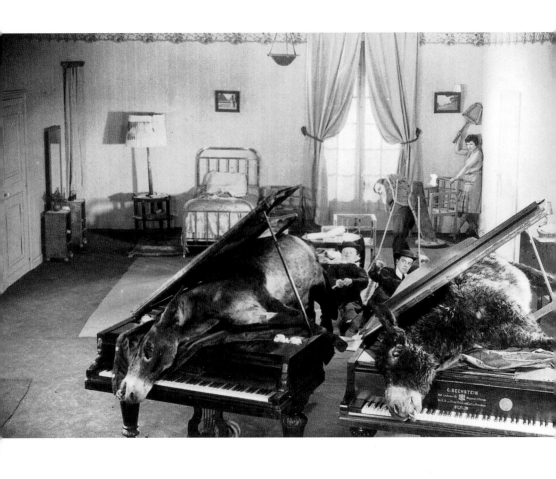

environment of the dream world. Its images were all the more emphatic and arresting because *Un Chien andalou* was made without a sound track – this was still within the period of the silent film – although music was provided in the first showings by Buñuel playing records behind the screen, a disturbing alternation between Wagner's *Tristan and Isolde* and Argentinian tangos.

The capacity for sudden transformations undoubtedly attracted Dalí, who must have been responsible for such sequences as the quick succession of visual rhymes which occur when the girl puts lipstick on her mouth, the man's own mouth disappears and is replaced by a patch of hair, she raises her arm revealing a hairless armpit, followed shortly by the appearance of a spiky sea urchin. 'Nothing in the film symbolizes anything,' Buñuel emphatically insisted, yet he meant nothing in a poetic or allegorical sense, for it is clear that the film abounds in psychoanalytical symbolism. We need only consider the scene in which the older man murders himself, as the young man that he once was. Despite all the comic relief of the following incident (59), quoted from the original scenario (in which Dalí appeared as one of the priests), it is easy to sense how the scene represents, in subconscious terms, the burdens of guilt, repression and hypocrisy associated with bourgeois respectability:

The man begins advancing towards her, pulling at the rope and making a great effort to pull whatever is attached to the ropes.

First we see a cork, then a melon, then two Catholic priests, then finally two magnificent grand pianos containing the carcasses of two donkeys. Their feet, tails, rumps and excrement are spilling out of the lids. As one of the grand pianos is pulled past the camera, we can see the big head of one of the donkeys hanging down over the keyboard.

One further element, of course, characterizes the film as a Surrealist product, and that is the level of aggression directed at the audience with the express intention to provoke both anger and revulsion. This begins with the 'gratuitous' and, even today, highly convincing violence of the opening scene in which the eye-ball of a woman is slashed open with a hand razor (60 and 61).

**59–61**
Stills from the film *Un Chien andalou*, directed by Dalí and Luis Buñuel, 1929
**Left**
Rotting donkeys and grand pianos
**Overleaf**
Eye being sliced open

*Un Chien andalou's* first showing was at an art cinema, the Studio des Urselines, before an invited audience of influential art followers and established Modernist artists such as Picasso, Jean Cocteau and Le Corbusier; Buñuel was anxious enough about its reception to fill his pockets with defensive stones, but in fact it was greeted enthusiastically: Buñuel was invited to join the inner circle of the Surrealist group, the script was published in the journal, *La Révolution surréaliste*, and he was soon charged with the role of advancing their cause through cinema. The film's second showing was a private event organized by the Vicomte and Vicomtesse de Noailles, prodigious patrons of Surrealism, who were to finance the next proposed collaboration between Buñuel and Dalí, *L'Age d'or* (*The Golden Age*). Access to *Un Chien andalou* was not confined to an exclusive art public and the film was then sold to a commercial promoter who gave it an eight-month run in Paris. Buñuel had not in his innocence realized that in receiving financial benefit in this way he had breached the basic code of behaviour demanded of Surrealist members: 'Are you with the police or with us?' Breton demanded to know.

*L'Age d'or* was a much more ambitious production, running for sixty-three minutes compared with the seventeen minutes of *Un Chien andalou*, and it was one of the first French films to be made with sound. However, its writing did not meet with the same accord between the two collaborators. Buñuel travelled down to Cadaqués around December 1929, but Dalí was too preoccupied and anxious about his future partner, Gala Éluard, and his expulsion from the family home (see Chapter 4) to concentrate on the task. Although he forwarded ideas – perhaps a whole filmscript – to Paris later on, the film as realized in terms of its narrative structure and ideological position must be seen as largely the work of Buñuel alone. Certainly by the time he was writing *The Secret Life*, Dalí denied responsibility for the film that finally emerged. What he objected to was the more politically anti-clerical and satirical message which had replaced the 'authentic sacrilege' of his own intentions. The facts about how much each man contributed are obscured by a long period of mutual antagonism which coloured their own accounts. However, many of the scenes – which they both referred to as 'gags' out of respect for the

**62–64**
Stills from the film *L'Age d'or*, directed by Dalí and Luis Buñuel, 1930
**Above**
Heap of skeletons
**Below**
The actress Lya Lys kissing the foot of a statue
**Overleaf**
Cow in a bed

classic comic films of Buster Keaton and the Marx Brothers – such as the woman ecstatically sucking the toe of the statue (63), the giraffe in flames, the blind man run down while crossing the road, the father shooting his son, have all the hallmarks of Dalí's peculiar obsessions.

The film's Surrealist and politically subversive purposes are made clear in a programme note released at its opening, to which Dalí added his name, pointing out that L'Age d'or coincided perfectly with that prime signal of the apparent collapse of capitalism – the New York stock-exchange crash – and that in it:

Policemen push people around just as they do in everyday life, accidents occur in bourgeois society while that society pays no attention whatsoever. But such accidents (and it must be noted that in Buñuel's film they remain uncorrupted by plausibility) further debilitate an already rotting society that tries to prolong its existence artificially by the use of priests and policemen ... pessimism takes on the value of negation and is immediately translated into anti-clericalism; it thus becomes revolutionary, because the fight against religion is the fight against the world as it is.

Evidence of its success as an act of provocation came with the riotous disruption of the film by Fascist and Royalist groups who threw ink at the screen, let off smoke bombs and vandalized a display of Surrealist paintings, including work by Dalí, in the foyer. Following complaints from the right-wing press, which was distinctly unamused by scenes such as the Christ-like figure emerging from an exhausting orgy, the film was banned by the office of censors.

Dalí's enthusiasm for cinematic projects persisted throughout his life. The twenty or so schemes on record include one proposal for a short publicity film to explain in simple terms the objectives of Surrealism. It would have included an explanatory scene, symbolizing the theory of the subconscious, in which an assembly of group members stepped down into a metro entrance, accompanied by automata and a half-nude woman, while raising their umbrellas. He also proposed, following the new experience of sound films, that the next obvious development for the film-goer should be tactile films, and he sketched out the necessary equipment.

Despite Dalí's later attempts at cinematic collaboration in the unquestionably 'anti-artistic' world of Hollywood, his principal engagement with Surrealist practice remained focused on the medium in which he was most competent, that of painting. *The Surrealist Manifesto* had been signed by nineteen members, none of whom was a painter, though, right from the start, the existence of a surreal visual art was acknowledged as a reality, despite the many theoretical problems that it raised. The one indispensable idea that had to be retained for painting to qualify as authentically Surrealist was the presence of the automatist process at some significant stage of the work's inception. As Breton wrote, 'a work cannot be considered Surrealist unless the artist strains to reach the total psychological scope of which consciousness is only a small part.' There was another potential source of imagery open to painters – scenarios derived directly from dreams – but this approach was suspect, since there was always the danger of allowing too much interference and 'correction' from the conscious mind of the artist.

We can identify one group of artists, including Marcel Duchamp, De Chirico and Picasso, who were highly respected by the Surrealists but who nevertheless kept a certain distance between themselves and the movement, and another group, including Ernst, André Masson, Miró, René Magritte and Tanguy, who were much more integrated within the movement during the 1920s, attending meetings, signing mani-festos and contributing to publications. Even these artists associated with the movement, however, did not submit to a restrictively theo-retical method of working. Ernst's collages served, for example, as a close equivalent to the method of the 'marvellous' effect of irrational coincidence that was valued in the writing of De Lautréamont. Masson (65) developed methods of automatic drawing by the use of drugs and Miró claimed to have induced states of hallucinatory vision through hunger, among other means.

Duchamp is now recognized as one of the most significant single contributors to Modernism; his example has established the basis for the Conceptualist approaches to art which have become increasingly dominant since the 1960s, although his influence lay dormant for a

65 Left
André Masson,
*Un Chevalier*
(*A Knight*),
1926–7.
Oil and sand on
canvas;
233·7 × 127·3 cm,
92 × 50⅛ in.
Private
collection

66 Right
Marcel
Duchamp,
*Fountain*,
1950 replica of
1917 original
(now lost).
Porcelain;
h.33·5 cm, 14 in.
Indiana
University Art
Museum,
Bloomington

long time during his apparent inactivity as an artist. This posture was
at the heart of the new definition of a certain kind of artist which
appealed to the Surrealists. He had achieved scandalous success as an
avant-garde artist in Paris, and then in New York when his Cubo-
Futurist painting *Nude Descending a Staircase* was shown at the
Armory Show in 1913. His notoriety was firmly ensured when in 1917,
also in New York, he exhibited *Fountain* (66), a urinal basin, under
the pseudonym R Mutt. It was accompanied by the claim that it was a
legitimate work of art for the simple reason that the artist had
chosen it and declared it to be art. Duchamp constantly mocked the
Romantic pretensions of the more traditional artist – enquiring why
Renoir should want to paint yet another nude woman: was it because
he liked the smell of paint? In 1918 he produced his own final

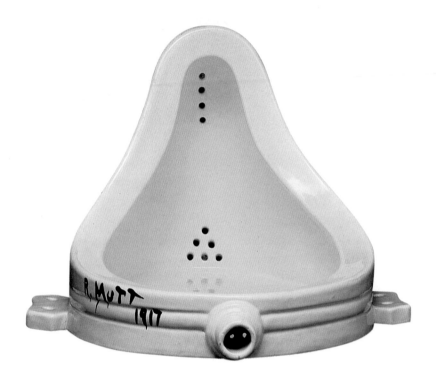

comment on painting, *Tu m'* (67), a title which, addressed to the act of painting itself, implies 'you bore me'. The methods and functions of painting are systematically derided in this piece, with its decorator's colour samples, a *trompe l'œil* representation of a ripped canvas that is nevertheless held together with a real safety pin, and a symbol of a pointing hand painted by a hired sign-painter. During the early 1920s he continued to produce a number of 'ready-made' objects which relied on an interplay between verbal and visual punning, such as the model of a French window to which he gave the name *Fresh Widow*. However, by the end of the decade he appeared to the world to be largely occupied with playing chess, which he did with expertise, representing France in international tournaments.

What the Surrealists admired in Duchamp was his stance of moral and philosophical 'indifference', his reliance on the rules of chance, his language play and his opposition to the aesthetic goals of art. As an individual, he impressed them by his apparent refusal to pursue a

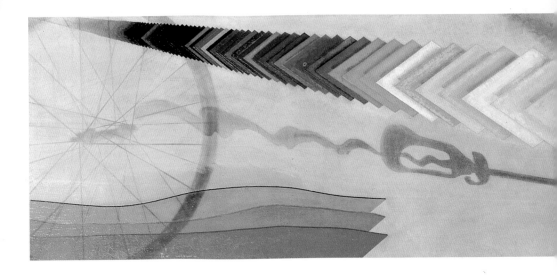

commercial career and, thus, his ability to retain his intellectual independence. Although he kept his distance from the movement's debates and activities, he designed the 1938 Paris Surrealist exhibition and he remained on good personal terms with Breton. He was also one of the very few of his contemporaries about whom Dalí always spoke with respect; in later years they were to be near neighbours when Duchamp had a home in Cadaqués.

The paintings of De Chirico cast the greatest spell over the movement. They seemed to have emerged as fully evolved instances of what Surrealist painting might be, but before the event, for it was his work of the period from around 1912 to 1922 which so enthralled Breton and Paul Éluard and influenced such painters as Tanguy, Magritte and Dalí. De Chirico's poetics were themselves moulded by his study of the writings of the nineteenth-century German philosophers Schopenhauer and Nietzsche. In the latter's work he found 'a strange dark poetry, infinitely mysterious and lonely, based ... on the atmosphere of an afternoon in autumn when the weather is clear and the shadows are longer than they have been all summer because the sun stands low in the sky ... The place where this phenomenon can best be observed is the Italian city of Turin.'

This familiar melancholic ambience can be identified in De Chirico's typical townscapes of classical arcade, factory chimney and scene of

67 Above
Marcel
Duchamp,
*Tu m'*,
1918.
Mixed media
on canvas;
69·8 × 315 cm,
27 ½ × 124 ⅛ in.
Yale University
Art Gallery,
New Haven

68 Right
Giorgio de
Chirico, *The
Enigma of a
Day*, 1914. Oil
on canvas;
185·5 ×
139·7 cm,
73 ¼ × 55 in.
Museum of
Modern Art,
New York

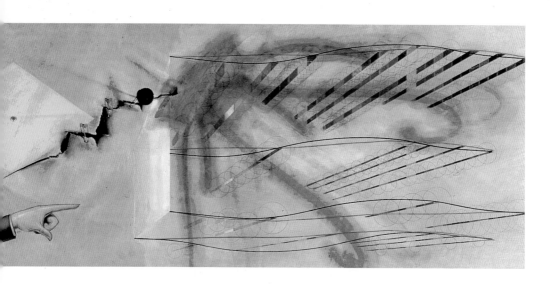

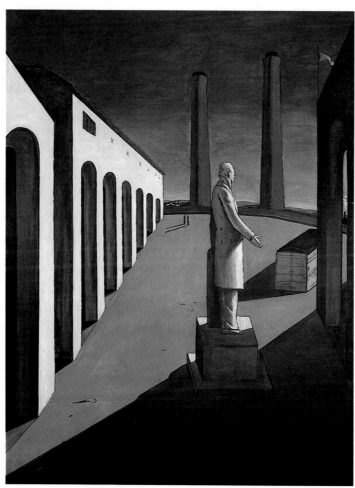

departure, by train or from a harbour. These scenes, such as *The Enigma of a Day* (68), painted in 1914, are the projections of a trance-like state of mind, a stilled moment of eternity yet heavy with impending threat or anxiety. Any human presence is in the surrogate form of a statue, though with, in this case, two distant silhouetted figures casting long shadows. Our uneasiness is further orchestrated by the inconsistency of the lines of perspective; in the past, the 'laws' of perspective assured us of our place in a knowable, measurable world, but modern science, having already deprived us of the certainties of religious faith, was now, in the era of Einstein, taking away the certainties of Newtonian space and time. The Surrealists used De Chirico's *The Mystery and Melancholy of the Street* of 1914, showing the figure of a girl with hoop in a deserted street, for one of their 'games', designed to stimulate imaginative response, asking members such questions as 'What is in the van parked in the street?' and 'What is about to happen to the little girl?'

Later, the human presence in his paintings was supplied by the surrogate form of a mannequin or a lay-figure (the articulated model used as a drawing aid), and this motif was to be taken up widely by artists as a suggestive symbol of the dehumanized condition of modern life. The 'Metaphysical' period of De Chirico's art in 1916–17 grants to objects such as drawing instruments, biscuits arranged in a shop window display and framed pictures the power to impose enigmatic feelings of nostalgia and disorientation, just as objects do in dreams.

Dalí was to adapt many of these devices of distorted perspective and hallucinatory extremes of brightness and shadow in his classic Surrealist works of the 1930s. De Chirico also foreshadows Dalí in his renunciation of modern painting. In 1922 he wrote to Breton, expressing his personal conflict with 'the problem of craftsmanship': he was becoming increasingly drawn to the power of the 'grand tradition' of Renaissance and then Baroque art, and by 1926 he was enthusing over 'the romanticism' of Courbet, and inevitably his painting style began to develop in parallel with these interests. Although this was in keeping with the 'Return to Order' being followed by many of his contemporaries in Italy and France, such abandonment of the

avant-garde was anathema to the Surrealists who turned violently against both the art and the artistic personality of De Chirico. So effective was their critical authority that it was not until the 1970s that the art world began to pay serious attention to the work of his later career.

The dominating presence of Picasso and his continuously restless artistic invention insured against any similar reappraisal of his importance by the group. Breton insisted that none of the explorative freedoms available to Surrealist artists could have been won without the prior formal and conceptual revolution of Cubism, in which Picasso was the leading pioneer. In 1927 he exhibited with the group and his work was constantly reproduced in its publications, but what is far from agreed is the extent to which we can discern essentially Surrealist elements within his painting at this stage. It undoubtedly displays a new emotional intensity following the repose and order of the Neoclassical and late Cubist period, and on occasions exudes violence and menace; this achieves its profoundest statement in the visual language of *Guernica*. There is also a desire for the brutal dismissal of aesthetic pleasure in such pieces as the *Guitar* which he conjures up from a scrap of sack-cloth attached to a canvas by two-inch nails and crossed by pieces of string, but only rarely do we find evidence of automatist practice – perhaps in the 'Anatomy' drawings of 1933 (69 and 70) and certainly in his poetry of the 1930s.

Picasso had taken a keen interest in the young Dalí, noticing his work at an exhibition he was visiting in Barcelona in 1926. He was helpful, when Dalí first came to live in Paris, introducing him to influential collectors, such as Gertrude and Leo Stein, and other artists in the wider circle of the Surrealists such as the photographer Brassaï, with whom he was to collaborate on articles for the journal *Minotaure*. Picasso advanced him the money for his first trip to America in 1934 but their good relations eventually soured, at first because of political differences at the time of the Spanish Civil War, and later following Dalí's repudiation of Modernism. They were never to be reconciled.

Of all the painters, Ernst maintained the longest and least disputatious relationship with the Surrealist group. A recruit from the Dada

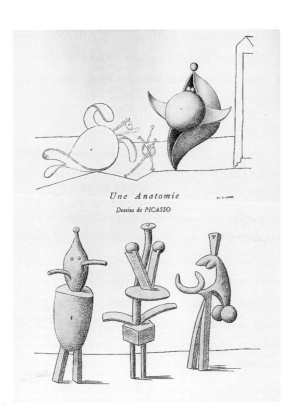

Une Anatomie

Dessins de PICASSO

**69–70**
**Left above**
**and below**
Pablo Picasso,
Women from
'An Anatomy',
*Minotaure*,
27 February
1933

**71 Right**
Max Ernst,
*The Wheel of
Light*,
1925.
Frottage and
pencil on
paper;
25 × 42 cm,
9⅞ × 16½ in.
Private
collection

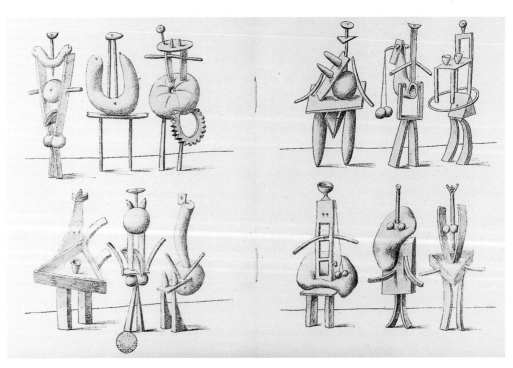

movement in Cologne, he brought elements of German Romanticism, the mystery of nature, of giant birds and threatening forests as well as the taste for allowing chance discoveries to stimulate his pictorial invention. He practised, for example, the techniques of frottage, rubbing chalk or pencil over paper pressed against textured surfaces – as in *The Wheel of Light* (71) – and grattage, scraping paint or ink surfaces with such tools as a decorator's wood graining comb. His collages, drawing on the childhood memories of his viewers with images extracted from illustrations to popular encyclopaedias and adventure stories, were often combined into books, such as *La Femme 100 têtes* with its absurd episodes of Freudian humour.

Miró had been influenced by Cubism at an early stage and he retained a sense of precision in drawing and design while developing his very personal vocabulary of signs. His paintings, such as *The Carnival of Harlequins* (72), hover between representation and abstraction. If we see a kind of childlike exuberance and directness about these pictures, it reflects Miró's intention of striking at the primal, instinctive levels of the psyche, accessible through techniques of mental concentration. Despite the final impression of order and

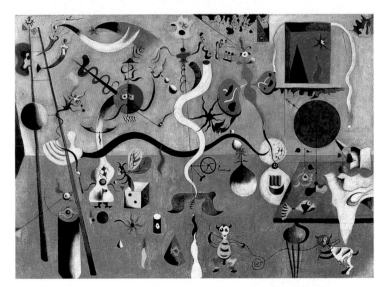

72
Joan Miró,
*The Carnival
of Harlequins*,
c.1924–5.
Oil on canvas;
66×93 cm,
26×36⅝ in.
Albright-Knox
Art Gallery,
Buffalo

control, many of the paintings originated through a process of random splashes and blots of paint intended to stimulate imaginative invention. He was attracted to the poetics of Surrealism and shared its opposition to the aesthetics of 'good' painting stating, 'The only thing that is clear to me is this – I intend to destroy, to destroy painting.' However, he resisted Surrealism's pressures towards ideological discipline.

Miró, as well as Picasso, had picked out the promise of Dalí's paintings on exhibition in Barcelona and had gone to much trouble on his behalf, visiting him in his studio and urging him to set up in Paris. When Dalí did eventually come to Paris in 1929 to work on *Un Chien andalou*, he was welcomed by Miró who advised him on the survival tactics necessary to advance his artistic career in the city – to buy a dinner jacket, not to say too much when invited out, to acquire an air of stubbornness and to take up physical exercise (not an idea likely to appeal to Dalí). During this stay he also met Camille Goemans, a dealer specializing in Surrealism, who offered him his first exhibition in Paris to be held in November of the same year. Goemans also introduced him to Paul Éluard, whom Dalí invited on a holiday visit to Cadaqués in the summer, together with his wife Gala. This was to be a momentous turning point in Dalí's life.

The holiday party also included Goemans' fellow Surrealist friends from Brussels, René and Georgette Magritte. René Magritte is significant for sharing with Dalí the illusionistic approach to Surrealist painting as distinct from the more obviously immediate and automatist procedures of the other Surrealist painters. He was clearly indebted to De Chirico but also to the Symbolist artists of his native Belgium such as Fernand Khnopff and William Degouve de Nunques for his powerfully convincing dreamscapes. After working as a designer in a wallpaper factory, he came to Paris and entered the circle of the Surrealists between 1927 and 1930, where his special contribution was to provoke, by means of paradoxical illusionistic devices, a profound questioning of the conventions of representation. In *The False Mirror* (74) of 1928, for example, we are invited to embark on an endless chain of speculation as to where the 'reality' of the clouds actually lies: is it a reflection on the mirror/eye of the artist/viewer or an image existing in the mind behind the eye? He also provided a disturbing visual accompaniment to the question posed in a 1934 pamphlet, 'Qu'est-ce que Le Surréalisme?' ('What is Surrealism?'), with an image (73) which, when he reproduced it as an oil painting, was entitled *The Rape*. Furthermore, Magritte challenges us to consider the absolute separation between an object, its image and its name in such well-known paintings as *The Treachery of Images* (75).

The activities and interests of the Surrealists are revealed in the journal that they first published in 1924, *La Révolution surréaliste*. Its cover made it look like a learned scientific periodical and the opening in the same year of the Office of Surrealist Research signalled their intention to be seen as objective investigators and commentators, whose work might only incidentally be in the field of art, for they were now at work on the larger mission of 'changing the world', approaching this task through provocation and scandal. The anarchist Germaine Berton, who had murdered a royalist, was applauded, lists of suicides from the newspapers were published and an enquiry was set up, asking readers if they considered suicide a justifiable act, a defrocked priest recounted his adventures with an actress, there were reports of the disruption of 'respectable' poetry readings and

theatrical performances, and articles appeared such as 'Open the Prisons, Disband the Army'. A Surrealist group 'Declaration' from 1925 insisted:

1 We have nothing to do with literature. But we are quite capable if need be of making use of it like everyone else.

2 Surrealism is not a new means of expression, not a simpler one, nor even a metaphysic of poetry. It is a means of total liberation of the mind and of everything resembling it.

3 We are determined to create a revolution ...

It was clear from the tone of this statement that the Surrealists were about to embark on a closer association with more formally constituted political agencies: the adventure of its troubled and, on occasions, farcical relations with the French Communist Party was about to begin. At first they made tentative approaches to the group around the long-established journal *Clarté*, which included sympathizers of Leon Trotsky and people who had been expelled from the Communist Party. With the return of a right-wing government under Raymond Poincaré (76), with rioters protesting against the colonial wars in Morocco and the banning of street demonstrations in Paris, a number of Surrealist members – Breton, Aragon, Éluard, Benjamin Péret and Pierre Unik – decided to join the Communist Party. The Surrealists' great aspiration was that the two agencies could work together, despite the wide disparities of their methods and ideology, to bring about the shared goal of revolutionary change.

Whereas the issue of political commitment was to prove much more contentious, Dalí shared with the Surrealists an acceptance of and interest in the psychological investigations of Sigmund Freud, who was a major theoretical influence on the movement. Freud's book *The Interpretation of Dreams* was first translated into Spanish in 1922 and Dalí says that he read it avidly while at the Residencia, presumably relating it to his personal sexual anxieties, although it does not appear to influence his painting before 1927. Breton's knowledge of psychoanalytic theory was rather more profound: he had encountered it in practice when treating trauma patients in his war-time duties,

76
Raymond Poincaré (centre, in uniform) at the French Peace Procession, 1919

and so impressed was he by Freud's model of the workings of the subconscious mind, that he went to Vienna to meet him in 1921. Dalí, too, managed to arrange a meeting with Freud in 1938, when he was in exile from the Nazis and living in London, and he made some portrait sketches on the occasion (77).

In *The Interpretation of Dreams* Freud is at pains to point out that the subject of the dream, or rather, unconscious thinking, must be dealt with scientifically, though he foresees the possibility of future expan–

sion into imaginative writing and the study of myth and folklore. The Greeks had considered that the space of the dream was the realm of the gods, which they made use of when they wished to deliver warn–ings or prophecies. In modern times there remained the popular feel–ing that dreams did, in some obscure way, have a meaning to them. He mentions approvingly the stories of Wilhelm Jensen which were founded on the significance of dreams (the character of one of these stories, Gradiva, was to be particularly adopted by the Surrealists).

**77**
*Portrait of Sigmund Freud* from *The Secret Life*, 1939. Pen and ink on blotting paper; 35 × 28·5 cm, 13³⁄₄ × 11¹⁄₄ in. Freud Museum, London

Clearly Freud's primary purpose is medical rather than literary, however, and he relates his finding that patients who suffered from hysterical phobias and obsessive ideas could be cured by unravelling the symptoms which were revealed when they recounted their dreams. He maintains that dreams are never simply innocent or trivial, and, although the details might only reflect the immediate experiences of the day, informed analysis would reveal their true but hidden significance. We dream because we are anxious or because we wish to fulfil those desires that we are unable to achieve in our waking lives. Because we tend to be ashamed of these desires, which are usually of a sexual nature and might involve masochism and humiliation, we repress them, which leads to their reappearance in a distorted or 'displaced' form. It must be remembered that sex was almost universally synonymous with guilt in the 1890s when the book was written, and this does not seemed to have changed radically for the generation of the Surrealist artists and their public. Buñuel, for example, confesses:

Men of my generation, particularly if they are Spanish, suffer from a hereditary timidity where sex and women are concerned. Our sexual desire has to be seen as the product of centuries of repressive and emasculating Catholicism, whose many taboos – no sexual relations outside of marriage (not to mention within), no pictures or words which might suggest the sexual act, no matter how obliquely – have turned normal desire into something exceptionally violent.

**Freud pointed out that dreams were not the only place to find references to these latent, 'shameful' meanings: they occur in conversational slips of the tongue (the famous Freudian slip), in proverbial sayings and in jokes, as his study *Jokes and their Relation to the Unconscious* testifies. The other substantial area where comparable processes are at work is that of myth, for example, the Greek story of Oedipus, which is not just a drama of destiny and will in times past, but, Freud argues, it is one which still has resonance for us today because every family is exposed to similar, repressed, generational rivalries and incestuous feelings.**

**Freud's case studies of dream analysis, of unravelling in search of the original (repressed) cause of anxiety, are frequently elaborate, inventive and often far from plausible, but they do seem to have supplied a 'method' which intrigued Dalí and which he was to develop at length in demonstrations of his own 'paranoiac-critical' method, such as the essay on Millet's *Angelus* (see Chapter 4). Dalí would certainly have paid particular attention to a number of Freud's interpretations, for example that 'there is a valid sexual meaning behind the neurotic child's intolerance of blood and raw meat, or his nausea at the sight of eggs or macaroni.' *The Interpretation of Dreams* also contains lists of phallic and uterine dream symbols which Dalí would later acknowledge and develop in his painting:**

All elongated objects, such as sticks, tree-trunks and umbrellas (the opening of these last being comparable to an erection) may stand for the male organ – as well as all long, sharp weapons, such as knives, daggers and pikes. Another frequent though not entirely intelligible symbol of the same thing is a nail file – probably on account of the rubbing up and down. Boxes, cases, chests, cupboards and ovens represent the uterus, and

also hollow objects, ships and vessels of all kinds. Rooms in dreams are usually women; if the various ways into and out of them are represented, this interpretation is scarcely open to doubt.

Freud, in his conclusions, demonstrates that his investigation of dreams can only contribute to his larger thesis, one which every Surrealist would endorse: 'The unconscious is the true psychical reality; in its innermost nature, it is as much unknown to us as the reality of the external world, and is as incompletely presented by the data of consciousness as the external world by the communications of our sense organs.'

Dalí's absorption of material from psychological studies was not restricted to Freud; reading the case studies of the German nineteenth-century neurologist Kraft-Ebbing, in *Psychopathia Sexualis*, provided him with information about abnormal sexual fixations and fetishes which he was ready to employ particularly in the remarkable crop of paintings from 1929. These include some of his best-known works (78–84), which quickly earned him notice, even notoriety, in the Paris art world.

78
*Dismal Sport*
(*The Lugubrious Game*),
1929.
Oil and collage on cardboard;
44·4 × 30·3 cm,
17 ½ × 12 in.
Private collection

Dalí returned to Cadaqués to prepare for the Goemans exhibition, which was to include, out of the eleven paintings shown, nine which were done that year. Although he once famously wrote, 'the only difference between a madman and myself is that I am not mad', the evidence of this group of paintings, in both content and manner of execution, coupled with his own description in *The Secret Life* of his hysterical bouts, would suggest that he most nearly approached what was certainly a highly disturbed state of mind during these months. On the other hand, the same evidence could be used precisely to confirm the validity of his claim that his special gift was that of holding on to sufficient critical control over these heightened mental experiences. He describes his method at this time in a way which conforms to the automatism required by Surrealist theory, invoking the idea of working like a medium:

I spent the whole day seated before my easel, my eyes staring fixedly, my eyes trying to 'see', like a medium, the images that would spring up in my

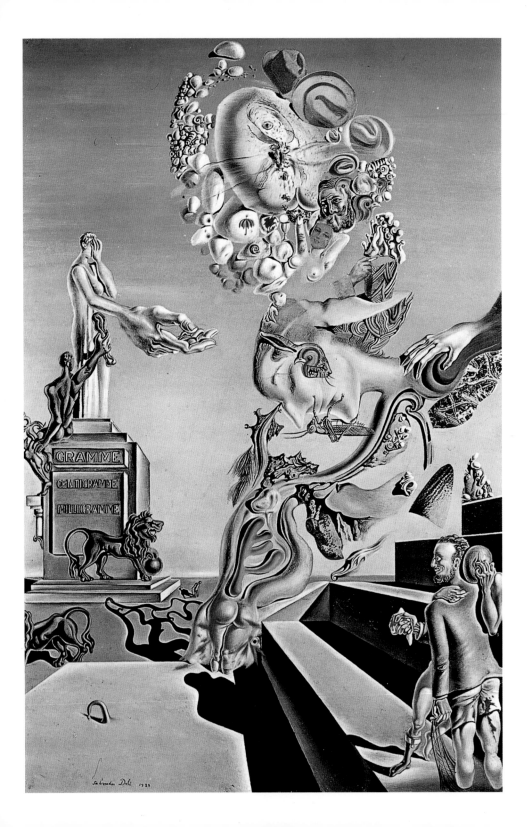

imagination. Often I saw these images exactly situated in the painting. Then, at the point commended by them, I would paint, paint with a hot taste in my mouth.

The Surrealist group had been going through one of its frequent ideological crises in 1929, which had resulted in a number of members breaking away and re-forming around the figure of Georges Bataille, who, together with Michel Leiris, brought out a journal, *Documents*, dedicated to 'Doctrines, Archaeology, Fine Art, Ethnography'. Bataille was particularly motivated to explore areas of transgressive behaviour, fetishism, magic, sacrificial rituals and such like: 'Masochism, sadism, almost all vices, in fact, are only ways of feeling more human,' he claimed. It is no surprise, then, that he was attracted to Dalí's work. In September Dalí was exhibited in a show of abstract and Surrealist art in Zurich, organized by Bataille, and his paintings were reproduced in *Documents*. Later on Dalí calculated that his interests would be better served by allying himself to Breton and so refused permission for *The Lugubrious Game*, also known as *Dismal Sport* (78), to be reproduced, but Bataille got round this by making a line sketch of it, to which he added a psychoanalytic inter-pretation of the 'contradictory' elements of the work in terms of Freud's theory of the castration complex. In an accompanying essay he finds in the picture 'a terrifying ugliness', a fitting expression of current, intellectual despair which needed to find an outlet in violence and rage. The reader is reminded of the Marquis de Sade, who, imprisoned in the Bastille, attracted a crowd outside by 'uttering an insane sermon through a drain which served to empty his dirty water', and Bataille concludes: 'It is evident that brutality is often quite brutally hilarious – I have no choice – than pursuing this bestial hilarity to its extreme – but I lift my heart to Dalí, and grunt like a pig before his canvases.'

The reference to De Sade is not entirely casual since the picture had been bought by the De Noailles and Marie-Laure de Noailles claimed descent from De Sade and kept an original manuscript of *120 Days of Sodom* in a case in the shape of a phallus. De Sade had for a long time been one of the most renowned eighteenth-century writers, yet

one of the least read, largely because the majority of his work had been destroyed or its publication prohibited. Bataille was foremost among those who were working to get his writing republished and he had always been a hallowed figure for the Surrealists. They admired his tirades against the state, the uncontrollable power of the law and the vice and hypocrisy of the Church. De Sade held up a beacon for absolute, personal liberty of thought and action, and he anticipated Freud by seeing dreams as the operation of the mind at an instinctual level, unmolested by conventional morality. While for Breton this seems to have been the extent of his importance to the Surrealist revolution, for Bataille and for Dalí the transgressive nature of the erotic material, in particular the celebration of sodomy, was primary.

Because Dalí's paintings have now become so familiar, there is the danger of ignoring the degree to which he travelled into forbidden areas of depiction. The soiled underwear and the reference to masturbation in *The Lugubrious Game* would have been highly shocking to the general public in the 1930s, and it did lead to severe questioning of his motives even from the Surrealist group. For Dalí, masturbation and fantasy were the only sexual experiences he allowed himself; he had visited the famous brothels of Paris by now, but only for the visual pleasure offered by their ambience, and it is apparent from accounts of his encounters with Gala that the anticipation of making love to a woman filled him with anxiety and fear of impotence. We need only look at the plethora of books published during those decades – 'plain talks to young men' – dealing with the subject of masturbation, to discover the source of the guilt which propelled Dalí to produce this remarkable set of pictures. A typical example of their fearful rhetoric warns: 'Masturbation outrages nature's sexual ordinances more than any or all the other forms of sexual sin man can perpetuate and inflicts consequences the most terrible.' These terrible consequences supposedly involved every kind of physical enfeeblement and degeneracy leading even to blindness and impotence.

His major work on this theme is *The Great Masturbator* (79). Its dominant form is an amalgam of various elements, a self-portrait

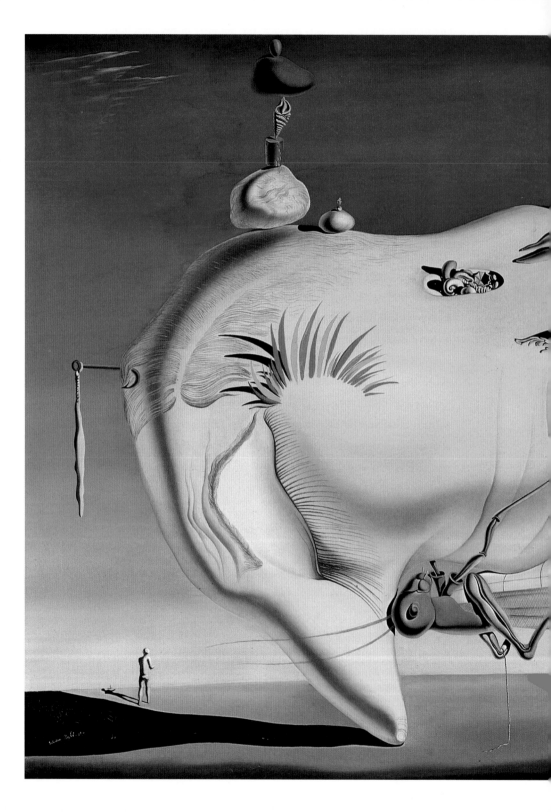

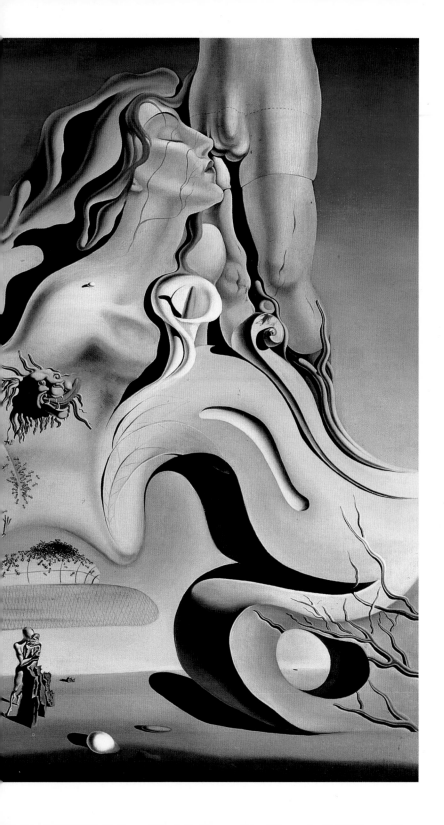

**79**
*The Great
Masturbator,*
1929.
Oil on canvas;
110 × 150 cm,
43³⁄₈ × 59¹⁄₈ in.
Museo
Nacional
Centro de Arte
Reina Sofía,
Madrid

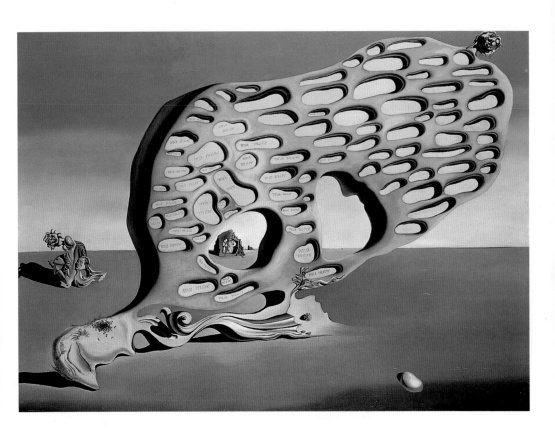

**80 Above**
*The Enigma
of Desire –
My Mother,
My Mother,
My Mother*
1929.
Oil on canvas;
110 × 150·7 cm,
43 3/8 × 59 3/8 in.
Staatsgalerie
Moderner
Kunst, Munich

**81 Right**
*The Enigma
of Desire*
(detail)

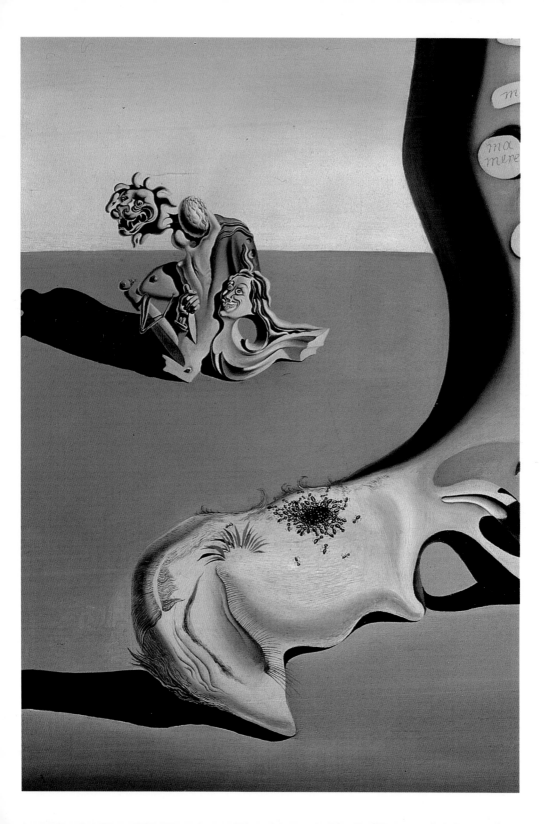

head, with eyes closed, rather foetus-like; a rock shape from the Cadaqués coast and furniture scrollwork, which manages to achieve the Dalínian trick of being both hard and soft at the same time. Attaching itself to the underneath of the head, covering the space where the mouth would be, is a gigantic grasshopper, whose own decay is signalled by the swarming ants infesting it. Dalí had a particular phobia of grasshoppers from his childhood onwards, and the image is used in a number of paintings to express a state of near hysterical panic. The other image cluster in the painting is that of the head and shoulders of a woman, which was derived from a fairground print of a beauty, delicately sniffing a lily. The lily now sports an erect stamen and the woman's face nudges the crutch of a male figure whose bleeding cuts suggest castration.

In *The Enigma of Desire – My Mother, My Mother, My Mother* (80) a number of these features are retained; the head has become more foetus-like and it grows out of a winged version of the rock formation, which moreover has indentations recalling a slice of cheese. In these cavities, the words *'ma mère'* (my mother) are repeated. The figuration just above the head amalgamates an insanely grinning head, an embracing couple, a bleeding egg/head, a leering face of a lion and a hand with a dagger, all dissolving into and out of each other, simulating the passage from one image to another in dream experience (81). The iconography and title direct us to the Freudian concept of the Oedipus complex, represented here as the eroticization of the relations between mother and son. This was one of the works purchased by the Vicomte de Noailles; later it belonged to a Swiss psychoanalyst who hung it in his consulting room.

One remarkable aspect of these works is the miniaturist technique with which they are painted; this is made all the more emphatic by the small format of pictures such as *The Accommodations of Desire* (82), which measures just $22 \times 35$ cm ($8\frac{5}{8} \times 13\frac{3}{4}$in). There is very little sense of conventional pictorial space here, except for a horizon along the top edge; instead seven pebble shapes are distributed over the picture plane which carry separate images – an extension of Dalí's idea that, given a particularly heightened state of perception, one can

82
*The Accommodations of Desire*, 1929.
Oil on panel;
$22 \times 35$ cm,
$8\frac{5}{8} \times 13\frac{3}{4}$in.
Private collection

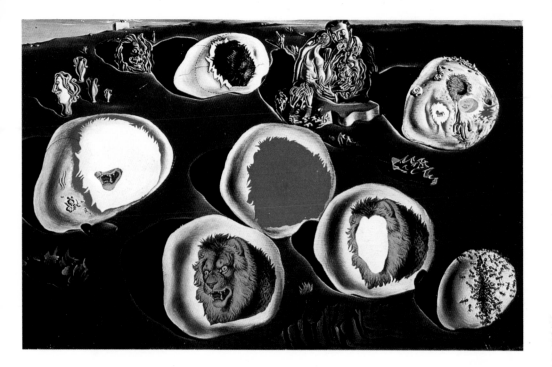

evoke hallucinations of scenes from the contemplation of abstract
natural surfaces such as clouds or stones. A similar cluster of images
to that in *The Enigma of Desire* occurs, establishing the subject of the
painting; the young man hides his head in shame before an embrac-
ing couple, while the bearded father figure gnaws his lover's fingers.
Ants swarm over one pebble forming the illusion of pubic hair around
a vulva. The lion's head, which Freud identifies as a dream symbol
with the libido or sexual drive, is repeated in various forms and shifts
of scale. Dalí plays the game of the virtuoso artist, challenging the
viewer to distinguish which are actual collaged elements and which
are painted imitations of collage.

Another miniaturist performance, and on the same scale, is *Illumined
Pleasures* (83). Here, the picture-within-a-picture device is one
adopted from De Chirico, with separate picture boxes. The central one
contains the familiar prone self-portrait head, accompanied by such
personal symbols as his grasshopper. The box to the right contains a
repeat pattern of cycling men carrying on their heads what Dalí
identifies as sugared almonds. The third panel reveals a scene

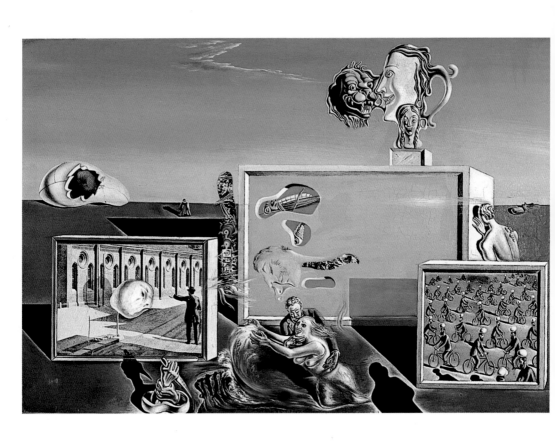

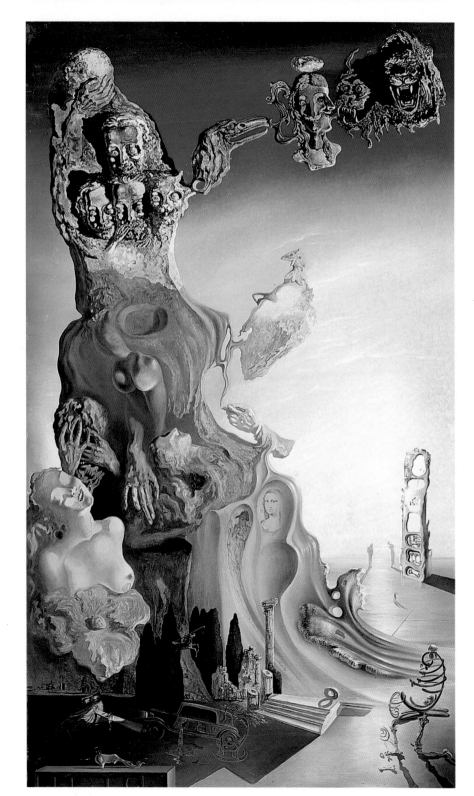

**83 Left**
*Illumined Pleasures*,
1929.
Oil and collage
on board;
23·8 × 34·7 cm,
9³⁄₈ × 13⁵⁄₈ in.
Museum of
Modern Art,
New York

**84 Right**
*Imperial
Monument to
the Child-
Woman*,
1929.
Oil on canvas;
140 × 80 cm,
55¹⁄₈ × 31¹⁄₈ in.
Museo
Nacional
Centro de Arte
Reina Sofia,
Madrid

reminiscent of an invention by Ernst, with a father figure shooting at a hard rock which is also a vulnerably soft head; this is set against a collaged image of ecclesiastical architecture.

This process of concentrated miniaturization continues with *Imperial Monument to the Child-Woman* (84). In order fully to apprehend such a work, the viewer has to examine it at close quarters, constantly searching and scanning the picture to discover and recreate the arbitrarily arrayed images, such as the tiny flat-iron in the lower left-hand corner, above the shrimp-like head (85). The act of viewing commits us to spending time and concentration in a manner which can itself be almost hallucinatory. A whole litany of Dalínian themes reveal themselves – Napoleon, Leonardo's *Mona Lisa*, Freudian keys and the first appearance of the couple from Millet's *Angelus*.

**85**
Detail of 84

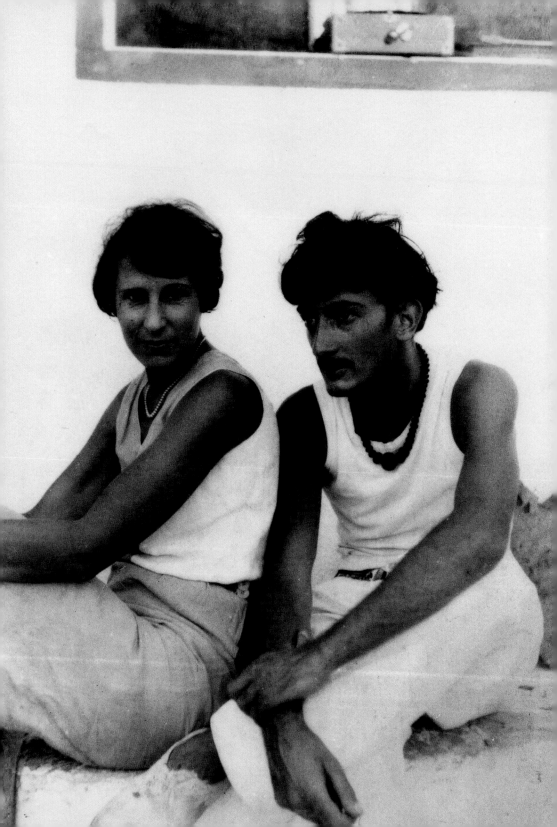

'Love, only love that you are, carnal love, I adore. I have never ceased
to adore your lethal shadow, your mortal shadow. A day will come
when man will be able to recognize you for his only master, honour-
ing you, even in the mysterious perversions you surround him with.'
This testament to an ideal of love – erotic, mysterious and perverse,
but above all inspiring – was enunciated by Breton in his book *Mad
Love*, but it distils the role of woman as muse which the male
Surrealists hoped for from their wives and lovers. It also precisely
reflects that idealized love which Dalí desired, and the illusion of
which Gala Éluard was willing to provide in their life-long partnership
(86).

Gala was the first and the most explicit embodiment of the Surrealist
muse. This is evident in Ernst's 1922 portrait of the group, *At the
Rendez-vous of Friends* (87), where, the only woman present, she
symbolizes that role by virtue of her exotic origins, her unpredictable
and changeable moods, her erotic allure and the power of her gaze.
The heedless, totally committed love for a woman was the ultimate
path of escape from reason and common sense into the mental sphere
of fantasy and liberation. Such an idea was, of course, not an inven-
tion of the Surrealists; they only raised a particularly Gallic tendency
of nineteenth-century Romantic thought to a new level of signifi-
cance, ingeniously grafting it on to the idea of revolution.

Gala was born Helena Deluvina Diakonoff, in Kazan, Russia. Her early
years were obscured in the mystique that both she and Dalí created
concerning her origins; even her date of birth is uncertain, although
1894 is most generally accepted. As a young woman she was sent to a
Swiss sanatorium for recuperation, where she met Paul Éluard; soon
after, she went to live in Paris where they were married in 1917. Five
years later, Ernst left his wife and child to live with the Éluards as a
threesome. Other affairs were to follow, including one with De

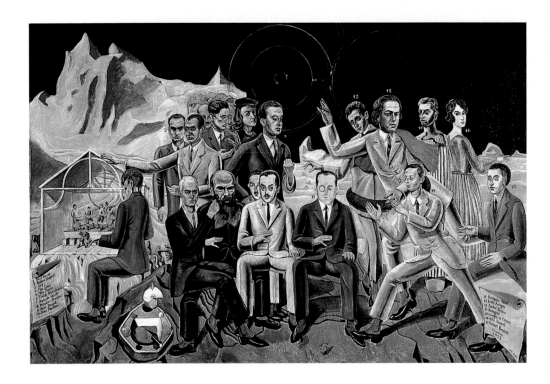

Chirico, and it was clear that despite the Surrealists' ideal of monogamy, so highly celebrated in *Mad Love*, the right to sexual freedom and the liberation from the ties of family and marriage was acknowledged in practice, and this applied as much for women as for men. So it was that in the summer of 1929 a party made up of Gala and Paul Éluard accompanied by their twelve-year-old daughter, René and Georgette Magritte, and the dealer Camille Goemans journeyed down from Paris to stay at Cadaqués. Dalí appears to have been suffering bouts of near hysteria, and at first found it impossible to communicate in any sensible way with Gala, but gradually she was able to release him from his anxieties and, attracted by his authentically surreal and dynamic irrationality, and, no doubt, by the dark and fanatic good looks of this virginal young man, some ten years younger than herself, she remained behind after the rest had returned to Paris, having decided that Dalí would be her next and major project. Dalí had now, at last, found someone who could free him from his fear of women and, announcing himself cured of his madness, he began on the path of recovery from his neurotic sexual anxiety. He

87
Max Ernst,
*At the
Rendez-vous
of Friends,*
(as numbered:
Rene Crevel,
Philippe
Soupault,
Jean Arp,
Max Ernst,
Max Morise,
Fyodor
Dostoevsky,
Rafael Sanzio,
Théodore
Fraenkel,
Paul Éluard,
Jean Paulhan,
Benjamin
Péret,
Louis Aragon,
André Breton,
J T Baargeld,
Giorgio de
Chirico,
Gala Éluard,
Robert
Desnos), 1922.
Oil on canvas;
130 × 193 cm,
51¹⁄₄ × 76 in.
Museum
Ludwig,
Cologne

devoted himself utterly to the Surrealist cult of love, as we see in one
of his more conventionally coherent poems of this period, 'Love and
Memory' (1931):

Gala
my love proves to me
my lack of memories of you
since I do not remember you
you do not change
you are beyond my memory
since you are my life...

Gala
the features of your face
do not express any sentiment
because you are beyond
ILLUMINATED PERSPECTIVES...

From this point on Dalí celebrated the extent to which Gala's person-
ality and presence were shaping his paintings by signing his work in a
variety of emblematic forms which incorporated both their names.
For all the complexities of multiple image and illusionistic ambiguities
of the work that was to follow, Dalí's pictorial language soon after
Gala entered his life seems to have been liberated from that intense
menace, based on the theme of sexual anxiety, which had character-
ized much of his painting between 1927 and 1930. Needless to say,
his affair with a married woman did not go down well at home; his
father was outraged and, following a review that he read in a Spanish
paper of the Goemans exhibition, his anger boiled over. One of the
works was an outline drawing, based on a popular devotional image
of the Sacred Heart, over which had been written, 'Sometimes I spit
for pleasure on the portrait of my mother'. When his father
confronted him with this apparent insult to his dead mother, Dalí
offered no satisfactory apology or explanation and was banished from
the family home. This action was to enter Dalí's personal mythology
over the next few years, with his father being cast as the angry God
evicting him from his Cadaqués paradise. He returned to Paris to work
on *L'Age d'or* and to meet up again with Gala, who had decided to

leave her husband and child, and in January 1930 Gala and Dalí
moved to a hotel near Marseilles, where he worked on the unfinished
painting *The Invisible Man* (88) and Gala assisted him in bringing his
theoretical ideas into shape; *The Visible Woman* (*La Femme visible*),
the first expression of Dalí's paranoiac-critical method, was published
as a book, with a photograph of Gala's eyes on the cover.

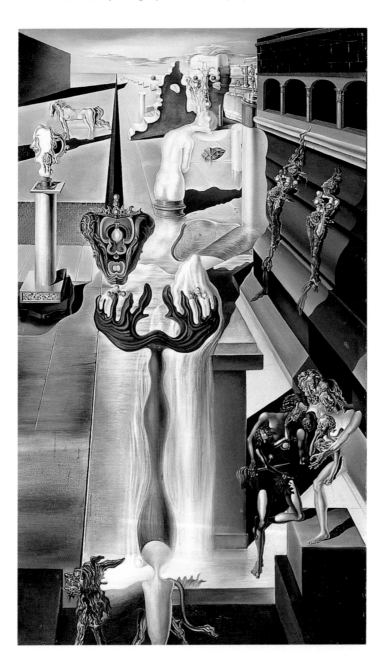

**88**
*The Invisible
Man*,
1929.
Oil on canvas;
140 × 80 cm,
55⅛ × 31½ in.
Museo
Nacional
Centro de
Arte Reina
Sofía, Madrid

Back in Paris, he was warmly received by the Surrealist group and, in turn, energetically engaged himself with their meetings, actions and publications. For the next three years he would play the part of an exemplary Surrealist. He belonged to a younger generation than most of the group, as is apparent from the group photographs of the time (57), and had no direct experience of the First World War and the long episodes of intellectual gang warfare which had enlivened the artistic life of Paris during the 1920s. *The Second Surrealist Manifesto* was brought out, with a frontispiece drawing by Dalí; he even came up with a poster design for the tenth anniversary of the French Communist Party. At this stage Breton had nothing but the highest hopes for what this new blood could bring to the movement: 'The art of Dalí, up to now the most hallucinatory known, constitutes a veritable threat.'

The new sense of vitality that Dalí was able to bring to the movement was not confined to the 'hallucinatory' nature of his imagery but also came from a major contribution to Surrealist theory. These ideas were developed through a number of essays and articles published in *Le Surréalisme au service de la révolution* (*Surrealism in the Service of the Revolution*; 89) and *Minotaure*, in addition to separate publications such as *The Visible Woman*. Although the term 'paranoiac-critical method' undoubtedly appealed to Dalí on account of its ring of scientific authority, it is in fact quite a reasonable means of summarizing his conceptual position. It must be stressed that this position seems to have evolved directly out of the experience of his current painting, rather than being a theory imposed artificially upon it.

In his essay 'The Stinking Ass' Dalí sets out his intentions for this new artistic approach: 'I believe the moment is at hand when, by a para-noiac and active advance of the mind, it will be possible (simultane-ously with automatism and other passive states) to systematize confusion and thus to help to discredit completely the world of real-ity.' The medical term 'paranoia' which Dalí is employing here refers to the state of mental abnormality in which one creates a personal model of the reality of the world which has a perfectly functioning internal logic and structure, no matter how widely or absurdly this

# LE SURRÉALISME
## AU SERVICE DE LA RÉVOLUTION

Directeur :
André BRETON

42, Rue Fontaine, PARIS (9ᵉ)  Téléphone : Trinité 38-18

---

### SOMMAIRE

**N. LÉNINE :** En lisant Hegel.
*(Introduction par André THIRION)*

---

*Il a été tiré de ce numéro 15 exemplaires numérotés sur Hollande van Gelder, dont 5 hors commerce.*

*Les numéros 5 et 6 de cette revue paraissent simultanément le 15 mai 1933.*

**ABONNEMENT**
les 6 numéros :
France..... 45 francs
Étranger ... 55 francs

DÉPOSITAIRE GÉNÉRAL :
ÉDITIONS DES CAHIERS LIBRES
25, passage d'Enfer
PARIS (XIVᵉ)

**LE NUMÉRO :**
France..... 8 francs
Étranger ... 10 francs

model deviates from the general understanding of reality. Obviously, this state of mind can mean that the individual is incapable of acknowledging society's presiding moral or criminal laws, and it can typically lead to an extreme sense of being persecuted, all of which is inevitably seen as a threat to social stability and requires the state to control the activities of the individual concerned. Of course, Dalí is not advocating a voluntary state of madness (which would in any case be impossible), but he admires the mental agility, the imaginative creativity of the paranoiac. What he particularly argues for is the development, as a positive mental asset, of the faculty to discover double or even multiple readings of images, permitting a much more complex set of meanings to emerge: 'By a double image is meant such a representation of an object that it is also, without the slightest physical or anatomical change, the representation of another, entirely different object, the second representation being equally devoid of any deformation or abnormality betraying arrangement.' A good example of Dalí's exploration of the multiple reading of images in his painting is *The Invisible Sleeping Woman, Horse, Lion* from 1930, a title which refers to only three of the many potential readings of the picture (90).

89
Page from '*Le Surréalisme au service de la révolution*' (*Surrealism in the Service of the Revolution*), 15 May 1933, no. 5/6

Dalí is not interested simply in some amusing visual trick performed for its own sake, but in finding a means of exposing and exploring the dominant Surrealist precept that the internal realm of the mind is infinitely more rewarding and more 'real' than the merely material understanding of reality. The intense and traumatic nature of visual imagery is capable of addressing itself directly to these more profound, and 'lyrical' mental states where connections are made and memories and ideas are related, on the basis of personal experience and preoccupation rather than of outside reality. This is where the 'critical' aspect of the term comes in, because such a process poses a challenge to conventional, routine and self-policed directions of thought: 'The ideal images of Surrealism will serve the imminent crisis of consciousness; they will serve Revolution.'

He was to find confirmation of these ideas through discussion with the young Jacques Lacan, who was later to make a highly influential

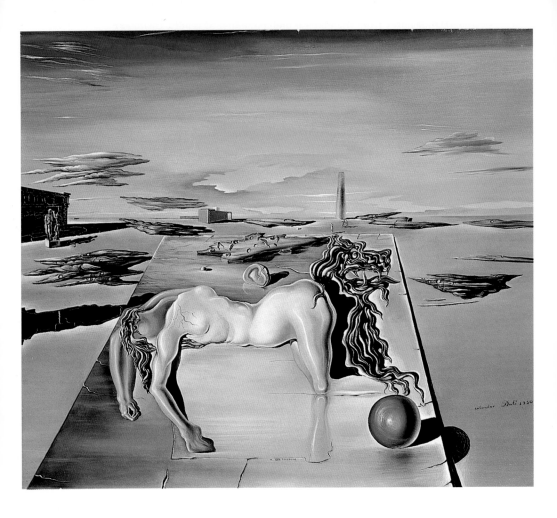

contribution to psychoanalytical theory. In an article written for
*Minotaure*, which was itself influenced by Dalí, Lacan points out that
the delirious experience of paranoiac subjects is closely analogous to
the creative content of folklore and myth, and that their imaginative
reach and complexity can frequently equal that of the greatest
artists. Furthermore, their violent actions and protestations reflect
closely the actual conditions of contemporary social tension. So
here was a means of improving or rather updating the Surrealist
principle of automatism. Automatism was now felt to be too passive,
too much concerned with 'pure experience', and to be insufficiently
on the offensive for the 1930s, when the greater political urgency of
the movement was reflected in the renaming of the Surrealists'
journal as being 'in the service of the Revolution'. From this point

on, Dalí's paranoiac-critical method, even if not always acknowledged as such, came to dominate approaches to Surrealist activities during this decade.

Dalí is always at his most convincing when he is able to make his point in visual terms, and one of the most memorable demonstrations of his idea is the *Paranoiac Face* which he illustrated in *Le Surréalisme au service de la révolution*. He describes how after he had been musing on certain images of Picasso, he was searching through a pile of papers looking for an address when he suddenly came across a post-card which he took to be a typical head done by Picasso, with a patch of blank canvas behind it. On turning the card round, he discovered it was actually a photograph of an African village house. He tested his theory further by showing the card to Breton, who was at the time deeply engrossed in the writings of De Sade and who immediately saw the face of the eighteenth-century aristocrat in his powdered wig.

90
*The Invisible Sleeping Woman, Horse, Lion,* 1930. Oil on canvas; 50·2 × 65·2 cm, 19³⁄₄ × 25⁵⁄₈ in. Musée National d'Art Moderne, Centre Georges Pompidou, Paris

Yet another initiative for which Dalí seems to have been largely responsible was to get the members of the group to produce Surrealist objects. This was, of course, far removed from any intention of producing 'sculpture', with all the aesthetic or conservatively representational qualities implied by that term. Fulfilling the description of his torrent of ideas and conversation as being like 'the outboard motor of a speedboat' – a description given by Picasso who was on friendly terms with Dalí at the time, he comes up with a string of suggestions for new Surrealist activities, reported in his 1932 article 'The Object as Revealed in Surrealist Experiment', including:

Examination of certain actions; liable owing to their irrationality to produce deep currents of demoralization and cause serious conflicts in interpretation and practice, *eg* a) causing in some way any little old woman to come along and then pulling out one of her teeth; b) having a colossal loaf (15 metres [49 feet] long) baked and left early one morning in a public square, the public's reaction and everything of the kind to be noted until the exhaustion of the conflict.

However, what was particularly important for the fabrication of the Surrealist object was that it should be touched and manipulated by

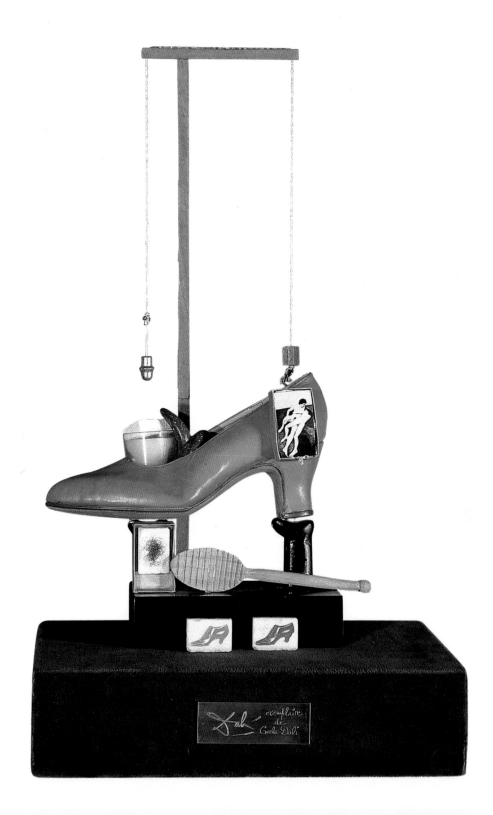

the viewer. Objects were made by various group members including Gala and Breton as well as Alberto Giacometti, but perhaps the most poetically effective was the arrangement of two gloves, one white, one red, against a roulette board, by Valentine Hugo. Dalí's object, reconstructed in 1974 (91), was described by him in *Surréalisme au service de la révolution* as:

A woman's shoe, inside which has been placed a glass of warm milk, in the middle of a ductile piece of pastry, of an excremental colour. The mechanism consists of plunging a lump of sugar, on which has been painted the image of a shoe, in order to observe the disintegration of the sugar and consequently the picture of the shoe, in the milk. Several accessories (pubic hair stuck on to a lump of sugar, a small erotic photograph) completing the object.

He came across a shop sign for a fireworks manufacturer in 1930 to which he added minutely painted images and lettering to produce what Duchamp would have called an 'assisted ready-made', *Mad Associations Based on Fireworks* (92).

These first years of the 1930s, the period of maximum commitment to the idea of Surrealism, were the only time of financial hardship in

91 Left
*The Shoe - Surrealist Object Functioning Symbolically,* 1974 reconstruction by Max Clerac-Serou of 1932 original (now destroyed). Lady's shoe, modelling clay, milk glass, brush, sugar cubes, spoons; 48 × 24 × 14 cm, 18⅞ × 9½ × 5½ in. Private collection

92 Below
*Mad Associations Based on Fireworks,* 1930–1. Oil on embossed pewter; 40 × 65 cm, 15¾ × 28⅝ in. Private collection

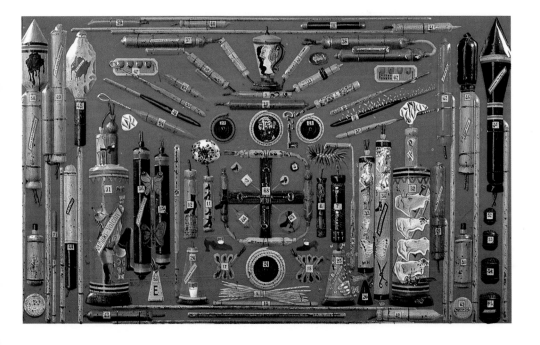

Dalí's life. His works were talked about and attracted plenty of scandal but this notoriety had become too extreme to entice the majority of picture buyers (after financing *L'Age d'or*, De Noailles had not only narrowly avoided excommunication but had been barred from the Jockey Club), although Gala worked strenuously on the Paris dealers to create a better market for his paintings. Dalí still needed to have close contact with the landscape and culture of Cadaqués which had contributed so much to shaping his formative experiences. But this raised severe difficulties, for not only had his father banished him from the family home but, as a man of some local influence, had let it be known that the ban was to extend to the whole village, and when Dalí insisted on returning he was snubbed and ignored in the streets. His solution was to take refuge in a small fishing settlement over the headland from Cadaqués, which was called Port Lligat, and here he was able to purchase, with money from the Goemans exhibition, a single-room fishing shack, which he and Gala converted into their home. Over the years this was extended with a number of interconnecting rooms; it was ultimately adorned with a phallic-shaped swimming pool, but for the time being they had to suffer the damp walls and cold mountain wind, the 'tramontana', which assails the region during the winter.

The extent to which the natural topography of the area directly influenced the paintings of the classic Surrealist phase of his work is debatable. Typical of these pieces must be *The Persistence of Memory* of 1931; indeed, the 'soft watch' has become almost a trademark for Dalí (93). Certainly the bare, hard outline of the cliffs and the crystal clear light of the sky are there, but the empty, desert-like expanses of the painting are much closer to the topography of the mind, to a dreamscape. The viewer's anxiety is fermented precisely through the lack of clues of distance, of recognizable landmark, of time of day, of temperature – it could equally be as hot, or as cold, as an unknown planet. We are in an arena of silence, a frozen nightmare, in which nothing moves or makes a noise. The unlimited horizons of these works invoke a sense of infinity which is close to agoraphobia.

93
*The Persistence of Memory,*
1931.
Oil on canvas;
24·1×33 cm,
9½×13 in.
Museum of Modern Art, New York

A hallucination, as experienced in certain states of illness, sensory deprivation or drug use, is a mental illusion which is so convincing that it is sustained even when we test it or view it from a different position; when Dalí's Surrealist paintings really work, they surely produce something close to this hallucinatory effect. It is reasonable to associate the watches in *The Persistence of Memory* with ideas about the passage of time and the relation between actual time and remembered time, but probably the dominant fascination for Dalí was the paradox of rendering that hardest, most mechanical of objects into its present soft, wilting form; even the tree metamorphoses into a sluggish softness.

This process of cheese-like softening of forms, which deserves the descriptive term 'deliquescence', continues in such works as *The Birth of Liquid Desires*, painted in 1932. This material state was an obsessive fascination for Dalí at this time; in a splendidly humorous piece

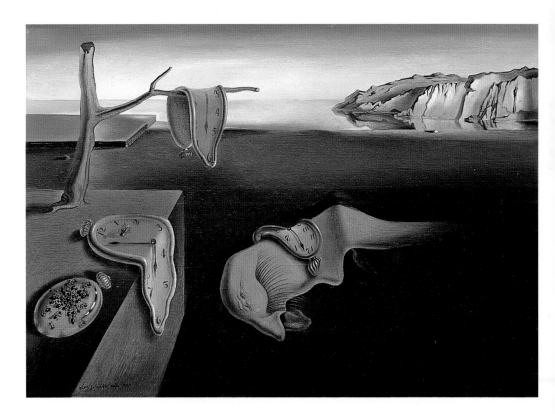

for *Minotaure*, grandiosely entitled 'Aerodynamic Apparitions of "Object-Beings"', he talks of 'the soft actuality ... the super-gelatinous, nutritive modern style of compressibility' in reference both to the forms of Gaudí's architecture and to those of the facial blackhead.

The bread loaf is a recurrent theme of Dalí and its fetishistic potential for him is most enthusiastically displayed in *Anthropomorphic Bread* (94), of 1932. Here, after all, is the material which most exquisitely traverses the passage from softness to hardness and back again, from dough to crust to mastication. The visual rhyme of the loaf with the penis in Dalí's rendering obviously invites a full range of further soft and hard associations, and he also felt that the idea of using the loaf as an ink holder, with the ensuing stains, was a pleasurably 'degrading and aesthetic' touch.

Dalí's complex feelings towards his father, involving love and admira-tion, but for the moment overshadowed by angry resentment, were far from resolved. Is Dalí senior, the swollen, soft-headed subject of *The Average Bureaucrat* (96) of 1930, brooding under the ominous shadow of the mountain which overlooks Cadaqués? Certainly the job of the notary is the supreme definition of bureaucracy, though the moustache indicates a more generalized version of the threatening patriarch. Dalí's relationship with his father seems to be at the heart of a series of paintings on the theme of William Tell. There were two main aspects to this resentment: not only had he been ejected and disowned, in a scenario referred to by Freud as representing the inevitable and recurrent battle between the generations and the need for the son to oppose and symbolically 'kill' the father, but also Dalí regarded the particularly domineering figure of his own father (along with the book, showing the effects of venereal disease, that he had kept for the young Salvador's education) as being largely responsible for his previous sexual anxieties. He adopted the legend of William Tell in which the father is forced to shoot an apple, placed on his son's head, with his cross-bow, and added elements from biblical stories such as Abraham sacrificing Isaac, to create his symbolic imagery.

94 Above
*Anthropo-morphic Bread*, 1932.
Oil on canvas;
16·2 × 22 cm,
6³⁄₈ × 8⁵⁄₈ in.
Salvador Dali Museum, St Petersburg, Florida

95 Below
*The Old Age of William Tell*, 1931.
Oil on canvas;
201·5 × 346 cm,
79³⁄₈ × 136³⁄₈ in.
Private collection

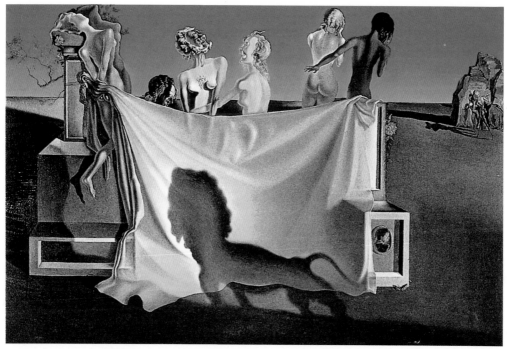

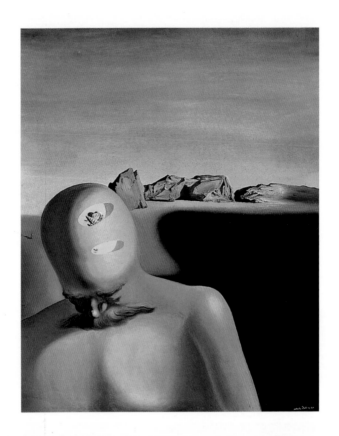

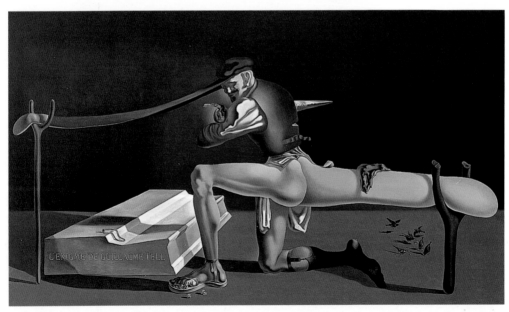

*William Tell*, the first of this series, was painted in 1930. In *The Old Age of William Tell* (95) of 1931 the hysterical expressions and the hidden activities of the hermaphroditic bodies of the players, behind the sheet that was put up for puppet shadow theatre performances, conjure up the Freudian lion of animal desire in some veiled sexual drama. The most significant of these paintings is *The Enigma of William Tell* (97) of 1933, where the specific features of the father-figure have now been transferred to a representation of Lenin, identifiable by his beard and (fetishistically extended) peaked cap. He nurses in his arms the infant Dalí who sports on his head not the apple of the Swiss legend but a lamb chop to indicate the cannibalistic desire of this ideological father. Under his foot, in imminent danger of being crushed, lies a tiny walnut shell, which according to Dalí cradles the infant Gala. Dalí's addition of what looks rather like excrement to Lenin's distended buttock was the final straw for the Surrealist group and a party was dispatched to avenge this insult to the revolutionary leader, by attacking the painting when it was hung at the Salon des Indépendents (though it proved to have been hung too high for them to reach it).

This was not the first occasion on which Dalí had revealed his perception of the cult of the revolutionary leader as possessing a fetishistic attraction, but his 1931 painting *Partial Hallucination: Six Apparitions of Lenin on a Piano* (98) apparently escaped censure. Two years later, however, the dominant political mood in France had taken on a new realism which extended to the Surrealists, and Dalí was officially summoned to a group meeting to answer charges that he was guilty of 'counter-revolutionary acts, tending to the glory of Hitlerian Fascism'. Dalí reacted to the grave and angry accusation by Breton, Aragon and others in characteristic fashion, by putting on a comedy act. Claiming to be feeling a cold coming on, he constantly took his temperature and peeled off layers of clothing during the hearing. He defended the charge of being obsessively fascinated by Hitler by insisting on the absolute obligation, as a Surrealist, to respond to his dreams and fantasies free of all censorship, goading the fiercely heterosexual Breton, by insisting, 'If I dream tonight that I made love to you, tomorrow morning I would paint our best amorous positions.'

96 Above
*The Average Bureaucrat*, 1930.
Oil on canvas;
81 × 64·8 cm,
31⅞ × 25½ in.
Salvador Dalí Museum, St Petersburg, Florida

97 Below
*The Enigma of William Tell*, 1933.
Oil on canvas;
201·5 × 346 cm,
79⅜ × 136⅜ in.
Moderna Museet, Stockholm

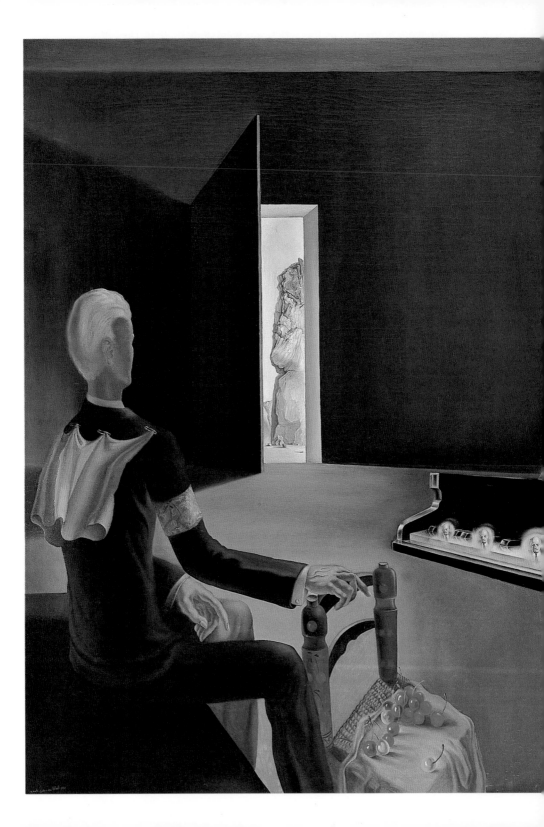

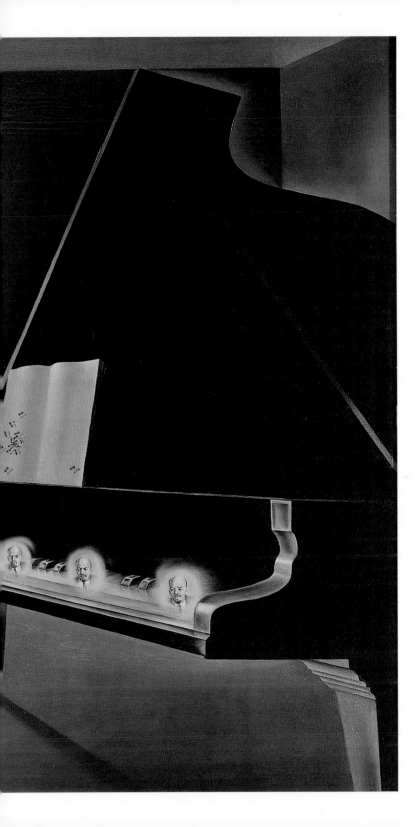

**98**
*Partial
Hallucination:
Six Apparitions
of Lenin on a
Piano.* 1931.
Oil on canvas;
114 × 146 cm,
44⁷⁄₈ × 57¹⁄₂ in.
Musée
National d'Art
Moderne,
Centre Georges
Pompidou,
Paris

It is perhaps easy for us today automatically to take Dalí's side in this affair, but we should take into account the political circumstances of the time and the extent of the moral dilemma which was facing the Surrealists and which this episode signified. Two years previously, Dalí had already incurred the wrath of Aragon, who had become closely associated with the cultural policies of the Communist Party. The artist had been discussing his proposal for a Surrealist object – an arrangement of a number of goblets of warm milk in the shape of a rocking chair – when Aragon protested that this nonsense should cease and that warm milk should be used for the children of the unemployed. At the time even Breton was shocked by the apparent banality of this objection, but now, in 1934, political positions were becoming polarized with the ever-growing threat of Fascism spreading across Europe.

Europe after the First World War was rife with unresolved tensions and conflicts. For some, there was the shame of defeat; for all, whether victors or vanquished, there was economic dislocation and hardship. These were the conditions which allowed Fascist parties to prosper and recruit members from among the disaffected multitudes. Party leaders offered the promise of radical social improvement through adherence to the virtues of patriotism and militaristic civic discipline. Very soon that nationalism would turn into racism, particularly anti-Semitism; that discipline would turn into brutal intolerance of all political opposition; and the promised social order would turn into totalitarian control. Mussolini had been ten years in power in Italy when Adolf Hitler, the leader of the Nazi (National Socialist) Party, had become Reich Chancellor of Germany in 1933; he was already forbidding the free expression of ideas, decreeing that the work of modern artists (including that of Ernst, for example) was 'degenerate' and could no longer be exhibited; there were Fascist parties, growing in popular support, throughout Central and Eastern Europe, in Britain and in Spain. In France itself, right-wing groups had already smashed up a Surrealist exhibition (which had included paintings by Dalí), and, more to the point, had succeeded in 1934 in bringing down the government, following riots on the streets of Paris (99). The various right-wing groups in France – the Jeunesses

99
Riot in the Place de la Concorde, Paris, 6 February 1934

Populaires, the Camelots du Roi, the Croix de Feu and the Parti Populaire Français – all appealed to different political interests and social groups, but they had in common the confirmed prejudice that the nation's loss of former glory was to be blamed on some designated group – whether the socialists, the Jews, the freemasons or foreigners. In response, the parties of the left, socialists, Communists and trade unionists agreed to forsake their former differences and

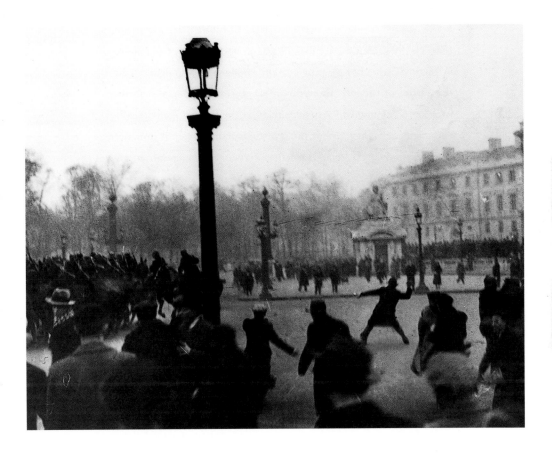

embarked on a policy of collective opposition to Fascism under the banner of the Popular Front. In the French national elections of 1936 a Popular Front government came to power under the leadership of Léon Blum amidst a (short-lived) burst of national optimism.

It is hardly surprising, then, that the Surrealist group should now be demanding a greater degree of political responsibility from its members. Dalí, however, was always firmly guided by his instinctive

responses to political as well as philosophical ideas; he could not simulate an ideological commitment, nor make a dishonest protestation of faith, even when the pressures to conform were very strong. When in 1935, in the prevailing spirit of Popular Front unity against the threat of Fascism, the former antagonists Bataille and Breton were instigating a new campaigning group under the name of Counter-Attack, they asked Dalí for his support. He replied respectfully enough, but was unable to offer them any militant, or even active, participation, 'because I DO NOT BELIEVE IN IT'. He stated that 'all the drama we are living through doesn't stem from political or tactical errors but essentially from a colossal ideological deficit of the parties of the left'. He passionately objected to Socialist Realism, which the Communist Party demanded as the official ideological approach to art, because of the stylistic banality which it promoted and its crippling effect on the artist's freedom of imagination; he was later prepared to take this argument to the pages of the American left-wing journal *Art Front* in 1937.

The result of all this was that from 1934 onwards he was progressively distancing himself from the Surrealist group as a formal entity, although there were mutual advantages for him still to be considered a Surrealist artist. It was not only differences over politics that separated them, nor even his evident careerist ambitions, but there was a growing artistic distance too, as he was beginning to show an increasing attraction to the techniques and the content of the art of the past – a position which had already led to the demotion of De Chirico from the Surrealist pantheon.

In *The Phantom Cart* (100), painted in 1933, the hard-edged clarity of the 'colour photograph of the dream', which he had previously expressed as his ideal pictorial effect, has been replaced by a much gentler atmospheric illumination, which relates much more to nineteenth-century landscape painting traditions. Significantly it is free of all distortion, yet still manages to bring off a single, understated illusionary effect, in which the two figures in the cart, at a certain point, switch into architectural elements of the town beyond. The subject would seem to carry a certain personal significance in that it

100
*The Phantom Cart*, 1933. Oil on panel; 19 × 24·1 cm, 7½ × 9½ in. Private collection

recalls Dalí's account of his childhood journey by horse-drawn carriage across the plain to the Pichot family home, where his mental life of reverie and fantasy first flourished, and where he explored his ability to see double images in the clouds of a summer storm, 'so that I became master of that thaumaturgical faculty of being able at any moment and in any circumstance always, and always, to see something else'.

A sensitive painterliness is also revealed in *The Weaning of Furniture – Nutrition* (101) of 1934, in the almost picturesque rendering of the hills and the boats of Port Lligat, and in such details as the blended hues on the nurse's apron. Again the irrational elements are limited, this time to the extracted void from the figure of the nurse, which has been transformed into a bedroom cupboard, which in turn has been cut into to form a smaller version of itself, with a bottle on top, leaving the negative shape of a turreted building. In fact this remem-

brance of his own former nursemaid was summoned up to serve as
the vehicle for his current fetishistic fascination with the 'soft' figure
of Hitler, and he had to be persuaded against giving her a swastika
armband.

Dalí's admiration for the technique and the illusionist realism of
seventeenth-century Dutch painting is celebrated in *The Angelus of
Gala* (102) of 1935. The decision to adopt a Realist style and tech-
nique for this picture was based on far more than a wish to demon-
strate his virtuoso skill. With the intention of exposing the viewer to
the kind of visual paradox most usually associated with Magritte, Dalí
knew that only the most convincing methods of illusion that painting
could provide would suffice, for in this double image of Gala the
painting is presented to us as if it were performing as a mirror – an
impossible or missing mirror, of course, because it is only a mirror
from the point of view of the subject inside the picture, which leaves
no rational space for us to occupy as viewers. The point is that

although we are, for the moment, seduced into thinking Dalí is a realist painter, we are soon made to remember that he is still very much a Surrealist, for the 'reflected' version of Gala is seated on a wheelbarrow, of all things. The explanation for this must be found in the severely doctored version of Millet's painting *The Angelus*, hanging on the wall behind her, in the position a picture might occupy in a composition by Vermeer.

The original 1859 painting by Millet, now in the Musée d'Orsay (103), was known to millions throughout Europe during the following decades in the form of mass-produced prints. There was a copy hanging on Dalí's schoolroom wall, for example. It held quite a grip on Dalí's imagination, recurring in a number of works at this time, notably the series of etchings for De Lautréamont's *Les Chants de Maldoror* (105) which reveal the morbidity of his reading of Millet's picture; other occurrences of the theme include *The Architectonic Angelus of Millet* (106), *Gala and the 'Angelus' of Millet before the Imminent Arrival of the Conical Anamorphoses* (104), *Imperial Monument to the Child-Woman* (84) and the later *Railway Station at Perpignan* (181). The image was also the source for his most elaborate, textual exploration of the paranoiac-critical method. Although *The Tragic Myth of Millet's 'Angelus'* was not actually published as a book until 1963, it was largely written between 1932 and 1935.

Based on anthropological and folkloric observations that agricultural labourers tended to eroticize their working tools, Dalí embarks on a discursive and complex interpretation, following Freudian concepts, of this dour depiction of rural piety. He determined that the true but hidden subject of the picture – that is, the cause of his personal, obsessive fascination and the explanation for its ubiquitous popularity – is that of the castration of the husband and the killing of the son. So he was eager to discover in an X-ray of the work, where the basket now stands between the feet of the two figures, the indication of an object which had been painted over. He assured himself that this form represented the coffin of a child (though this interpretation is far from convincing). However, the whole virtue of the paranoiac-critical method is revealed in the comment, which he attributes

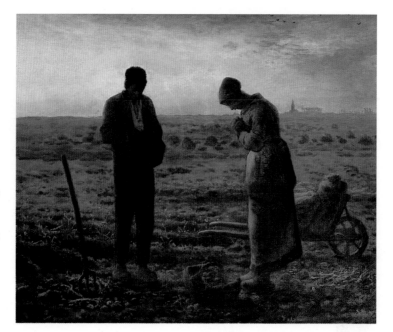

**102 Left**
*The Angelus
of Gala,*
1935.
Oil on panel;
32·4×26·7 cm,
12³⁄₄×10¹⁄₂ in.
Museum of
Modern Art,
New York

**103 Right**
Jean-François
Millet,
*The Angelus,*
1857–9.
Oil on canvas;
55·5×66 cm,
21⁷⁄₈×26 in.
Musée
d'Orsay, Paris

to Gala, that 'if this constitutes a proof, then it would be marvellous;
if the whole book was purely a construction of the mind, then that
would be sublime.'

So, blithely ignoring any pedantic requirement of the historian for
evidence beyond reasonable doubt, he treats us instead to an exhila-
rating mental excursion, taking in on the way ancient standing
stones, Rudyard Kipling's *Jungle Stories* and the hidden vulture that
Freud saw in Leonardo's *Virgin and Child with St Anne* (c.1508–10).
This diversion gives a higher priority to the rules of the game (of the
paranoiac-critical method) than to a search for any certain and fixed
truth, and it is on occasions like this that Dalí's proximity to the
strategies of Duchamp is most apparent. He also makes persuasive use
of images derived from popular culture – cartoons, the decorative
pattern of a tea-service and above all of pre-First World War picture
postcards – to demonstrate the extent to which respectable 'high' art
denies or sublimates the prevalent desire for erotic expression.
Indeed, Dalí worked from a postcard reproduction of *The Angelus*
while writing this essay, as if to facilitate the liberation of the image
from its material actuality into the subjective domain of personal

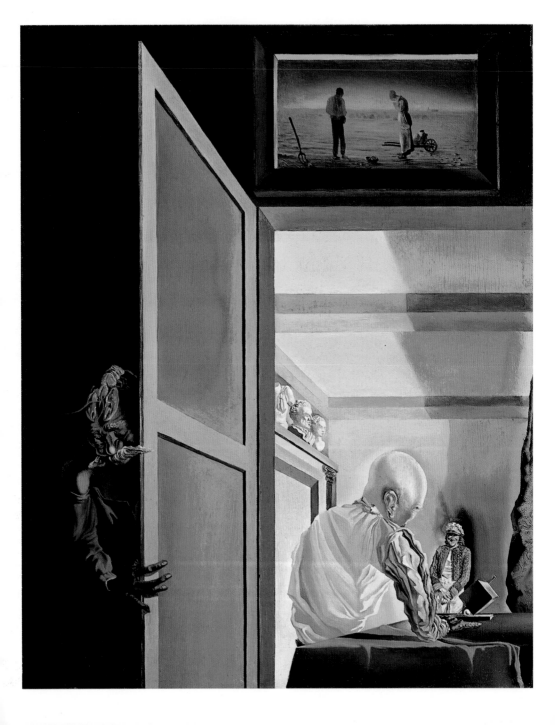

**104 Left**
*Gala and 'The Angelus' of Millet before the Imminent Arrival of the Conical Anamorphoses,* 1933.
Oil on panel; 24 × 18·8 cm, 9¹⁄₂ × 7³⁄₈ in.
National Gallery of Canada, Ottowa

**105**
**Above right**
Illustration for *'Les Chants de Maldoror',* 1934.
Etching; Salvador Dalí Museum, St Petersburg, Florida

**106**
**Below right**
*The Architectonic Angelus of Millet,* 1933.
Oil on canvas; 73 × 61 cm, 28³⁄₄ × 24 in.
Museo Nacional Centro de Arte Reina Sofia, Madrid

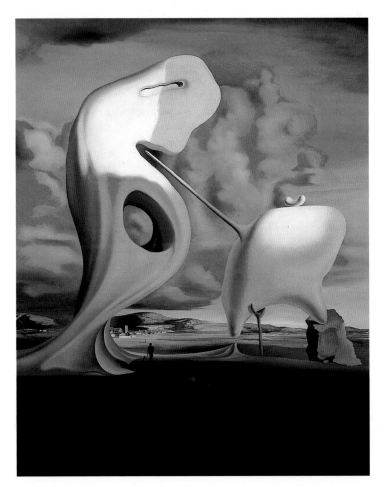

reality. He acknowledges that his own 'delirious' vision of the paint-
ing, in which the man is hiding his phallic shame and the woman is
transformed into a praying mantis, was largely formed by his personal
anxiety about impotence and his fear of what he felt to be the anni-
hilating force of the sexual act. It is worth noting that Paul Éluard
also collected postcards of this era, reproducing them in *Minotaure*
and using them in his collages, but he interpreted their cultural func-
tion in more orthodox Marxist terms: 'Commissioned by the exploiters
to amuse the exploited, they should not, however, be counted a popu-
lar art. They are, rather, the small change of art and poetry: and this
small change sometimes reveals ideas of gold.'

Despite Dalí's increasing estrangement from the kind of political
discipline demanded from its members by the Surrealist group, his
prominence as an artist ensured his continued if uncomfortable asso-
ciation with the movement. Surrealism in the middle years of the
1930s not only represented the best-organized and most influential
grouping of artists in Paris, it was also taking on a new international
scope with groups emerging in Belgium, Spain, Czechoslovakia,
Yugoslavia, Japan and Britain. This rise in prominence was marked by
three major exhibitions, in London and New York in 1936 and in Paris
in 1938, all of which included memorable contributions from Dalí,
both in terms of exhibits and personal 'performances'.

The International Surrealist Exhibition, which was held at London's
New Burlington Gallery, was largely responsible for establishing for
the first time an organized group of Surrealist artists in Britain, and
for stimulating a wider recognition of the movement in the public eye
(107). Two of its promoters, Roland Penrose and David Gascoyne (who
had written the first significant study of the movement in English, *A
Short Survey of Surrealism*), knew the artistic life of Paris intimately,
and the critic Herbert Read wrote the catalogue introduction. Read
insisted on using his own preferred term, 'Superrealism', and rendered
it almost as broad in scope as the term 'Romantic', which allowed him
to embrace William Blake and Lewis Carroll within the company. No
doubt in anticipation of the fashionable success and journalistic friv-
olity the show would arouse, he warns: 'Do not judge this movement

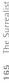

**107**
The First
Surrealist
Exhibition in
London, 1936
(back, left to
right): Rupert
Lee, Ruthren
Todd, Salvador
Dalí, Paul
Éluard, Roland
Penrose,
Herbert Read,
E L T Mesens,
George Reavey,
Hugh Sykes-
Davies
(front, left to
right): Diane
Lee, Nusch
Éluard, Eileen
Agar, Sheila
Legge and
friend

kindly. It is not just another amusing stunt. It is defiant – the despe-
rate act of men too profoundly convinced of the rottenness of our
civilization to want to save a shred of its respectability.'

The exhibition opened just a month before the outbreak of civil war
in Spain, and Breton, in his catalogue preface, was in no mood to
treat the mission of Surrealism lightly. (It must be said that his tightly
argued attempt to justify Surrealist art, with due respect for the
teachings of Marx and Engels, would have been comprehensible to
only a very specialist public in Britain.) But what the press and the
public at large certainly took note of was the figure, modelled by
Sheila Legge, in a white satin dress with her head covered in pink
paper rosebuds, which was designed by Dalí and entitled *Phantom of
Sex Appeal*, a realization of the subject of the 1935 painting *Woman
with the Head of Roses*. They also noticed his *Aphrodisiac Dinner
Jacket* (108), festooned with wine glasses and filled with crème de
menthe and floating flies, but above all they remembered Dalí's

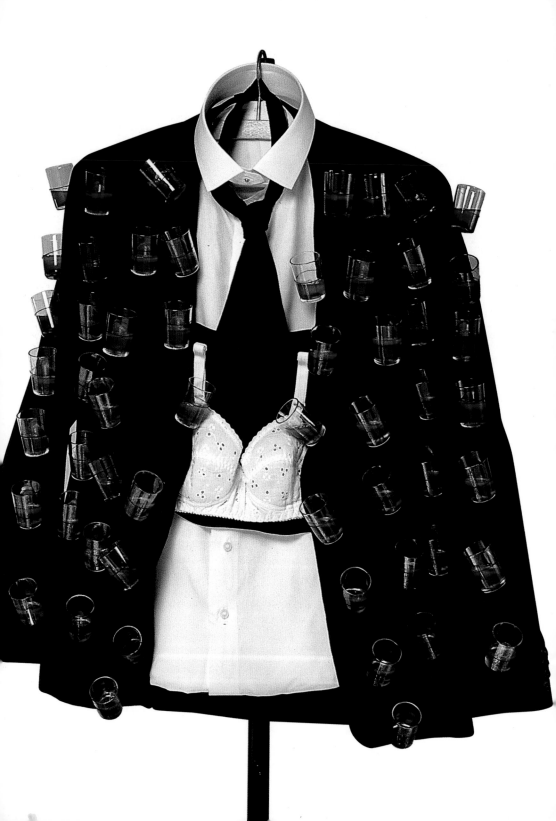

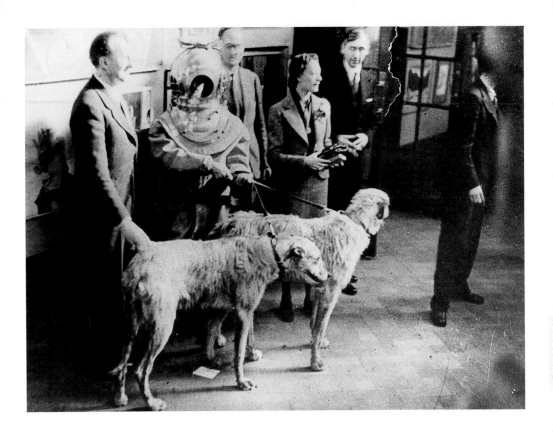

attempted lecture, delivered from inside a diving suit (109). He shuf-
fled slowly into the stiflingly hot gallery with lead-weighted boots,
two decorated daggers in his belt and leading a pair of enormous
wolfhounds; having struggled to the speaker's table, the helmet glass
was opened to allow him to speak, but it was immediately evident
that he was close to fainting. Desperate attempts were made by the
artists present and members of the audience to release him from the
helmet, including the use of a billiard cue, until a man with a spanner
could be found to come to his rescue. After this he gamely embarked
upon his talk entitled 'Childhood Memories', in his Catalan-inflected
French.

New York's Museum of Modern Art mounted an exhibition called
'Fantastic Art, Dada, Surrealism' between December 1936 and
January 1937 which followed on from an earlier exhibition that year
dedicated to 'Cubism and Abstract Art'. The Museum's director, Alfred
H Barr, whom Dalí had met earlier in Paris and whose 'erudition', he

considered, 'verged on the monstrous', in comparison with European directors of modern art collections, was intent on establishing a coherent model for the development of modern art, and on giving the subject something of the same authority that had formerly only been afforded to the art of the past. This process was reinforced by the inclusion of work by artists ranging from Giuseppe Arcimboldo, Hieronymus Bosch and Albrecht Dürer to Blake and Jean-Ignace-Isidore Grandville, which comprised the 'Fantastic' section of the show. The collection that the Museum of Modern Art acquired under Barr's guidance, and its arrangement, cataloguing and archival support, were to become powerfully influential in establishing how succeeding generations have evaluated modern art. For the Surrealists, however, a respectable place in the museum was the last thing that they wanted, and Dalí, sensing that the dead hand of historical classification was about to descend on the movement, complained to Breton of the attention given in the catalogue essay by Georges Hugnet to Dada, a definitively defunct movement, at the expense of the current vitality of Surrealism. This process of 'normalization' by Barr was undeniable, for Surrealism was presented to the public entirely in terms of one more artistic movement, completely devoid of any socially disruptive, indeed revolutionary, intention; this perception of Surrealism as being more entertaining than threatening dominated its public reception in the United States.

A further International Surrealist Exhibition, which was to prove the last major manifestation of Surrealist activity before the outbreak of the Second World War, was held in Paris in January 1938. Breton had at first tried to exclude the renegade Dalí but he was eventually admitted as a 'special adviser', since his prominence in the movement in the mind of the public could not be ignored. Although as many as 300 paintings, drawings and found objects were exhibited, the most memorable aspect was the installation itself. The formal and dignified ambience of the Beaux-Arts Galleries was transformed into an environment of total disorientation. Visitors entering the foyer first encountered Dalí's *Rainy Taxi*, in which a system of hoses played constantly over two mannequins seated inside the vehicle – the driver, who bore the head of a shark, and the passenger, a glamorous

blonde, over whom trailed a colony of giant live snails. Next they passed along a 'Surrealist Street' between a file of female mannequins, each adorned by a different artist (Dalí's wore a mask and a collection of small spoons), before entering the main space. This had been transformed by Duchamp into a kind of grotto, with an uneven floor covered in leaves and twigs, a pool with water lilies, a glowing brazier, a luxurious bed in each corner and the ceiling hung with 1,200 coal sacks. Each visitor was handed a torch to illuminate the artworks, distributed within this installation, as he or she chose. An *Abridged Dictionary of Surrealism*, compiled by Breton and Éluard, was published to coincide with the exhibition; the entry for Dalí described him, with Gallic irony, as 'Prince of Catalan Intellectuals, colossally rich'.

The affront to the dignity of art rendered by this exhibition still had some effect in France, and the general reaction of the press was that of hostility and outrage, whereas in America, where art occupied a relatively marginal cultural position in the life of the nation, the press were more ready to grant the Surrealists the jester's licence to amuse. In fact the movement was no more exempt in Paris from the risks of trivialization and co-option as entertainment by the socially privi-leged leisure class, to whose destruction its members were ideologi-cally committed. Dalí was only unusual in the extent to which he unashamedly acknowledged the irony of the situation, and, with his unerring eye for self-interest, strove to exploit it to his advantage. The mixture of fascination, envy and disdain that he felt towards the wealthy is revealed in his recollections of this period in *The Secret Life*:

I took advantage of my appearances in Paris to go out into society. Very rich people have always impressed me; very poor people, like the fisher-men of Port Lligat, have impressed me; average people, not at all. Around the real Surrealist personalities were beginning to gather average people, a whole fauna of misfit and unwashed petty bourgeois. I ran away from them as from the cholera. I went to see André Breton three times a month, Picasso and Éluard twice a week, their disciples never; society people, almost every day and every night ... Most society people were unintelli-

gent, but their wives had jewels that were hard as my heart, wore extraordinary perfumes and adored the music that I detested. I remained always the Catalonian peasant, naïve and cunning, with a king in my body. I was bumptious, and I could not get out of my mind the troubling image, postcard style, of a naked society woman, loaded with jewels, wearing a sumptuous hat, prostrating herself at my dirty feet.

This circle of high society – remnants of the French aristocracy 'exhausted with its sterile, self-refinement', exiled Russian princes, Americans in Paris, Indian Maharajas, fashion-house entrepreneurs – was happy to invite him and Gala to their balls and house parties, knowing that, with his extraordinary appearance, his sharp wit, his unpredictable attitudes and behaviour, he would perform and entertain. For his part, he sought in exchange, as well as his own entertainment, an economic return in the shape of sales and commissions.

It is here, when examining the social group who patronized the work of the Surrealists, that we encounter the insecure boundaries existing between art and fashion, and some of the troubling questions that this raises for modern art, for these were the very same people who demanded excitement and novelty as customers of the top Parisian couturiers. Dalí was always drawn to fashion: it was a world as equally rooted in fantasy and disdainful of the rule of reason as his own art. He understood its eroticism and its displacement of erotic form in exotic detail and styling. He found a sympathetic collaborator in the fashion designer Elsa Schiaparelli, who was able to translate his concepts into reality. His various figures with drawers inserted into their torsos formed the basis of her *Desk Suit* with a set of real and false pockets embroidered with knob-like buttons (110); she also printed up a design of his for a dress fabric which gave the appearance of rips in the garment (111), and another with a pattern of lobsters, mayonnaise and parsley, and she made up his idea for a *Shoe-Hat*. An equally fascinating but rather less translatable concept is elaborated in his 1936 gouache painting *Night and Day Clothes of the Body* (112).

110
Cecil Beaton,
Photograph of
*Desk Suit* and
*Crown Hat*,
inspired by
Dalí, 1936

It was at such a society event, given by the De Noailles, that he met the English millionaire Edward James; a personal (and probably inti-

111 Left
Elsa
Schiaparelli,
Tear patterned
silk crêpe,
inspired by
Dalí, 1938.
Victoria and
Albert
Museum,
London

112 Right
*Night and Day
Clothes of the
Body,*
1936.
Gouache on
paper;
30 × 40 cm,
11¾ × 15¾ in.
Private
collection

mate) and financial relationship was to develop between the two men
which was to have a considerable impact on Dalí. Although he
preferred to think of himself as a poet and a creative patron, on the
lines of the great patrons of the Renaissance and Baroque courts,
rather than merely as a collector, nevertheless, by the end of the
1930s James had amassed the largest individual collection of
Surrealist works anywhere in the world. He particularly supported
Magritte and Dalí. The decoration of his houses in London and West
Dean in Sussex led to the inception of two of Dalí's best-known
surreal 'furniture objects', the sofa in the form of Mae West's lips
(113) and the *Lobster Telephone* (114). Lesser known objects designed
by Dalí for James include his chair with hands (115). James passed on
to Dalí a large stuffed polar bear – a family hunting trophy. Supplied
with a drawer in its stomach and dyed at one stage in Schiaparelli's
'shocking pink', it was to remain a distinctive feature of the furnish-
ings at Port Lligat. James put up the money for Dalí's first excursion
into ballet design, *Mad Tristan* (*Tristan fou*), and financed the revival
of *Minotaure*, but, above all, he provided Dalí with an assured
monthly income in return for the exclusive right to his total produc-
tion of paintings and drawings. For the time that this contract oper-
ated, between 1936 and 1939, Dalí was released from all the vagaries
and unreliability of income he had experienced in his dealings with

**113**
*Mae West's
Lips Sofa,*
1936–7.
Wooden frame
covered with
pink satin;
h. 86 cm,
33⅞ in.
Private collec-
tion, on loan
to the Victoria
and Albert
Museum,
London

**114**
*Lobster
Telephone*,
1936.
Telephone with
painted plaster
lobster;
15 × 30 × 17 cm,
5⁷⁄₈ × 11³⁄₄ × 6⁵⁄₈ in.
Tate Gallery,
London

the commercial galleries, and James acquired a collection of the most impressive works of Dalí's late Surrealist period. The artist also benefited from James's invitations to travel to Italy with him, staying in Rome and at his villa in Amalfi. Dalí thus embarked on the traditional journey to Italy which had in the past been considered to provide the necessary finishing to an artist's education.

*Sleep* (116), one of Dalí's most celebrated Surrealist images, was painted in 1937 for James. With its associations of dreams, fantasies and the freeing of the subconscious, *Sleep* was a subject of particular interest to Surrealists. Dalí wrote later in *The Secret Life*: 'I have often imagined and represented the monster of sleep as a heavy, giant head with a tapering body held up by the crutches of reality. When the crutches break, we have the sensation of "falling". This common sensation, Dalí suggests, is a memory of expulsion from the womb at birth. He also said *Sleep* was a 'painting in which I express with maximum intensity the anguish induced by empty space'. Dalí's travels in Italy are suggested by his inclusion in the background of what he describes as the 'well-known summering town that appears in the boring dream of Piero della Francesca', referring to *The Dream of Constantine* in Piero's cycle of 'The Legend of the True Cross' in the church of San Francesco in Arezzo (c.1452–66).

Dalí's travels in Italy happened at just the time when his philosophical and artistic ideas were responding to the attraction of Italian Renaissance culture. This is very apparent in such paintings as *Thalia Corridor of Palladio* (118), where the symmetrical perspective of the seventeenth-century architect is exploited to provide a theatrical setting for Dalí's fantastic personages, and *The Metamorphosis of Narcissus* (117), both of which were painted in 1937.

In the latter painting, perhaps inspired by a version of the theme by Caravaggio, Dalí set himself an ambitious task of finding a pictorial format which would fuse traditional and Modernist approaches to the content of painting. At one level he is treating a Classical subject and presenting it somewhat in the traditional form of allegory, using elements which hint at various Renaissance styles, such as the figures in the middle ground and the dense modelling of the main figures,

115
'Hands' chair, c.1936. Painted wooden chair with cushion. Private collection

116 Overleaf
*Sleep*, 1937. Oil on canvas; 51×78 cm, 20⅛×30¾ in. Private collection

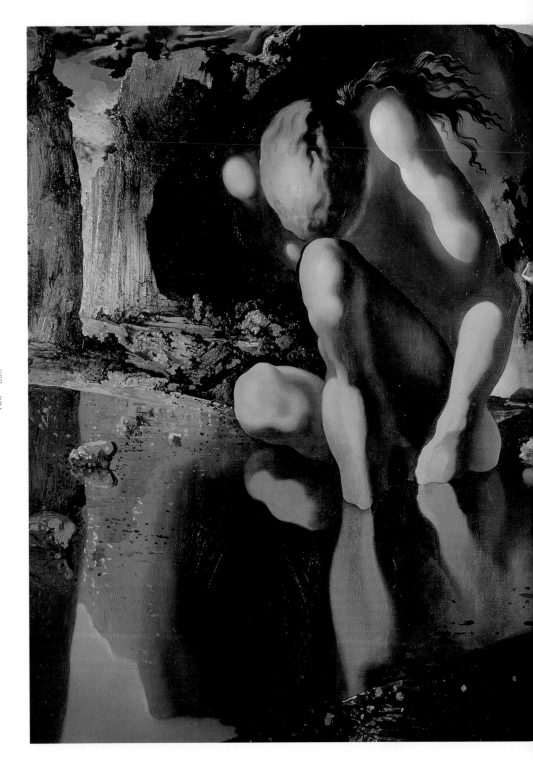

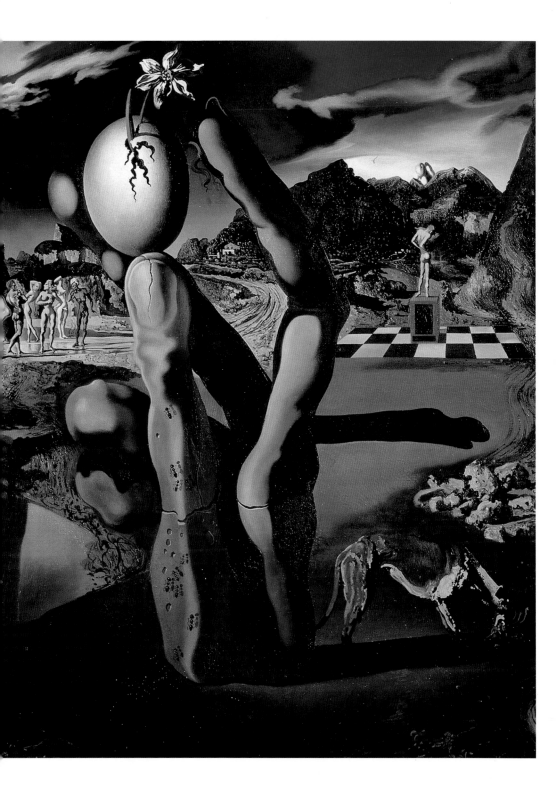

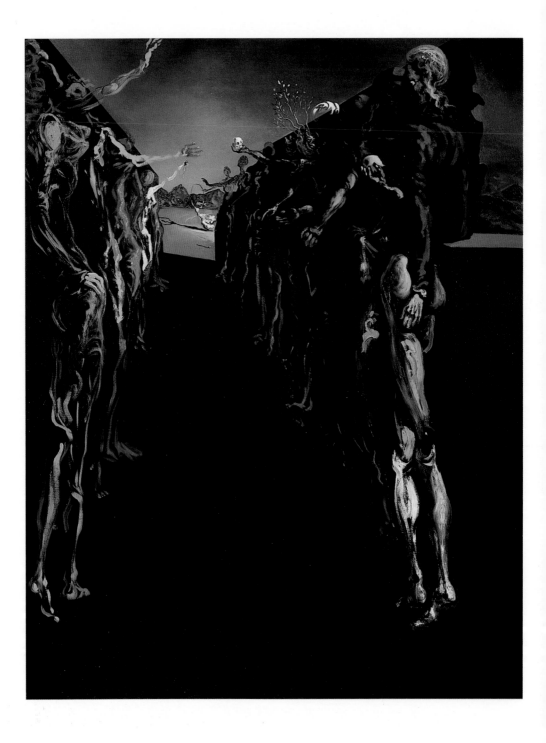

but at the same time he relates the theme to Freud's psychoanalytical interpretation of the myth, which he adds to by supplying his own personal set of meanings.

Even a simple summary of the myth, popularized by the Roman poet Ovid, would suggest many points of contact for Dalí. Narcissus brought grief to the nymph Echo by rejecting her love and he was punished for this by being condemned to fall eternally in love with his own reflection, which naturally paid no heed to his fervour, and so, in desperation, he killed himself, the flower which bears his name springing from his spilt blood. Dalí's inventive application of the double image, supplemented by the effects of the reflection in the pool, switching between perceptions of figure, hand and rock form, cleverly responds to the idea of metamorphosis in the original poem. The imagery of metamorphosis, or transformation of matter, also invites readings of the painting in alchemical terms. Alchemy as a system of thought attracted the Surrealists because of its anti-rational and magical interpretation of life. Its methods centred on the idea of transformation from base states of material form to progressively purer states; these processes were to be understood as metaphorically representing the passage to purer states of knowledge.

Dalí wrote a poem at the same time to accompany the picture; the final verse reads:

When that head splits
when that heads splits
when that head bursts,
it will be the flower,
the new Narcissus,
Gala –
my Narcissus.

Freud had identified a certain stage in the normal growth of erotic interest at which, prior to focusing on another person, the subject's own body becomes the centre for her or his erotic attraction; he referred to this as the narcissistic stage. Psychological problems ensue if the person becomes arrested at this level and fails to develop

117
Previous page
The Meta-
morphosis of
Narcissus,
1937.
Oil on canvas;
50·8 × 78·3 cm,
20 × 30⅞ in.
Tate Gallery,
London

118
Thalia Corridor
of Palladio,
1937.
Oil on canvas;
116 × 89·5 cm,
45⅞ × 35¼ in.
Private
collection

beyond this stage. But when 'Gala' becomes 'my Narcissus', Dalí is perhaps suggesting that the two personalities Gala/Dalí have now become fused, as two sides of a joint personality.

No matter how much he would have preferred to close his mind to the crude political realities surrounding him, by 1935 he could no longer ignore the inexorable build-up of oppression and conflict in Europe. This mood is well reflected in *Suburbs of a Paranoiac-Critical Town: Afternoon on the Outskirts of European History* (119). There are hints of an allegorical intention here, though seen through the filters of paranoiac-critical perception, with the contrasted image of the ideal Renaissance temple and the 'picturesque' streets of Cadaqués. The work is also remarkable for the multiplication of images evolving from the form of the bunch of grapes, ranging from the horse's rump to the animal skull, using a method of visual association which is revealed in a set of studies for the picture.

Following Primo de Rivera's fall from power in 1930 in Spain, a republic had been established which, under the liberal Manuel Azaña, instigated a modernizing and reformist programme. However, it moved too far for conservative, monarchist and church interests, and too little for the revolutionary and anarchist factions, and the

119
*Suburbs of a Paranoiac-Critical Town: Afternoon on the Outskirts of European History,* 1936.
Oil on panel;
46×66cm,
18⅛×26in.
Private collection

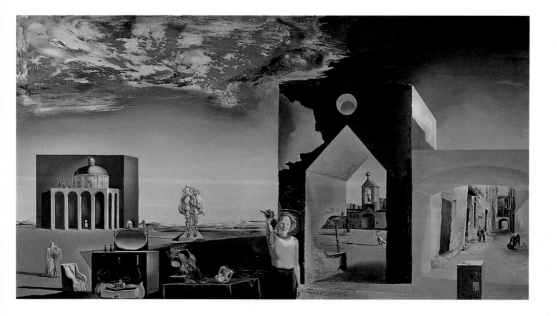

government collapsed within three years. A period of strikes and even an armed revolt by Asturian miners ensued, in reaction to the right-wing government which succeeded it. In February 1936 a new election brought victory to a Popular Front coalition but civil disorder continued, fuelled by the young Fascists of the Falange movement, who together with other right-wing military forces, many wishing to return to a monarchy with a descendant from the old Carlist line, rebelled against the state in July 1936, plunging the country into a war that was to ravage Spain for the next three years (120, 121). The Spanish Civil War was an event of international significance, for despite the local political complexities involved, it was essentially a test of strength between the ideological polarities represented by Fascism and Communism.

In October 1934 Dalí was travelling down to Barcelona to give a lecture on Surrealism when he was forcefully confronted with the measure of the conflict that was boiling over in Spain. Catalan Republicans and Anarcho-Syndicalists had joined forces in a declara-

**120**
Civilians line the barricades in Barcelona during the Spanish Civil War, 1936–7

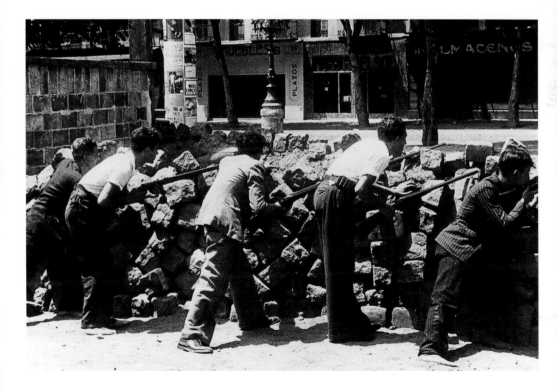

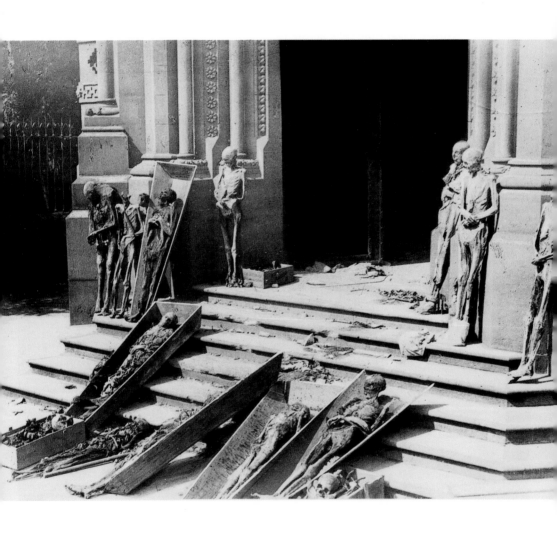

tion of independence for the region, and although Government troops had officially regained power, the streets of Barcelona and the rural areas of Catalunya were the scenes of gunfire and barricades. Terrified by these events, Dalí and Gala eventually found a taxi driver willing to return them to the French border. At a stop for petrol on the way, the locals started to make pointed remarks about Gala's ostentatious luggage – here Dalí admits to being very scared indeed. Although they managed to escape, their driver was less fortunate as on his return journey he was killed by a sniper. The impressive painting *Soft Construction with Boiled Beans: Premonition of Civil War* (122) undoubtedly draws on that fear, as well as his anger at the stupidity of the slide into civil war in Spain (which actually did not require the unusual powers of foresight implied in the title). A gigantic figure, inevitably recalling Francisco de Goya's *Saturn Devouring one of his Children* (c.1820–3), rises up over a dry, parched landscape, but the 'figure' is in fact an impossible combination of body parts, merging forms of fleshy softness with the hardness of decomposition.

The imagery of food and cannibalism is fittingly applied as a metaphor of a nation literally consuming itself, in *Autumn Cannibalism* (123), another painting from 1936. The landscape is even more arid and stripped of signs of human presence than usual in his painting, for Dalí sees the war as the enactment of natural forces, with all the inevitability of a geological process, rather than the outcome of particular political events. The scarcely humanoid forms are made up of a couple who embrace with the same gestures with which they carve into each other; the softness of the flesh allows a spoon to scoop directly into it, and – a particularly sadistic detail – a nail is driven through a protruding tongue in the foreground. A brilliantly effective device is the suppression of the tonal range of the sky, the ground and the wizened figures to dull, autumnal browns, which allows the one area of light tone, on the blade of the knife, to shine with a phosphorescent glow.

The war dragged on into 1938 when he painted *Spain* (124). Under a terminal, darkened sky, against a wasted, desert plain, the body of

121
Skeletons of Salesian nuns displayed at the entrance to a convent in Barcelona during the Spanish Civil War, 1936

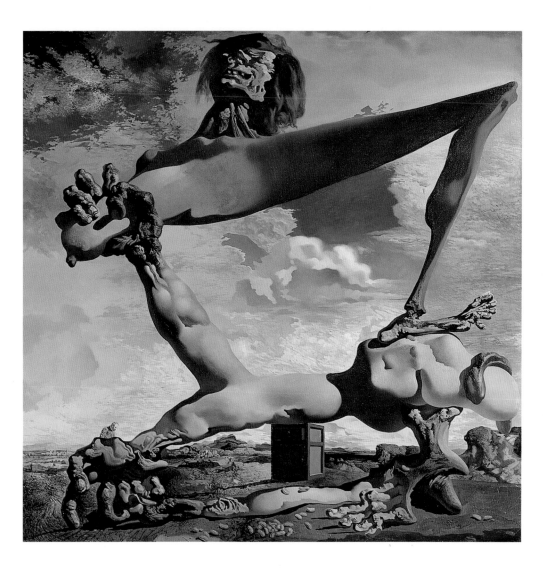

**122**
*Soft Construction with Boiled Beans: Premonition of Civil War*, 1936.
Oil on canvas; 100 × 99 cm, 39³⁄₈ × 39 in.
Philadelphia Museum of Art

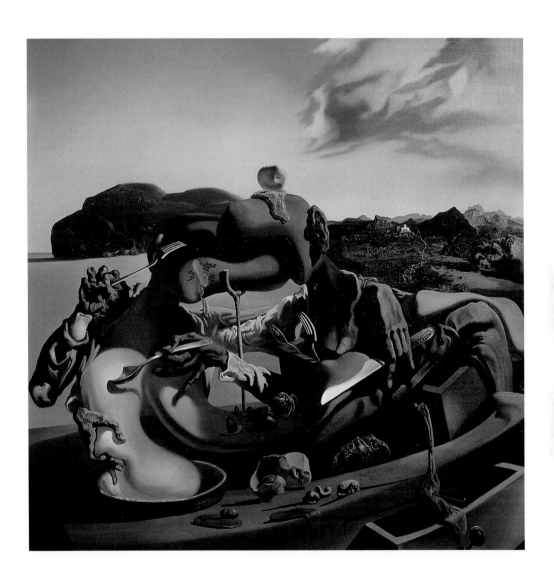

**123**
*Autumn
Cannibalism,*
1936.
Oil on canvas;
65 × 65·2 cm,
25⅝ × 25⅝ in.
Tate Gallery,
London

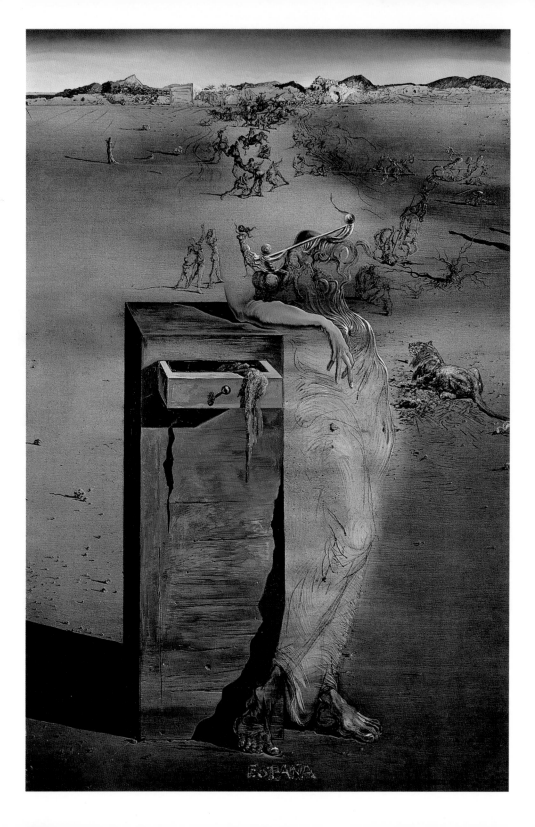

'Mother Spain' has now been so ravaged that she has lost all substantiality. An apparition, she emerges only as a double-image, composed of ant-like, fighting figures derived from his study of the notebook drawings of Leonardo.

At the time, Dalí's position was seen by most of his artist contemporaries as reprehensible, even treacherous. He soon lost what little credibility he had left with the Surrealists, and even his friend Edward James accused him of abandoning his former radical politics as the tide of events swung in favour of the Fascists in Spain. Not only had he been content to spend much of the time of the war in Italy, from where Mussolini was directly aiding Franco's forces, but he had declined to give any support as an artist to the Republicans, in signal contrast to the contributions made by Picasso, Julio González, Miró and other Spanish artists exiled in Paris. Dalí could never comprehend the readiness of his generation to die for an idea, and the horrifying waste and futility of the war was brought home to him most poignantly when in August 1936 Lorca, who was not a political activist, was executed by supporters of Franco in Granada. This only confirmed his view that the civil war was no more than the latest recurrence of Spain's traditional capacity for extremes of fanaticism, the masochism of the flagellant, the passion of the martyr and the cruelty of the inquisitor.

But the ever tightening grip of political menace in Europe could not be ignored. Hitler was intent on occupying Czechoslovakia and the British and French leaders, Chamberlain and Daladier, travelled to Munich in September 1938 to confer with Hitler and Mussolini. They returned from the conference with an agreement that they would never go to war with one another, but the cost of this 'appeasement' was the abandonment of the Czechs to the will of Germany. The events of the Munich crisis seem to be evoked in Dalí's painting from 1939, *The Enigma of Hitler*, with its imagery of telephonic diplomacy and Chamberlain's umbrella (125). What could be more disquieting than this 'dripping' telephone with the receiver transforming itself into a lobster's claw just where you would place it against your ear? The image of Hitler, in the scrap of torn photograph, has lost its

124
*Spain*, 1938.
Oil on canvas;
91·8×60·2 cm,
36⅛×23¾in.
Museum
Boymans-van
Beuningen,
Rotterdam

125 Overleaf
*The Enigma of Hitler*, c.1939.
Oil on canvas;
51·2×79·3 cm,
20⅛×31¼in.
Museo
Nacional
Centro de
Arte Reina
Sofía, Madrid

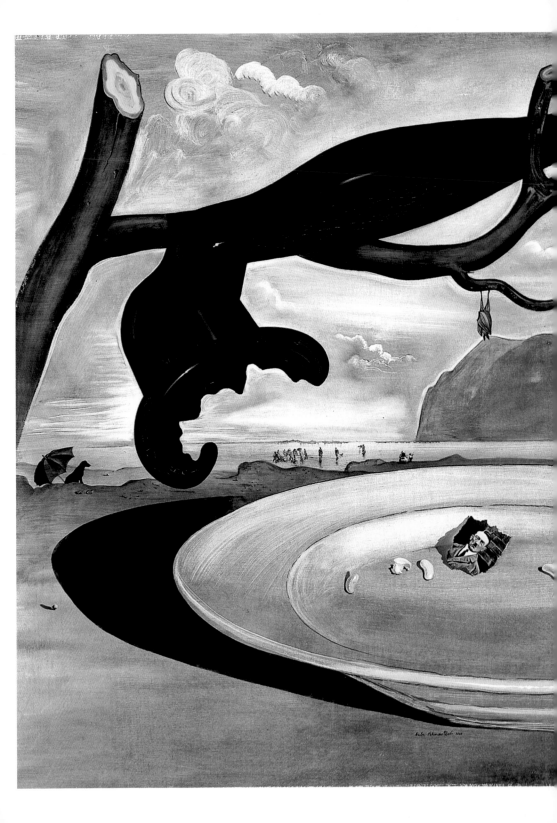

former obsessional attraction: now it is simply part of the bleak over-
cast environment of the days leading to the final outbreak of war.
When war was finally declared, Dalí and Gala moved down to
Arcachon in the southwest of France, as part of a small colony of
exiles which included Leonor Fini and Duchamp. It was a productive
period for Dalí, and he was also able to enjoy the gastronomic plea-
sures of the region. But by the middle of 1940 Paris had been occu-
pied by German troops, and safety could no longer be assured in
France, nor indeed anywhere else in Europe. Dalí had always been well
received in the United States – his latest exhibition in New York had
sold well – so, after making a hurried journey to Figueres for a recon-
ciliation with his family, and then to Madrid for a visa, he now
prepared to embark on the next great phase in his life – the love
affair with America.

Dalí's first acquaintance with America had been, appropriately
enough, a journey of the imagination, conducted via the alluring
images of its prosperity and modernity. Many of these he came across
in such illustrated magazines as *Town and Country*, which he read
while weekending with Caresse Crosby, proprietor of the Black Sun
Press, at her country home outside Paris. His affair with America was
to be long lasting, with increasingly frequent visits during the 1930s
and a more permanent residence of some ten years, enforced by the
outbreak of the Second World War; yet it was always to be the *idea*
of America, its fantasies, its excesses, its innocence – and, above all,
its money – which lay at the heart of his attraction, rather than its
particular landscapes or urban environments, the reality of its

126
Berenice
Abbot,
*Wall Street,*
1930s

economic and racial conflicts or even an appreciation of the pioneer-
ing energies of its artists and writers. To European eyes, especially to
the eyes of a suspicious intelligentsia, America also represented the
newly emerging power of the mass media, embodied in its tabloid
newspapers, its illustrated magazines and, of course, in the exciting
'jazz' rhythms of its popular music and the seductive glamour of
Hollywood films. Responses to this new cultural force, significant for
its capacity to sail over language and cultural frontiers, were conflict-
ing. To writers and critics committed to revolutionary change in
accordance with Marxist theory, this new global mass culture was
essentially a tool of the capitalist system to gain colonial dominance
by subtler means and, furthermore, to lull the latent sense of discon-
tent among the masses through seductive and mentally soporific
entertainment. On the other hand, it was impossible to deny the
vitality and youthful challenge to the conservatism of Europe's offi-
cial, 'bourgeois', cultural forms and institutions, or to ignore the
authentic voice of popular expression which appeared to emerge
through America's new cultural exports. The Marxists' solutions,
Proletarian art or Romantic Realism, seemed pretty unenticing in

comparison. Dalí was in no doubt where his sympathies lay; writing about Hollywood for *Harper's Bazaar*, he saw the aims of Surrealism and the American film industry as practically identical in the way that they answered the public's hunger for the life of the imagination:

Reduced to idiocy by the material progress of a mechanical civilization, the public and the masses demand urgently the illogical and tumultuous images of their own desires and their own dreams. It is for this reason that today the crowds press hungrily around Surrealism's rescue table ... thus do we try to keep them from sinking forever into that thick leaden sea which is the every-day which is the vulgarity and stupidity of the so-called 'realist world.'

When Breton had called Dalí to trial in 1934, the two fundamentally opposed positions that each of them represented were clearly exposed. Later, when Breton came to New York during the war, he pointedly refused to learn English and attempted to protect the sacred flame of Surrealism there as an esoteric and élite truth, whereas Dalí wholeheartedly accepted the methods of America's mass culture. He swam in the waters of publicity which irrigate the system, without reservation and with immediate mastery of the strokes. He provided the press with a new 'typology', that of the 'crazy', unpredictable, rule-breaking artist. It was a convenient variant of the existing stereotype of the artist – foreign, bohemian, intellectual – to which was added the fashionable glamour of the latest modern art movement, Surrealism, with all its potential for populist mockery; above all, he gave them an appealing and unforgettable, photogenic image.

So it was that in 1934 Dalí and Gala sailed on a third-class passage to New York for the first time, with financial assistance from Picasso. They were taking paintings over for his second solo show at the Julien Levy Gallery. His anxiety over potential disaster meant that he spent most of the time in his cork life-jacket and, on disembarking, attached himself to his paintings by lengths of string. On arrival, he encountered, also for the first time, the ranks of the society page news reporters, who gleefully, and obligingly, wrote about the portrait of Gala with the lamb cutlets on her shoulder (but who, curiously

enough, ignored the gigantic French loaf which he had had baked on the voyage and brought along to the press conference). He soon learned the benefits of entertainment and ambiguity to be derived from his spoken version of English, delivered, as he admitted, in an exaggerated Catalan accent. The flavour of this can be gauged from the euphonically spelt version of the press statement he delivered on arrival:

aye av ei horror uv joks
Surrealism is not ei jok
Surrealism is ai strange poizun
Surrealism is zi most vaiolent and daingeros toxin for dsi
imagineichon zad has so far bin invented in dsi domein ouve art
Surrealism is irresisteible and terifai-ingli conteichios
Bieur! Ai bring ou Surrealism
Aulredi meni pipoul in Nui York jave bin infectid bai zi laifquiving and
marvelos sors of Surrealism

This is not to say that some fame, as an authentic modern artist, had not gone before him. His picture *The Persistence of Memory* (93) had been exhibited at the first Surrealist exhibition in the United States, at the Wadsworth Atheneum, Hartford, Connecticut, in 1931, then by Julien Levy in New York, and the image of the famous soft watches had been widely diffused – and caricatured – to the point where it had acquired a cult status by the time it was bought by the Museum of Modern Art in New York. It was there that Dalí gave a lecture in which he reportedly said that the public could rest content with their difficulty in understanding the work since the artist himself did not know what it meant either.

The fashionably scandalous aspect of Dalí's future relations with American 'society' was anticipated in the costume ball arranged just before he and Gala returned to Paris. Guests were requested to come dressed as their dreams, and Gala's costume, which included a baby doll worn as a headpiece, apparently mutilated and covered in leaves and flies, caused unintentional notoriety when it was taken to refer to the case of the aviator Charles Lindbergh, whose child had been kidnapped. The party was reported as far afield as the Soviet Union,

presumably as an example of class decadence in America. It should not be forgotten that the Great Depression was at its height at this time and the poverty and unemployment of the 'other America' was wilfully excluded from Dalí's imaginary version of the country.

The Julien Levy Gallery specialized in Surrealism and, indeed, was almost unique in offering contemporary modern art to the New York public during the 1930s. Publicity had to play an important part to counter the widespread lack of understanding and informed critical debate. The taste of American collectors (aside from a few notable and more adventurous exceptions such as the Steins, John Quinn and Walter Arensberg), schooled as they had been by such art historians and critics as Bernard Berenson and Roger Fry, still centred on either the Renaissance or Impressionism. It was, then, a highly effective coup to get Man Ray's photograph of Dalí (127) on the cover of *Time* magazine to coincide with the 1936 show at Julien Levy and the Museum of Modern Art's 'Fantastic Art, Dada and Surrealism'. Such personal prominence did not amuse Breton, of course, who arrived for the exhibition only to discover that Dalí had effectively usurped his leadership of the movement as far as the public in the United States was concerned. It was on this visit that Dalí went to Hollywood to meet the Marx Brothers and plans were laid for a collaborative film project. He was particularly attracted to the persona of Harpo Marx, whom he intriguingly described as possessing 'the troubling perfume of Watteau', and painted his portrait as *The Laughing Cavalier*, as well as seated at a Dalí-inspired harp, equipped with barbed wire strings and ornamented with spoons.

**127**
Dalí photographed by Man Ray for the cover of *Time* magazine, 1936

The pivotal work shown at his third Julien Levy exhibition, in 1939, was *The Endless Enigma*, which elevated the technique of multiple images to its ultimate level of virtuosity (128). To assist the viewer in deciphering these, the catalogue (129) contained a set of six super-imposed cellophane sheets on which the outlines of a boat, a reclining figure, a head and shoulders, a dog, a still life and a horse were revealed in turn, each perception excluding all the others. Breton, now in open opposition to Dalí, aggressively dismissed such work as having degenerated into a kind of crossword puzzle. He then went on

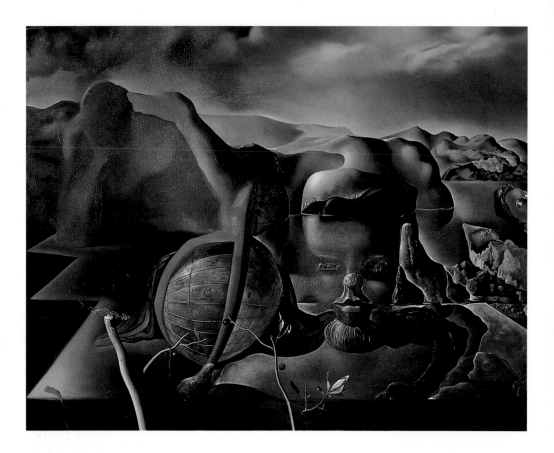

to charge him with having made racist statements worthy of the Italian Fascists. This accusation is probably quite undeserved and whatever Dalí had said was presumably intended deliberately to provoke and annoy Breton. Shortly after, Dalí wrote proudly of his family descent from Arabic origins, and futhermore, in *Poetry of America – The Cosmic Athletes* (130), he appeared to be making a pictorial statement which highlighted the exploitation of African peoples in the United States with its weeping map of Africa. The painting marks the first appearance in art of the Coca-Cola bottle as a symbol of American commercial culture, though in this case its contents empty out to form a pool of black blood.

It was also on this 1939 visit that two events occurred which were to pay maximum dividends in terms of press publicity: they both involved making inroads into more popular, or at least more commercial, art activity. Dalí had been commissioned to design a window display for

**128 Above**
*The Endless Enigma,*
1938.
Oil on canvas;
114·3 × 144 cm,
45 × 56¾ in.
Museo Nacional Centro de Arte Reina Sofía, Madrid

**129 Right**
Catalogue for the third exhibition of Dalí's work at the Julien Levy Gallery, New York, 1939

the Bonwit Teller department store in New York, and he took the theme of 'Day' and 'Night'. The centrepiece of 'Day' consisted of a water-filled bath tub, lined with Persian lamb, from which three wax arms arose, holding mirrors, and the 'Night' scene contained a recumbent mannequin, lying on a bed of glowing coals under the gaze of a hunting trophy, described by Dalí as 'the decapitated head and savage hoofs of a giant somnambulist buffalo'. Upon his return to view the piece next morning, he was outraged to discover that the whole display had been toned down, and now featured conventionally dressed figures. He set about demonstrating his anger by entering the display and attempting to overturn the bath tub, at which point it

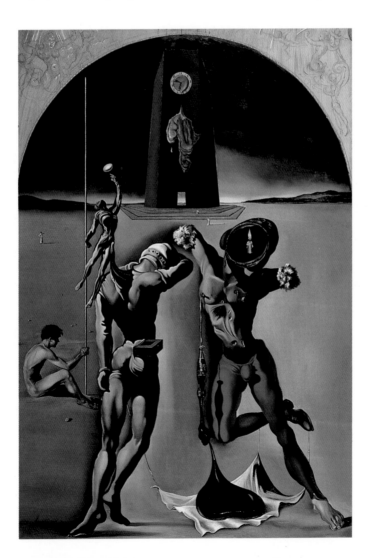

**130 Left**
*Poetry of America -The Cosmic Athletes,* 1943. Oil on canvas; 116·8 × 78·7 cm, 46 × 31 in. Fundació Gala-Salvador Dalí, Figueres

**131 Right**
*Dream of Venus,* pavilion at the New York World's Fair, 1939–40

slipped from his grasp and careered through the plate glass window onto the sidewalk with Dalí sliding along behind it. He was duly taken to court and charged with malicious damage, but received a suspended sentence, the magistrate acknowledging the excitability of the artistic temperament. When he was later asked if he had in fact planned the 'accident', he vigorously denied it, pointing out his lucky escape from the guillotine sharp edges of the shattered glass.

When Dalí took on the design of a pavilion at the New York World's Fair, he probably did so with the genuine intention of bringing a Surreal experience before a wide, popular audience to produce what might today be called a piece of temporary public art, but the

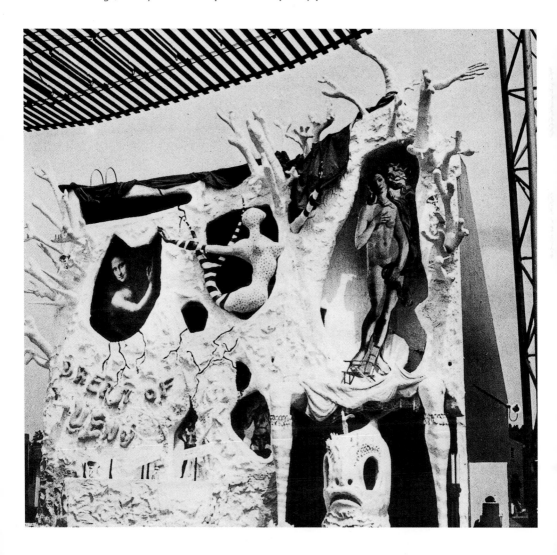

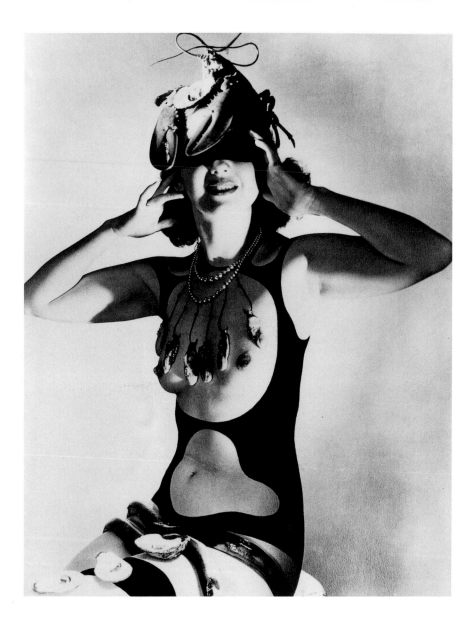

outcome of his encounter with the authentic Coney Island entertainment industry was to prove an unhappy compromise. His *Dream of Venus* (131) was installed in the amusement area of the fair, announced by an impressive façade containing reproductions of Leonardo's suggestively gesticulating *St John the Baptist* and Sandro Botticelli's *Venus*. Visitors paid at a ticket booth, in the shape of a fish, passed between a pair of gartered legs which formed the entrance, before encountering an aquatic, Surreal interior consisting of two pools, one of which was inhabited by 'living mermaids, clad in crustacean fins, long gloves and little else' (132, 133). It was these mermaids which were at the heart of Dalí's inevitable dispute with the promoters. Along with many other aspects of his initial design, he was to be thwarted in his idea of reversing the familiar arrangement of parts of the figure by giving them fishes' heads. This rather bruising – and rare – experience of not getting his own way at least gave him the opportunity to publish a pamphlet, which he distributed by means of an air drop over New York, entitled, in mock grandiosity, *The Declaration of the Independence of the Imagination and the Rights of Man to his own Madness*, in which he makes the valid point: 'the first man who had the idea of terminating a woman's body with the tail of a fish must have been a pretty fair poet; but ... the second man who repeated the idea was nothing but a bureaucrat.' (This noble complaint rather overlooks the fact that the reverse mermaid had already been realized by Magritte in 1935, in a painting called *Collective Invention*.)

During the 1930s Dalí had been free to alternate between the two separate worlds of Europe – an experience itself divided between the intellectual and fashionable sophistication of Paris and the more timeless authenticity of Port Lligat – and America, with all its brash vitality and optimistic sense of purpose. Now, in 1940, with France under enemy occupation, his removal to the United States was enforced by circumstance rather than choice, and during the next nine years he and Gala were required to construct a new and appropriate philosophy of life, adapted to their changed environment. It was a complex and confused New York which greeted them; the American painter, Robert Motherwell described it as 'a strange

132–133
The *Dream of Venus*, 1939
Above
Horst P Horst,
Dora Maar in
one of Dalí's
costumes
Below
George Platt
Lynes,
Dalí and model

mixture of Cole Porter and Stalinism, immigrants and emigrés, establishment and dispossessed, vital and chaotic, innocent and street-wise – in short a metropolis, clouded by the war.'

Motherwell's reference to Stalinism might seem a little surprising until we recognize the peculiar circumstances of the economic depression in the United States in the 1930s and the steps that the Roosevelt administration had taken to counteract the resulting widespread unemployment. A vast and comprehensive system of government-financed work projects was initiated by the Works Progress Administration (WPA), which covered the needs of all trades and occupations. So, for the first time, artists were treated just like any other body of workers, and work was made available for artists in financial need on a series of schemes under the umbrella of the Federal Art Project (FAP). This was aimed especially at the production of murals for public buildings, but it also allowed artists to produce prints and easel pictures, designated for sale to the public. Most of the generation of New York School artists who were to attain prominence after the war had been involved at some stage with these WPA/FAP schemes. Artists were now regarded as comparable to hourly paid industrial workers; their natural response was to become unionized, and the Artists' Union and the more specifically Marxist Artists' Congress thrived as forums for political debate and action. Again, we may need reminding that, in the early and mid-1930s, before the repression and atrocities of the Stalin era were fully revealed, the idea of Communist revolution was as powerful and persuasive a force among both the working classes and intellectuals in America as it was in Europe. The residue of this sentiment still remained during the first months of the war, although with the redirection of industrial production to the war effort, the WPA schemes were being run down. Moreover, it was becoming increasingly difficult to reconcile ideological support for the USSR once the reality of Stalin's treaty with Hitler was fully recognized.

It is revealing to see the rather less than idealistic light in which Peyton Boswell, the editor of the *Art Digest*, a journal widely read by professional artists, viewed the situation soon after the announce-

ment of the war in Europe, when he predicted 'a spectacular rise in appreciation in our native artists' following the cessation of imports of art from Europe. This, he argued, could be the opportunity for American art to finally throw off the yoke of subservience and to recognize that it has now come of age. He saw the main obstacle to the success of native artists, however, as the deplorable and snobbish taste of the leaders of society, and he rhetorically advised his readers: 'Forget social consciousness, get social correctness. It's the cut of your coat, not the beauty of your brush that counts – for America as a nation doesn't give a tinker's cuss about art!' He also reported, in January 1941, that European exiles were out on a buying spree, looking for art as an investment. Presumably this refers to the 'emigrés' whom Motherwell lists as distinct from the humble 'immigrants'.

Dalí was far from alone in his flight, as a sizeable group of established Parisian artists also came to New York during 1940. The contributors to the Artists in Exile show at the Pierre Matisse Gallery in 1942 included the formidable array of Tanguy, Ernst, Marc Chagall, Léger, Piet Mondrian, Breton, Masson and Ozenfant. The name of Dalí is notable for its absence, reflecting the fact that he chose to isolate himself, not only from any grouping of American artists, but also from his former Paris-based compatriots.

134 Overleaf
*Slave Market with the Disappearing Bust of Voltaire*, 1940. Oil on canvas; 46·5×65·5 cm, 18⅜×25¾ in. Salvador Dali Museum, St Petersburg, Florida

This sudden influx of senior Modernist artists was viewed with mixed feelings even by the relatively small number of American painters who were concerned with avant-garde art, but who up to then had only been acquainted with developments in Europe through reproductions in imported art magazines or the summary exhibitions at the Museum of Modern Art. The generation of Jackson Pollock, Lee Krasner and Willem de Kooning, schooled in the somewhat isolationist approach of the FAP, were sensing that the baton of Modernism was being handed on to them to develop the next major phase of the movement. As for their attitude to Surrealism, they were attracted to Freudian and Jungian theories of psychoanalysis and they accepted the value of automatist methods, but this concept was often broadened out to stand for a generalized notion of 'spontaneity'. In short, with the exception of such figures as Arshile Gorky and William

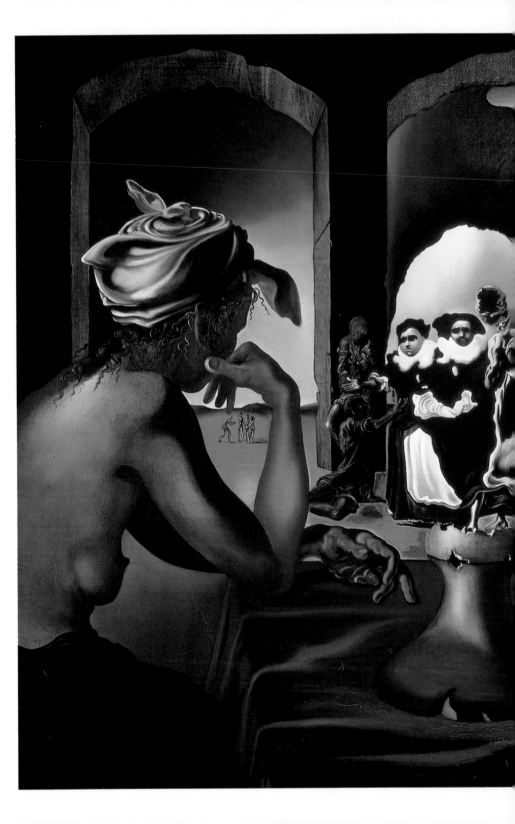

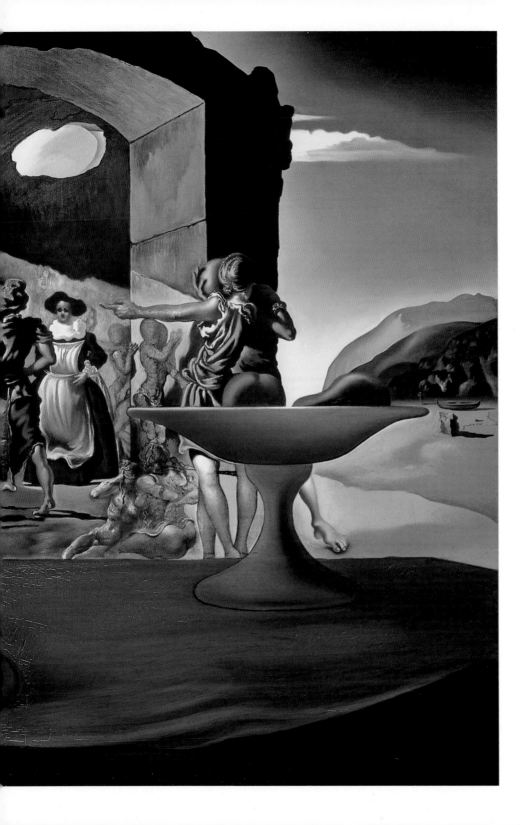

Baziotes, there was a native resistance to the intellectual and literary overtones of the movement. Furthermore, it was only the abstract tendencies of Surrealism which had an appeal to this emerging group: Dalí's illusionistic techniques were dismissed as 'illustration', which was a very insulting word in their vocabulary.

Despite his self-imposed exile from the company and creative stimulation of other artists, Dalí was destined not to be ignored. Just as on other occasions in the past, he protected himself against any potential trauma of displacement by resorting to a kind of megalomaniac delirium. In an essay entitled *New York Salutes Me* he reduces the awesome architectural spectacle of New York to a vision of personal fantasy:

To me New York is only a great, silent plain of yellow alabaster ... What immense solitude! ... in the centre of the plain, rising to a colossal height, are two well-known anguished silhouettes, antique statues, representing the celebrated and tragic couple of Millet's 'Angelus'. The figure of the man is myself. I am represented as blind, with a golden mouth, splashed with excrement, very beautiful, feminine breasts, whip in hand and crowned with roses. The female figure is made flesh by Sacher Masoch, her eyes look into mine with infinite sadness ... New York: why, why did you erect my statue, long ago, long before I was born?

135
Explosions at
Pearl Harbor,
Hawaii,
7 December
1941

Within the first year of his arrival, Dalí had arranged a further show at the Julien Levy Gallery and in 1941 the Museum of Modern Art gave him his first major retrospective exhibition, which was shared with Miró. It was clear that he was still producing impressive Surrealist pictures of great variety and invention. *Slave Market with the Disappearing Bust of Voltaire* (134), painted in 1940, makes more purposeful use of the multiple image technique than we encounter in *The Endless Enigma* (128), for there is an allegorical intent behind the confrontation between Gala and Voltaire. Her passionate life-force outstares the cynicism of the agnostic philosopher, who, appropriately, disappears when we concentrate on the newly revealed image of the women in seventeenth-century Spanish Catholic costume. Gala will also protect him from exposure to the 'slave market' of material reality to which the masses are condemned.

*The Face of War* (136) has the graphic directness of a poster and would have reflected widely held feelings in the country, especially following the Japanese attack on Pearl Harbor in December 1941 (135), which, after a period of caution and reserve, finally precipitated the United States into a full declaration of war and a commitment to fight on both the European and the Far Eastern fronts.

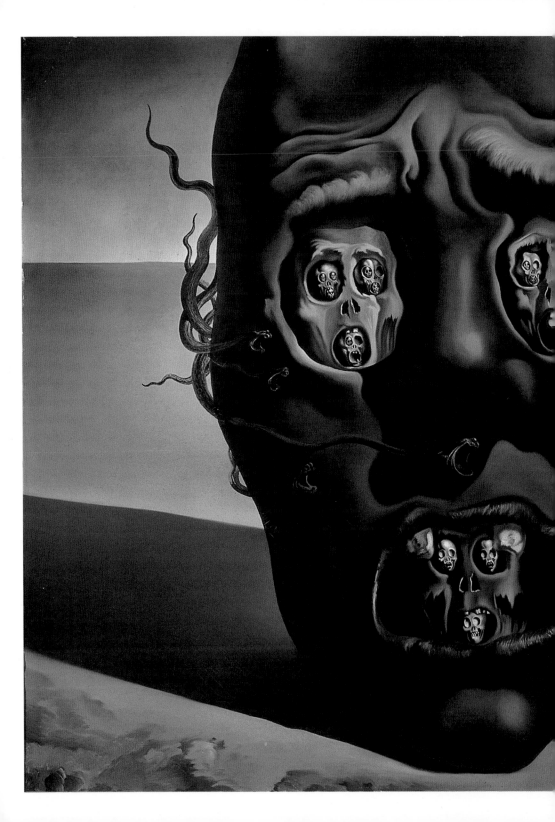

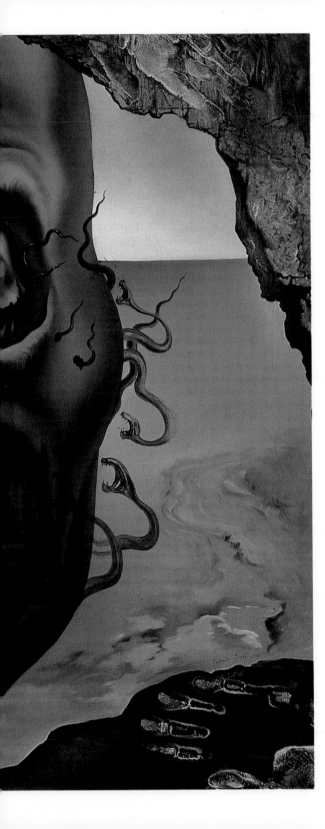

**136**
*The Face of War*, 1940-1.
Oil on canvas;
64 × 79 cm,
25½ × 31⅛ in.
Museum
Boymans-van
Beuningen,
Rotterdam

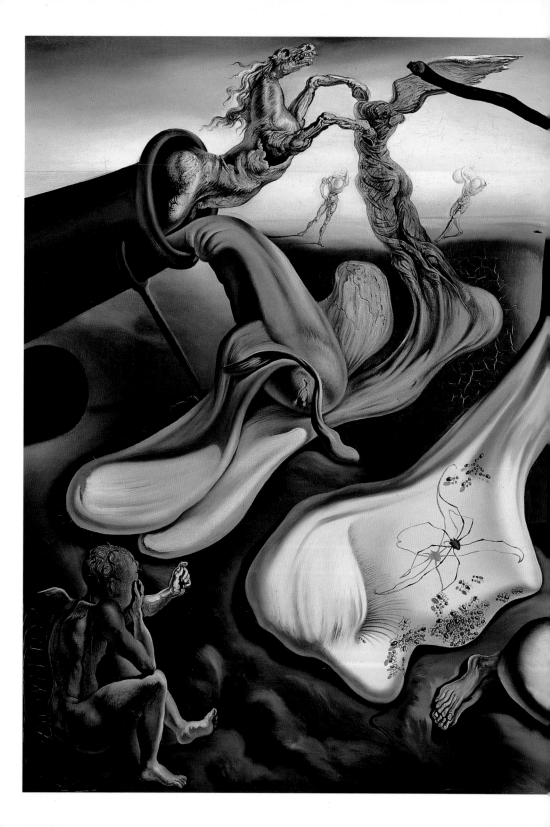

**137**
*Daddy
Longlegs of
the Evening...
Hope!* 1940.
Oil on canvas;
64 × 79 cm,
25 ½ × 31 ⅛ in.
Salvador Dalí
Museum,
St Petersburg,
Florida

The atmosphere of war anxiety seems to infuse another painting from 1940, *Daddy Longlegs of the Evening ... Hope!* (137); the English title a rather inadequate rendering of the French proverb, 'Araignée du soir ... Espoir!' Stylistically the work represents a transitional phase: the lugubriously soft forms and some typical motifs are retained from his Surrealism of the 1930s, but also present are elements of the defined drawing and classical motifs more obviously associated with Italian Renaissance art. Dalí had already announced his intention 'to become classic' in a pamphlet, *The Last Scandal of Salvador Dalí*, brought out to coincide with the Julien Levy show, for which he used his middle names, Felipe Jacinto, as a pseudonym. He is not yet ready, he says, to renounce the idea of Surrealism and is still dedicated to 'the conquest of the irrational', which he intends to pursue by researching into the 'Divina Proportione', or system of mathematically based harmonic proportions, in the tradition of Raphael, Bramante and the architect of the Escorial, near Madrid, Juan de Herrera. There is no inconsistency here in Dalí's position, since his repudiation of Romanticism's subjectivity and his embrace of classicism's objectivity follow on directly from his theoretical statements in the late 1920s.

*Daddy Longlegs of the Evening ... Hope!* is also of interest in demonstrating the fluidity of 'meaning' in a successful Surrealist work. The meaning of such a painting should not be seen as some fixed, essential entity, breathed into it by the artist at the time of its inception, but as something which is infinitely variable, arising from the engagement with the work by a certain viewer at a certain moment. To Reynolds Morse, who bought the painting (indeed, for whom this was the first step on a life-long adventure as Dalí's principal collector), the associated images of the leaping horse, the statue of victory and the daddy longlegs were symbolic forewarnings of the victorious outcome of the war by means of air power. Dalí himself, however, writing twenty-five years later, interprets the painting in terms of his familiar theme of erotic shame, pointing out 'The child with angelic wings ... hiding his eyes so as not to see a sexual cannon [from which emerges] a putrescent horse and a gigantic, runny foot that connects with a long, limp breast also oozing out of the cannon like sperm'.

138
Gala and Dalí with Caresse Crosby, at Hampton Manor, from 'Life calls on Salvador Dalí', *Life* magazine, 7 April 1941. The *Life* caption explained: 'On the floor sprawls a purebred Hereford bull which Dalí invited in for after-dinner coffee.'

Dalí and Gala spent most of their first year in the United States as
guests of the obliging Caresse Crosby at the isolated and historic
Hampton Manor, a country house designed by Thomas Jefferson near
the village of Bowling Green in Virginia. They were not alone as exiles
from France – fellow guests included Anaïs Nin and Henry Miller, who
was at work on *The Colossus of Maroussi* – although they made every
effort to ensure the household revolved around them. This evocative
setting encouraged Dalí's taste for what today would be called

installation and environmental art, to which Caresse Crosby seemed
ever ready to accede. The drawing room grand piano was variously
elevated by a crane into the branches of a tree and allowed to bathe
its feet in the estate pond. The publicity value of such events was not
scorned; a filmed interview was made by Pathé News, and *Life* maga-
zine ran a picture story, with photographs of a Hereford bull sprawl-
ing on the fireside carpet (138), reliving a scene from *L'Age d'or* (64).
A pose of domestic normality bore the enigmatic but somehow
revealing caption, 'He always takes three sugars in his coffee. His wife
always wins at chess.' For another photograph he arranged a formal
tableau of the household's black servants, the piano and two black
pigs to be set outside the portico of the house for a study in contrast
against the white snow. The same amount of effort also went into the
preparation of a purely private, practical jokes. The Sicilian Duke,

Fulco de Verdura, was invited down to stay in order to discuss the production of some jewellery to be made to Dalí's designs, but was directed not to the venerable and well-provided manor house, but to another house nearby which had long laid in ruinous state and which Dalí had converted into a Gothic Horror set, with every artifice of creaking door and guttering candle.

The press were well aware that Dalí was a skilful manipulator of publicity, yet were happy to comply since he always provided entertaining copy. Gala and Dalí performed an elaborate double act for another photo-story under the title 'Dalí's Daffy Day' for the high-circulation *American Weekly*, for which he had previously provided drawings (139). He was interviewed in bed at the St Regis Hotel with a 'selective mask' (a waste-paper bin) on his head to allow him to savour his waking dreams; he arranged his fried egg and ketchup breakfast in suitably pictorial form, inscribed a Medusa face on Gala's forehead and seated himself to paint astride a high stool, supported on the backs of four turtles. The report concludes:

And so life goes on in a Surrealist household and so the money pours in and existence continues to be far more pleasant in a smart hotel apartment than a left-bank attic. War has not interrupted the flow of shekels into the Dalí coffers. His Surrealist portraits are selling like hot cakes.

The instinctive marketing skills that Dalí developed in America, ensuring that a good story was available to the press in time for a forthcoming exhibition, served an important purpose, since his Surrealist paintings were not selling particularly well; the client base for such art in war-time New York was not that big, causing Julien Levy to close his gallery in 1944. So alternative sources of income were needed to support the lifestyle the couple demanded, and one financially rewarding area of work which he turned to was portrait painting. It is often forgotten that he had painted portraits throughout his life – even during the classic Surrealist period, as Paul Éluard's 1929 portrait testifies – and, of course, portraits of Gala were a continuous theme; yet the fact that he took commissions to paint portraits of contemporary, wealthy socialites was used by his critics as clear evidence of his lack of seriousness as a Modernist artist. The implicit

rules of Modernism simply outlawed this traditional and staple professional activity, because it offended notions of 'experimentation' and 'authenticity'. Needless to say, Dalí, who was taking his cue now from Raphael rather than Picasso, was undeterred by such criticism and was content to collect a fee of around $5,000, at this stage, for his trouble. (To put this figure in context, *Art Digest* was reporting in 1939, admittedly with indignation, that Gerald Brockhurst, a now scarcely remembered member of Britain's Royal Academy, was getting $10,000 from American clients.) There is no dispute that these portraits do vary in quality; they are at their best when there is a full pictorial integrity between the represented figure and the Surreal setting that the sitter's personality or presence has stimulated; at their worst when a characterless face appears almost collaged onto a background, decked out with a few 'Surreal' contrivances. A good example of the more successful would be *Lady Louis Mountbatten* (140) of 1940, where the subject emerges, full of menace, like some saturnine spirit of nature from a mysterious world.

140
*Portrait of Lady Louis Mountbatten,* 1940.
Oil on canvas; 65×54 cm, 25⅝×21¼ in.
Private collection

It could be argued that the most effective outlet for Dalí's imaginative energies in the 1940s was his writing. Much of the time he spent at Hampton Manor was devoted to writing his 400-page autobiography, *The Secret Life of Salvador Dalí,* which he claims to have produced in a paroxysm of work, at a rate of thirty-five pages a day. Sections of the manuscript were actually exhibited and the almost impenetrable forest of sentences, annotations and shorthand drawings demonstrate how much credit must also go to his translator, Haakon Chevalier. It was published by the Dial Press (chosen, no doubt, for the anagrammatical virtue of its name), and proved highly successful, soon running to a number of editions. Among its many illustrations, the *Soft Self-portrait with Fried Bacon* (141) appeared as the frontispiece, and he produced a number of inventive improvisations based on the line drawings of objects from nineteenth-century children's books (142). The strategies adopted and the content of a number of the episodes have already been examined (see Chapter 1), but it is worth repeating that Dalí reveals himself as a fluent, if rhetorically overflowing, writer of considerable literary quality, despite the fact that he had never previously written any text which

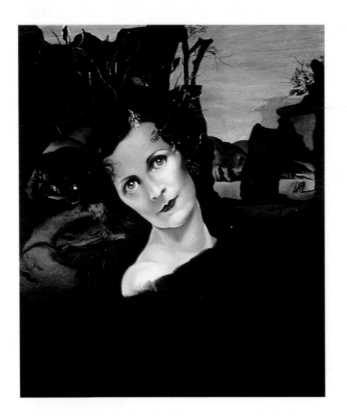

remotely approached this scale. There has been a recent growing academic interest in Dalí's writing and, as an example of this, David Vilaseca has asserted that his autobiographical texts are: 'One of the contemporary bodies of writing in which identity and the status of the post-modern subject (author) are addressed and interrogated in the most challenging, complex, original and ... generous manner.'

The most instructive contemporary response to *The Secret Life* came in a review of the book, headed 'Benefit of Clergy', by the British writer George Orwell. It is instructive because its world view, and specifically its belief in the ethical position that the artist should hold in relation to society, are diametrically opposed to those held by Dalí. Orwell's professed purpose as a writer was: 'The desire to see things as they are: to find out true facts and store them up for the use of posterity', an objective he admirably fulfilled in *Homage to Catalonia*, where he unflinchingly exposed the intrigues of the Stalinist factions against the Trotskyites and Anarchists, when they were supposed to

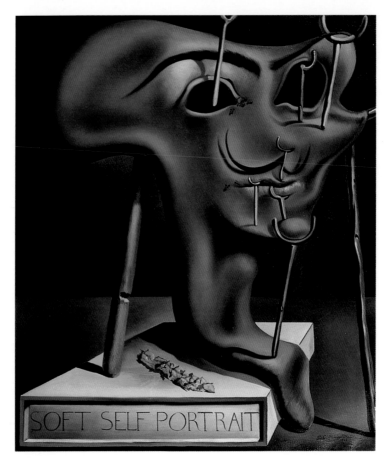

SOFT SELF PORTRAIT

**141**
*Soft Self-
portrait with
Fried Bacon*,
1941.
Oil on canvas;
61·3 × 50·8 cm,
24¹⁄₈ × 20 in.
Fundació
Gala-Salvador
Dalí, Figueres

be fighting in alliance against Franco's forces in the Spanish Civil
War. To Orwell, who had volunteered to fight for the Republicans,
Dalí – a man who had failed to take sides in the civil war going on in
his own country and who had 'scuttled like an ant' out of France as
soon as it was in danger – was 'a good draughtsman and a disgusting
human being'. Of the book itself, he declares unequivocally, 'It is a
book that stinks. If it were possible for a book to give a physical stink
off its pages, this one would'. As a Marxist, he looks beyond the fault
of the individual in order to identify its social significance, pointing
out that there is something fearfully wrong with a society which
allows success to an individual who is determinedly anti-social,
pornographic and unrepentently immoral. That such a book should be
written, and such a man should achieve success, in a time of war was,
in brief, a clear sign of capitalist decadence.

143. Cette poule n'a pas de queue.    144. Cet arbre n'a pas de fouilles.

145. Une plume.    146. Une montre.

147. Une clef.    148. Un encrier.

147 Une clef

**142**
Illustrations
from *The
Secret Life of
Salvador Dalí,*
1942

In 1944 Dalí published his one novel, *Hidden Faces*. It deals with the period of time leading up to, during and anticipating the end of the Second World War; Dalí's motive for taking up this theme may be explained as a means of evading the horror of the war's carnage and any personal guilt that he might have felt, by mythologizing the historical reality of his own day. Always the stylist as a writer, Dalí adopted the genre of *fin-de-siècle* 'decadence', revelling in the flamboyantly detailed description of over-wrought sensibility among the circle of aristocratic characters, based on his observations of the last survivors of the breed, whose company he had fostered in Paris. The presiding tone is one of lassitude and melancholic weariness, 'an insurmountable indolence in the face of everything', which symbolizes the spent energy of a degenerate European aristocracy – not that the characters from the New World, such as the wealthy American widow taking vitamins with her martinis and ostentatiously trailing between the Ritz and Schiaparelli's and back again, are portrayed any more attractively. Dalí makes the most of the opportunity to explore his fetishistic attraction to the aesthetics of dress and the erotics of food. One character wears 'a Chanel dress with a very low neck, edged with roses, cut out of three thicknesses of black and beige lace between which were hidden rather large, pearl caterpillars'. The novel contains the ultimate statement of Dalí's sexual taste in the shape of the character Solange de Cléda, from whom he wished to derive the term 'Clédalism' to express the synthesis of sadism and masochism, a pure emotion of pleasure and pain, induced by a lifetime of eroticized celibacy. She is attending a banquet given by her admirer, the gourmand Grandsailles:

Her skin [of her breasts exposed by her décolletage] was so fine and white that Grandsailles, looking at her, cautiously dipped his dessert spoon into the smooth surface of his cream cheese, taking only a small piece to taste it, snapping it adroitly with the agile tip of his tongue. The slightly salt and tart taste, evoking the animal femininity of the she-goat, went straight to his heart.

Dalí also took the opportunity to explore his fascination with Hitler, which had caused him so much trouble with the Surrealists. In *Hidden*

143
*Geopolitical Child Watching the Birth of the New Man*, 1943.
Oil on canvas;
44·5 × 50 cm,
17½ × 19¾ in.
Salvador Dalí Museum, St Petersburg, Florida

*Faces*, the Führer reveals his motives as those of a perverse masochist, who pursues his megalomaniac fantasies to their extreme point to ensure his own voluptuous and Wagnerian demise, immured and alone in his Eagle's Nest, obsessed by personal hygiene and surrounded by his pirated collection of Old Masters.

A rare note of idealism seems to be struck by a painting made in 1943, at the worst stage of the war, *Geopolitical Child Watching the Birth of the New Man* (143). The symbolism of a new world order emerging as hard-won prize from the global conflict is readily accessible. However, the sickly yellow light, the emaciated standing figure and the unsettling shape of the overhanging form of the parachute render Dalí's prognosis rather ambivalent. (At around the same time he got the photographer Philippe Halsman to conjure up an image of

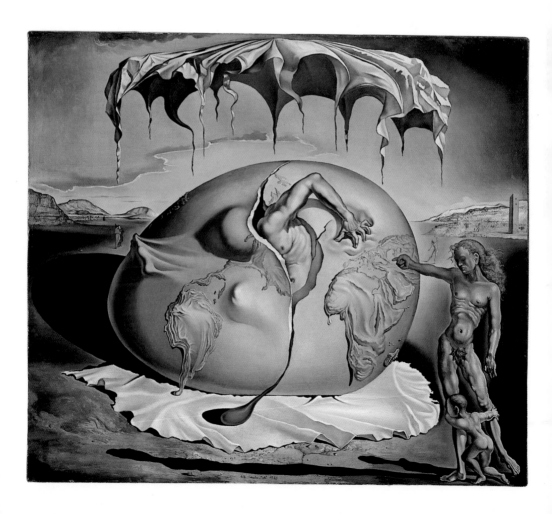

himself contained within an egg, in foetal position.) The painting *Basket of Bread* (144), done in 1945, demonstrates how historical events can impose their own frame of reference on a work, which might be totally removed from the artist's original intentions. The significance for Dalí was to remake his 1926 version of the same subject (43) in the light of what he was now calling his 'classic' manner. He claimed to have devoted four hours a day for over two months to paint this small panel of $33 \times 38$ cm (some $13 \times 15$ in), and he hinted at the complex mathematical decisions underlying its composition. Its completion happened to coincide with the announcement of the end of the war, and the image was later taken up by the propaganda programme for the Marshall Plan, by means of which the United States directed a policy of economic aid for the reconstruction of Europe. The magazine *This Week* used it as a cover picture, with the caption explaining that it was 'the best expression of what the world is thinking in 1947'.

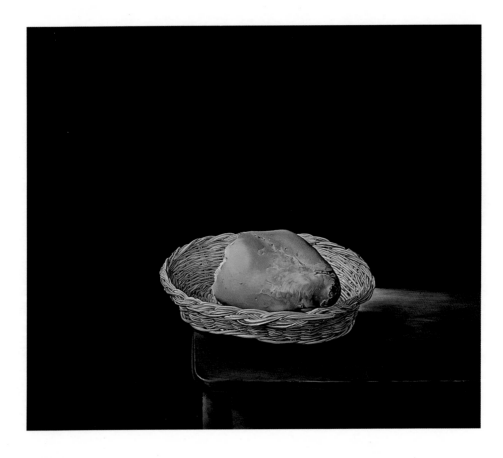

The 1940s were the most prolific decade for Dalí as a designer for the stage; he particularly favoured the media of ballet and opera because of the creative opportunities for rhetorical excess that they offered – freed from leaden demands of realism and logic. The fact that both these high art forms were still largely resistant to Modernist innovation, and attracted a predictably conservative audience of public and critics, would also have appealed to his taste for confrontation and outrage. Perhaps the most successful enterprise was the ballet *Labyrinth* (1941), for which he produced both libretto and set and costume designs for the Marquis de Cuevas. Massine was the choreographer and the music was Schubert's Seventh Symphony. The stunning backcloth is now prominently displayed at Dalí's Theatre-Museum in Figueres (187) and a witty solution was found for the costume of a cock, which was worn backwards, allowing the dancer to simulate the the bird's leg shape and to activate the wings convincingly. Dalí was able to return to one of his favourite myths, Tristan and Isolde, with the more classicist design for *The Mad Tristan* in 1944 (145), again for De Cuevas. The performances were curtailed, however, when the draft board decided that most of the young men in the company were patently fit enough to serve in the war!

**144 Left**
*Basket of Bread*, 1945. Oil on panel; 33 × 38 cm, 13 × 15 in. Fundació Gala-Salvador Dalí, Figueres

**145 Right**
Design for *Mad Tristan*, 1944. Watercolour on paper; 63·8 × 50·7 cm, 25⅛ × 20 in. Private collection

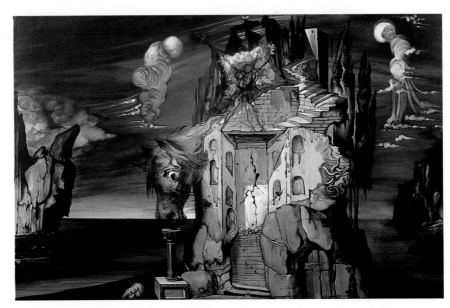

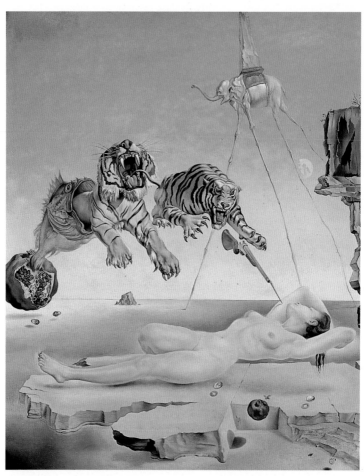

**146 Left**
*Dream Caused by the Flight of a Bee around a Pomegranate, One Second before Awakening*, 1944.
Oil on canvas;
51×40·5 cm,
20×16 in.
Fundación Colección Thyssen-Bornemisza, Madrid

**147 Right**
*Design for the Interior Decoration of a Stable-Library*, 1942.
Chromolithograph overpainted in gouache;
51×45 cm,
20×17¾ in.
Fundació Gala-Salvador Dalí, Figueres

While designing for the stage had a long and prestigious history as an appropriate activity for an artist, the same could not be said for designing for advertising, and when Dalí produced a number of such pieces, including a cover for American *Vogue* in 1939, he was roundly ridiculed by critics from the art press. The *Vogue* cover was followed by a number of fashion plates and other ads. It was around 1942 that Breton coined the anagrammatic insult for Dalí of 'Avida Dollars' (eager for dollars), confirming the strength of prejudice pervading high art culture against working for commercial projects that were consumed by a mass public. The complaint of making too much money was rarely raised by the same voices against such financially well-rewarded figures as Henri Matisse or Picasso, so it is clear that the objection arose from the fact that the artist was not producing a

unique art object, designated for a specialist public. Yet Picasso
himself had also produced a design for an advertisement – for the De
Beers' diamond mining syndicate in 1941 – for a fee of $6,700.
(Dalí's fee for an advertisement for the same source was $2,200.)

Though attracting considerable attention, Dalí's direct connections
with commercial projects were rather limited during the 1940s. Yet
Surrealism in general, and Dalí's motifs and pictorial structures in
particular, dramatically influenced advertising design from this
decade onwards, and have remained a constant stimulant for
succeeding generations of graphic designers. Many of Dalí's paintings,
for example *Dream Caused by the Flight of a Bee around a*

*Pomegranate, One Second before Awakening* (146) from 1944, show
a closeness to the imagery of advertising. This is not surprising as
both aim to address themselves directly to the subconscious responses
of the viewer and to elicit the universal desire to live out our
fantasies through a process of sublimation, though in the case of
advertising the anticipated form of this sublimation is through the
consumption of commodities. The relationship with popular and mass
culture was always one of exchange, and Dalí continued to reveal the
same affection for the 'innocent' found image that he had shown in
his study of Millet's *Angelus*. In *Design for the Interior Decoration of
a Stable-Library* of 1942, for example, images of grazing sheep have
been transferred (and only slightly altered) from a nineteenth-
century salon painting to a modern, popular print of a reclining
girl (147).

After their stay at Hampton Manor had come to an end, Dalí and
Gala settled into a pattern of dividing their time between a suite at
the St Regis Hotel in New York and a home in California – which
everyone agreed was perplexingly ordinary and, indeed, bourgeois – a
bungalow attached to the Del Monte Lodge Hotel in Pebble Beach,
Monterey, where Dalí acquired his taste for Western-style fringed
leather jackets and moccasins. The flow of publicity continued (148).
One benefit of this location was that it enabled him to continue his
courtship of Hollywood. This resulted in a collaborative project with
Walt Disney in 1946 for designs to be animated in accompaniment to
a love song, called *Destino*. Despite the length of time that he
devoted to investigating studio procedures and working on the
designs, the film did not go into production. He had rather more
success with his designs for a dream sequence commissioned by Alfred
Hitchcock for the film *Spellbound* (149, 150). Dalí had to create the
sense of a dream experienced by a man (played by Gregory Peck) who
had lost his memory and who stood accused of murder. Hitchcock
wanted Dalí for this, not only for his psychoanalytical understanding
but also because of the hallucinatory sharpness of his imagery, as
distinct from the misty vagueness of the clichéd representation of the
dream in film.

On 6 August 1945 an atom bomb was dropped on the Japanese city
of Hiroshima, causing 240,000 casualties and levelling vast areas of
the city; a further bomb devastated Nagasaki three days later, and on
14 August the Japanese surrendered and the Second World War came
to an end. Dalí's response to the atom bomb was presented in *Three
Sphinxes of Bikini*, painted in 1947. The Bikini atoll was the American
nuclear testing site and the typical mushroom cloud associated with
these explosions is exploited in this painting as a vehicle for illusion-
istic transformation, without any sense of the horrific power such
weaponry could and did unleash. He writes instead of 'the calm,
atomic explosions, recalling idyllic, mossy and mushroomy trees of a

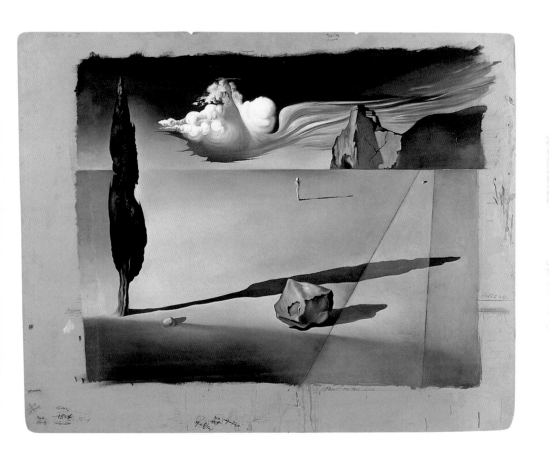

terrestrial paradise after all the hells of the heaven of the war just ended'. This may seem an astonishing response, but such was the general euphoria among the Allied nations that the war had ended that the widespread reaction to the atomic bomb was more a sense of wonder at the new power over natural forces which science was gaining, with its growing understanding of the processes of nuclear fission, rather than the threat that it entailed of global destruction.

Dalí was to be particularly impressed by the idea that the physical world could no longer be conceived of, nor pictorially represented, in terms of fixed, unmoving, weighty objects, but rather in terms of isolated objects held in suspended relation to each other. This insight was to dominate much of his painting in the years to come, commencing with his first studies for *Leda Atomica* (151) in 1947, the compositional structure of which draws on the mathematical demonstrations of Matila Ghyka. (Ghyka explored the geometrical basis of classical aesthetics in his search for a broader idea of harmony in nature; Dalí adopted this Platonic approach to incorporate his understanding of the newly revealed laws of quantum physics.) The vitality of the idea is caught in an exuberant, manipulated photograph by Philippe Halsman, from 1948, an image produced after five hours and twenty-six takes (152).

151
*Leda Atomica*, 1949.
Oil on canvas; 61·1×48 cm, 24×18⅞ in.
Fundació Gala-Salvador Dali, Figueres

The arrival of peace meant Dalí was able to return to Port Lligat for extended stays (153). One widespread reaction in Europe to the end of hostilities was a turning to religion to provide some means of coming to terms with the accumulation of grief and guilt of the war's survivors, and a number of symbolically prominent schemes for building and rebuilding churches were inaugurated in which Modernist artists such as Matisse, Léger and Graham Sutherland were called on to produce works of public, religious art. Something of the same tendency seems to have affected Dalí during the post-war years when he produced a significant body of work, the subject matter of which is evidently drawn from the Christian tradition. However the extent to which these paintings serve a primarily religious or artistic function is highly ambivalent and it is significant that none of them was actually commissioned by a religious body.

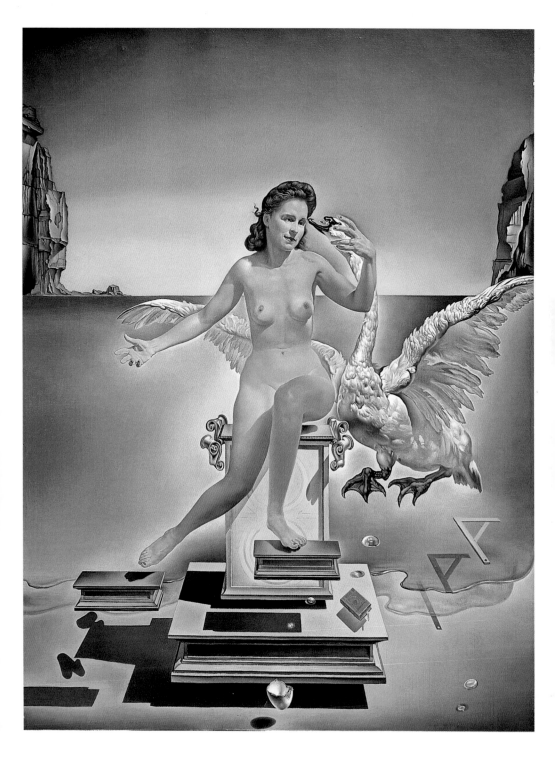

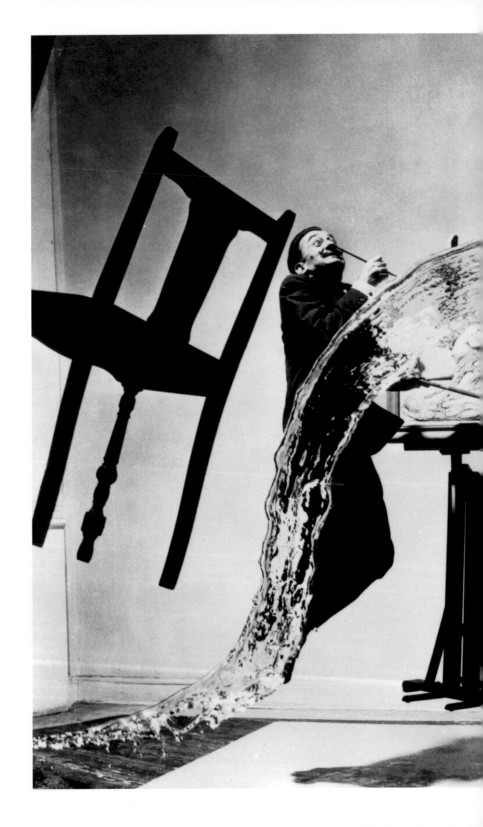

**152
Philippe
Halsman,**
*Dalí
Atomicus,*
1948

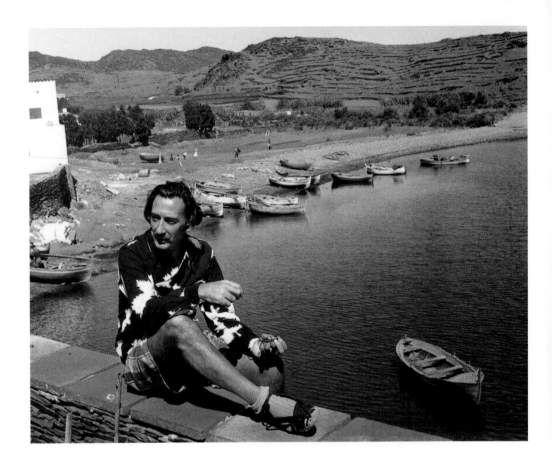

Some of these ambiguities are revealed in the first of these paintings, *The Madonna of Port Lligat* (154). It has the format of a Renaissance altarpiece; and it also redeploys the iconography of suspended egg and shell as symbols of Platonic idealism borrowed from the Milan *Madonna and Child* (c.1473–4) by Piero della Francesca. Yet even though the pervasive feature of 'nuclear' suspension could be read as compatible with the traditional representation of the Assumption of the Virgin, there are many private, Dalínian symbolic inventions present, such as the sea-urchin and the window space cut through the torso of both the 'Madonna' and the 'Child', which are too insistent for it to serve a traditional, liturgical function. Further, the work creates the uneasy suspicion that much of its motivation was the symbolic transferral of divine qualities to a deified figure of Gala.

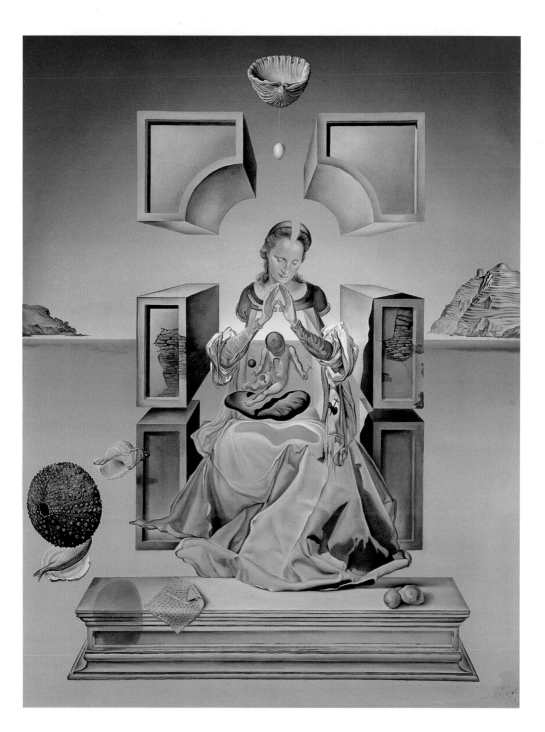

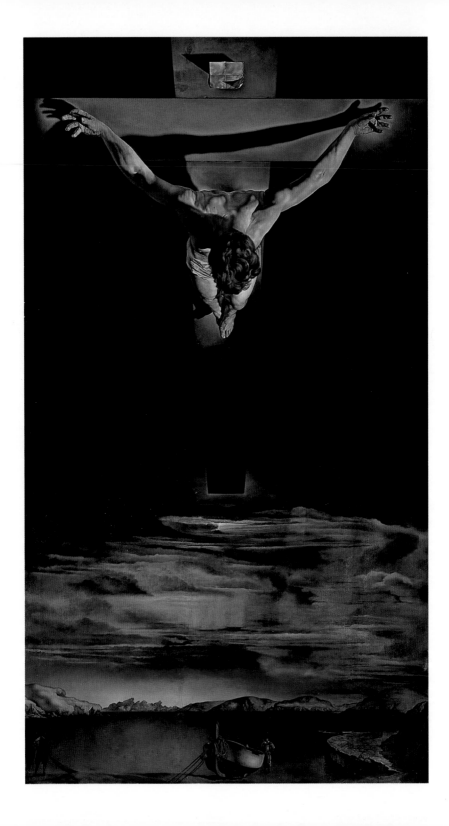

The *Christ of St John of the Cross* (155), painted in 1951, avoids most of these ambiguities. Although it marks significant departures from the conventional representation of the subject, these can be perceived as authentic innovations which do not intrude on the value of its religious meaning. For example, Dalí claimed that he developed the idea of Christ viewed from above with head bowed from an old drawing made as the outcome of a vision by the Carmelite friar John of the Cross (156); but it must also be admitted that this positioning overcomes the vexing problem for modern, realist artists of how to depict the face of Christ in a manner acceptable to the worshipper. He wanted the body of Christ to express an ideal beauty rather than

**155 Left**
*Christ of St John of the Cross*, 1951. Oil on canvas; 204·8 × 115·9 cm, 80⅝ × 45⅝ in. St Mungo Museum of Religious Life and Art, Glasgow

**156 Right**
St John of the Cross (attrib.), *The Crucifixion*, Sixteenth-century drawing; dimensions unknown. Monastero de la Incarnación, Avila

the Expressionist anguish and suffering associated with the Northern Gothic tradition which had largely influenced contemporary, Modernist representations of Christ. (The impressively formed shoulder and arm muscles were modelled by a Hollywood stuntman.) Clearly the challenge of testing his abilities of both design and execution against the achievements of Zurbarán and Velázquez was foremost in Dalí's personal aims, yet he did arrive at a pictorial solution which has proved highly convincing and moving over many years to a wide audience, whether specifically Christian or not. The fact that the painting was attacked and seriously damaged by a gallery visitor in 1961 puts it in the same category of 'sacred' art objects,

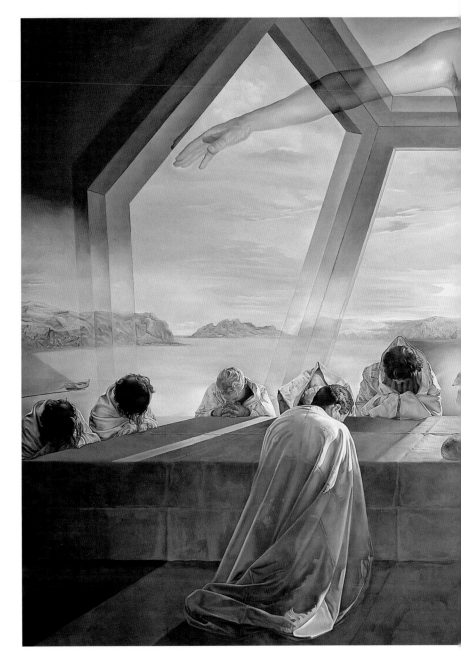

**157**
*The Sacrament
of the Last
Supper*, 1955.
Oil on canvas;
167 × 268 cm,
65³⁄₄ × 105¹⁄₂ in.
National Gallery
of Art,
Washington, DC

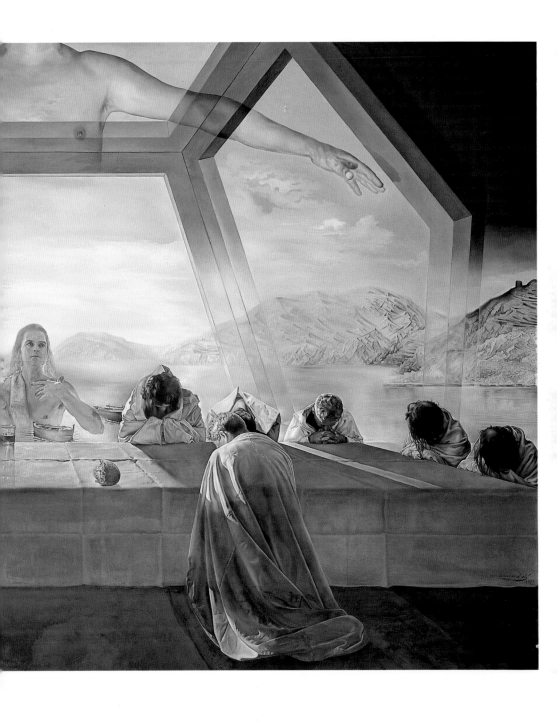

such as Leonardo's *Mona Lisa* and Rembrandt's *The Night-Watch*, which have the power to attract the wrath of the mentally unstable to 'blaspheme' against art. Its present location, in Glasgow's St Mungo Museum of Religious Life and Art, strikes an appropriate balance between its artistic interest and its religious strength.

Dalí was to explore such religious themes further in his painting *The Sacrament of the Last Supper* of 1955 (157), which depicts the moment when Christ says that one of his apostles will betray him. Although lacking the drama of earlier representations of the Last Supper, such as that of Leonardo, Dalí's painting does have an eerie power. Chester Dale, the collector who commissioned the work, was delighted with it and said: 'I consider Picasso a very great painter. I have fifteen of his canvases in my collection, but never will he paint a picture equal to Dalí's Cena [Last Supper], for the very simple reason that he is not capable of doing so.'

In the last four decades of his life, Dalí rose to a new level of success
and recognition on a global scale, with frequent exhibitions of his
work mounted throughout Europe and the United States, as well as in
Japan and even the Soviet Union. Yet paradoxically his painting from
this period is, with a few major exceptions, the least known and least
appreciated of his life's work. He seemed at times to be simply bored
with the actual project of painting, certainly to be in opposition to
the prevailing trends in Modernist art, and was undoubtedly prepared
to put his name to work of questionable quality which he dismissively
dashed off for the market. Yet on other occasions he dedicated much
time and concentration on highly ambitious pictures, on a monumen-
tal and public scale, which were seriously intended to rival the
'museum' artists of the past, as well as pursuing a range of experi-
mental projects which were derived from personal and often esoteric
fields of research.

158
Gala and Dalí
in fur coats,
1980

What lay behind the uneven quality of the work of this period was
the unresolved struggle between the two sides of his artistic and
personal identity: the mystic and the dandy (158), the magician and
the celebrity, those aspects of his art which were hermetic and hidden
and those which were immediately apparent and accessible. In its
purest form, the mystical impulse revealed itself in his attraction to
the Christian revelatory tradition of St John of the Cross or St Teresa
of Avila; but its attraction for Dalí lay precisely in the aspect of its
ecstasy – its transcendence beyond the ordinary and the rational
experience of the mind – rather than its aspect as a guide to any
conventional submission to the authority of the Catholic faith.
Despite his audience with Pope Pius XII in 1955 and his series of
quasi-religious paintings, his interest in the Church was centred
largely on his fascination with its hierarchical power and authority
and the display and ritual of its liturgy. Certainly the Church's teach-
ings on modesty and moral discipline never intruded into either his

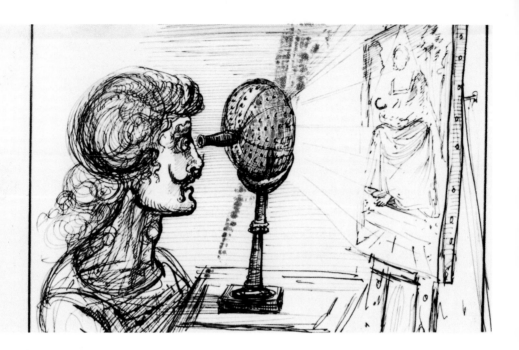

personal or public life, and he once mischievously referred to his occasional church attendance at Port Lligat as necessary to set a good example to the locals.

The playful side of his 'mysticism' reveals itself in his book *Fifty Secrets of Magic Craftsmanship,* which is a pastiche of a Renaissance artist's manual in the manner of Cennino Cennini, and is engagingly illustrated with mock diagrams (159). At the time when avant-garde artists – the Abstract Expressionists in America and the Tachistes in France – were deliberately rejecting the values of skilful technique and fine materials in favour of directness of gesture and the admission of chance, Dalí's appeal for a return to Renaissance values and methods could perhaps only be made in this half-humorous manner. Certainly it displays a genuine celebration of oil paint and its materiality: oil is 'the honey of light itself' which allows one to paint 'the mystery of the flesh', and there is a constant sense of how close the precise methods and the knowledgeable selection of precious materials, which the 'craftsman' disposes, are to the alchemist's more magical and philosophical gifts of transformation. He also calls attention to the mathematical interests of Luca Pacioli and Leonardo in

elements such as the Golden Section and the construction of Platonic solids, hinting at their magical and symbolic function, as well as their practical use to the draughtsman. This level of esoteric instruction is alleviated with such advice to the apprentice artist as having your valet pour a perfume, which evokes the period of your adolescence, on your pillow one hour before waking, to enrich your creativity.

In a typically adventurous leap of the imagination and with a confidence unique among his artist contemporaries, Dalí embraced the revelations of current scientific investigation – approaching them with the same fascination he showed for the paraphernalia of archaic and pre-scientific systems of thought. His understanding of modern science was obviously not that of a specialist but he consumed the pages of *Scientific American* and consulted books covering a wide range of theoretical inquiry, from nuclear physics, the genetics of DNA structures as revealed by Francis Crick and James Watson, plate tectonics and Catastrophe Theory as expounded by René Thom. He derived from these grand ideas his own interpretations, which allowed them to be appropriated within his overarching and essentially magical explanation of the world. It was a perspective close to that shared by many writers and readers of science fiction, a genre that flourished during the era leading up to space flight. He was convinced that the directions of current scientific thought were far closer to mysticism than to Newtonian rationalism. Freudianism had now been almost entirely replaced for him as a dominant impulse by this personal synthesis of ancient and modern ideas which he called 'nuclear mysticism'; this is symbolically clarified in the 1952–4 remake of his most familiar Surrealist image, *The Disintegration of the Persistence of Memory* (160).

The human figure is also subjected to the explosive dynamics of his new perceptions in *Young Virgin Auto-sodomized by her own Chastity* (161), a title which at least one American reviewer felt unable to translate from its original French, of 1954. This would also appear to be a remake, of the *Figure at a Window* (39) of 1925, and so was probably made partly in the spirit of revenge against his sister for her audacity in puncturing his carefully fabricated myth of their early

**161**
*Young Virgin
Auto-
sodomized by
her own
Chastity,*
1954.
Oil on canvas;
40·5 × 30·5 cm,
16 × 12 in.
Playboy
Collection, Los
Angeles

family life with the publication of her own account. The floating and
menacing forms are to be identified as rhinoceros horns. Dalí had
come across the theory of biological morphology made famous by
D'Arcy Wentworth Thompson, which demonstrated the frequent
occurrence of logarithmic, spiral patterns of growth and form in
nature. These are common, for example, to both the cauliflower and
the horn of the rhinoceros. Naturally such an idea was happily assimi-
lated into Dalí's grand mental schema. One of the more complex
attempts to employ the traditional language of art, in this case the
genre of still life, to express his current theory of nuclear mysticism,
must be *Nature Morte Vivante* (162), usually translated as *Still Life –
Fast Moving*, of 1956. The paradoxical title and the use of conflicting
pictorial language would seem to support his intention to offer, at an
allegorical level, his personal, mystical demonstration of quantum
physics:

I show the fruit bowl floating in space with the fan and fruits and a cauli-flower and a bird and a glass and a bottle emptying itself and a knife, in front of a window through which there is an endless moiré sea, while a hand holds a rhinoceros horn as maximum energy in minimum space, facing the infinite spaces of the sea, the picture becomes the privileged locus of a geometry that translates not only the loftiest scientific and philosophical speculations, but allows me, Dalí, to know the truth of time-space.

He clearly felt alienated from the prevailing currents of most contem-porary art and set out his opinion of its decadence on numerous occasions. He particularly derided the Abstract Expressionism of 'the new barbarians' who possessed neither art-historical knowledge nor connoisseurship and who produced 'a hybrid art, half decorative and half caricature'. Pollock, he jibed, concocted 'the same fish soup as Monticelli, but far less tasty, merely the indigestion which goes with it' (Adolphe Joseph Thomas Monticelli, a late nineteenth-century painter admired by Van Gogh, had employed an encrusted impasto technique). Dalí had been attacking abstract art since the 1930s but was optimistic that its reign would be short-lived and that it would have served its purpose in restoring 'virginity' to figurative art. We should not be surprised to discover arbitrary inconsistencies within this pattern of condemnation: he wrote warmly of De Kooning, for example, and formed a particular admiration for the work of the French gestural abstractionist Georges Mathieu. Mathieu was another showman who achieved wide acclaim for his 'battle pictures', often painted as public performances with athletic attacks on the canvas. Dalí even tried out this martial approach himself when Mathieu presented him with an harquebus – a long-barrelled gun, which he used to shoot pellets of ink at a litho stone to stimulate designs for a set of illustrations to Cervantes' *Don Quixote*. Ballistic power was utilized again in 1959 when he constructed a kind of nail bomb, appropriately enough, to scar the copper plates for the illustrations to his *Apocalypse of St John*.

He set about clarifying his ideological position, with regard to politics as well as art, shortly after his return to Spain in 1951, when he

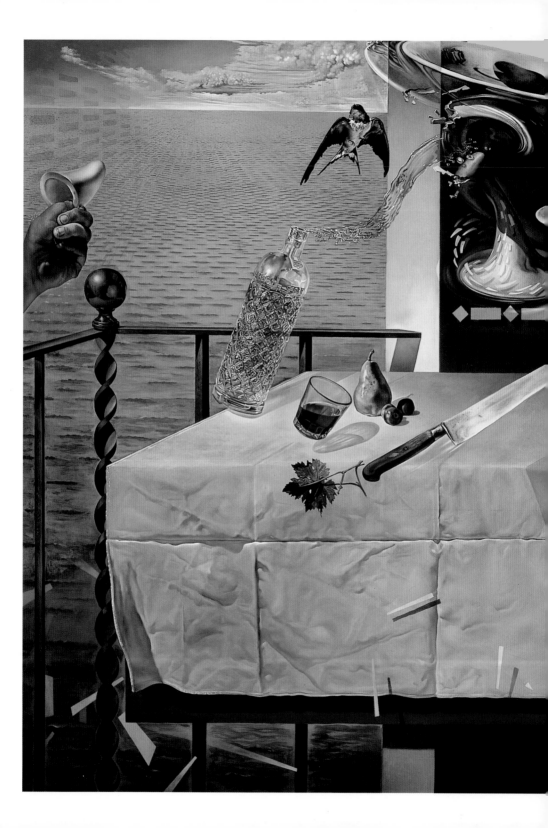

**162**
*Nature Morte, Vivante (Still Life – Fast Moving)*, 1956.
Oil on canvas; 125 × 160 cm, 49¼ × 63 in.
Salvador Dalí Museum, St Petersburg, Florida

addressed a theatre audience in Madrid on the theme 'Picasso and I'. Conscious as he always was that Picasso, his substitute father-figure, still maintained the moral higher ground and an impregnable recognition as the pioneering Modernist, he reveals his ambivalent attitude in two portraits: the first (163) was originally made in 1930 and later published as a print with the words 'I too have known the emperor' added; the other, a complex and disturbing caricature (164), was painted in 1947. He started off the performance with the following comparison:

Picasso is Spanish
So am I

Picasso is a genius
So am I

Picasso is probably about 72 years old
and I am about 48

Picasso is known in all the countries of the world
So am I

Picasso is a communist
neither am I

He delivered a few throwaway lines in praise of the 'clarity, truth and order' that Franco had restored to the country and went on to remind the audience that it was two Spaniards, Picasso and Gris, who had invented Cubism. Now, he declared, 'the motto of Spanish painting must be mysticism and realism'; Picasso's role had been to take modern painting to the extremity of its attack on beauty, allowing the new era of mystical painting to begin with Dalí.

This typical bravura performance had its predictable effect and produced a wave of reaction and debate in the press and among artists and critics in Spain. This was the other Dalí – the showman and dandy. The latter term was first applied to those young English gentlemen who, at the turn of the eighteenth century, adopted an ostentatiously fastidious approach to dress which signified a mode of behaviour excessively concerned with style. It continued and

flourished throughout Europe over the next century, representing a world-view directed towards celebrating the aesthetic principle of life. The poet and critic Baudelaire pointed out, 'The Dandy must live and sleep in front of the mirror', and Dalí accepted this imposition as readily in his later life as ever he had done in his adolescence. In an entry for July 1952 in his *Diary of a Genius*, he affirms:

The uniform is essential in order to conquer. Throughout my life the occasions are very rare when I have abased myself to civilian clothes. I am always dressed in the uniform of Dalí.

When a young Parisian hopeful asked for his advice on how to succeed in America, Dalí told him to give up his ability to live cheaply:

Caviar and champagne are things that are offered you free by certain very distinguished ladies, wonderfully perfumed and surrounded by the most beautiful furniture in the world. But to get them, you must be quite different from the you who comes to see Dalí with dirty fingernails, while I have received you in uniform.

One major element of the 'uniform' was, of course, the moustache – which must be considered more as his logo – and in 1954 he brought out an inventively humorous, indeed self-mocking, book dedicated to its honour, in collaboration with Philippe Halsman (165). Dalí was unique among his generation of Modernist artists in being so readily consumed by the mass media and disseminated to such a wide general audience, and the reason must be that he alone wanted and knew how to modernize the idea of the dandy, transforming it into the contemporary mode of the 'celebrity'. Dalí was the first celebrity artist, in whose wake Andy Warhol was later to follow, as were a generation of media-aware artists in the 1980s. Celebrity in America had all the attributes of power – recognition, deference and privileged reception in public places, hotels and restaurants – which in Europe had been traditionally awarded only to members of the aristocracy, who fiercely defended its frontiers against newcomers, whom they branded as 'arrivistes'. Dalí enjoyed performing for the media and he handled the TV interview and the documentary film of the 1950s and 1960s as expertly as he had previously manipulated the

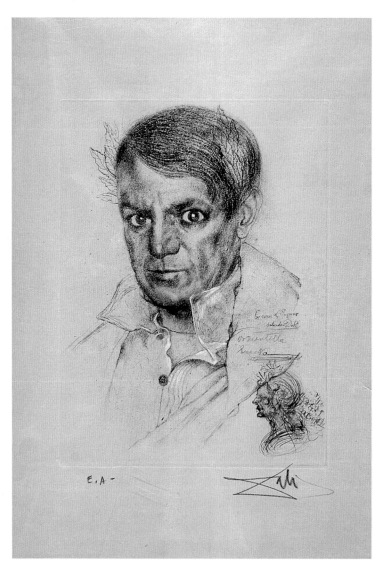

**163 Left**
*Portrait of
Picasso - I too
Have Known
the Emperor,*
1970.
Drypoint
etching after
a drawing of
1930;
39 × 29·5 cm,
15³⁄₈ × 11⁵⁄₈ in.
Salvador Dalí
Museum, St
Petersburg,
Florida

**164 Right**
*Portrait of
Picasso,*
1947.
Oil on canvas;
64·1 × 54·7 cm,
25¹⁄₄ × 21¹⁄₂ in.
Fundació
Gala–Salvador
Dalí, Figueres

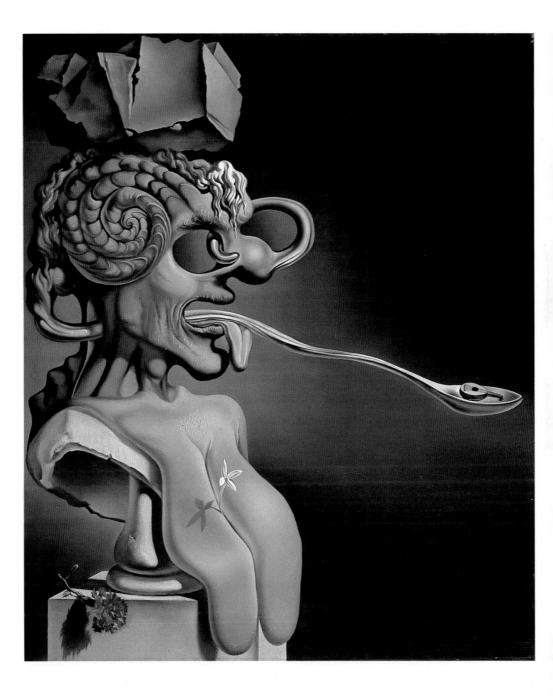

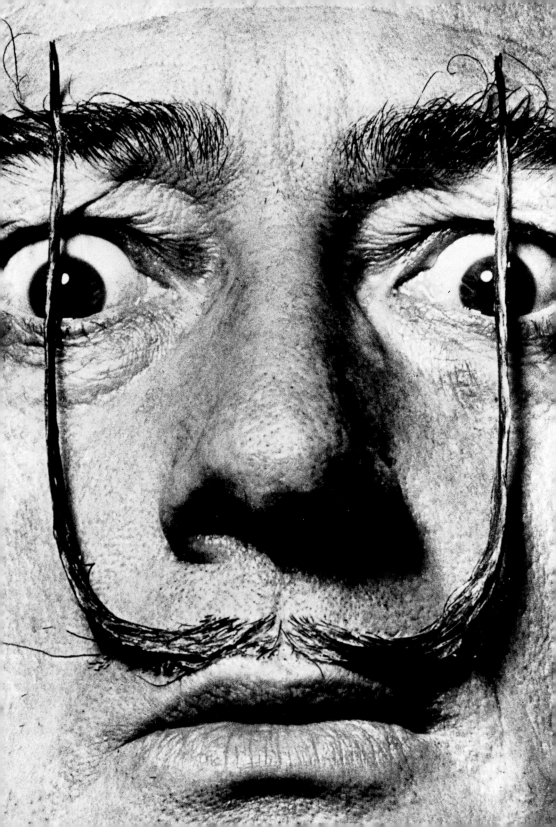

print media. On the occasion of an interview for Columbia Broadcasting System in 1956, he managed to take total command of proceedings, in an exercise of deconstruction of the medium, by directing the camera to film the production crew during the broadcast, declaring that 'confusion is best, accidents make creativity, order makes boredom'.

The life of Dalí and Gala established a regular seasonal pattern, with their time dispersed between two luxury hotels, the Meurice in Paris and the St Regis in New York, and their home and studio in Port Lligat, which had now expanded with the purchase of adjoining fishermen's houses. Most of the serious painting was done there, with the hotel residences reserved for pleasure, for publicity and for attracting prospective buyers, although a room in their suite would usually have a significant painting on show, on which Dalí could be seen to be working. Typically he would work in the mornings, then the couple would eat well at the best restaurants, with seafood, champagne and fine Bordeaux, to be followed by a siesta. In the afternoons, his secretary/business manager would arrange interviews with a stream of journalists, clients and models, which gave him the opportunity to amuse himself with a public performance, while Gala would go out shopping or else in pursuit of an amorous liaison, for she gained a formidable reputation as a seducer of attractive young men, a tendency which she continued well into her seventies. It would appear that Dalí was not especially upset by this behaviour, since his constantly declared, all-consuming love for Gala was always pitched at a near metaphysical level of meaning. However, they did go through a marriage ceremony in 1958, conducted in a chapel at Girona, out of the glare of publicity, which seemed to have a strong personal significance for Dalí, though this might have been confined to his participation in an ornate liturgical ceremony. There had been a previous civil marriage in 1934 in Paris which had probably been undertaken to satisfy the US immigration authorities.

Dalí's delight in the richness of the decorative arts associated with the Catholic Church found expression in his jewellery of the 1950s. He had been designing pieces since 1941, typically based on parts of

165
Dalí
photographed
by Philippe
Halsman
for the book
Dalí's
Moustache,
1954

**166 Left**
*The Eye of Time* (worn in a fashion photograph), 1949. Enamel, platinum, diamonds and rubies; 4 × 6·4 × 1·5 cm 1⅝ × 2½ × ⅝ in. Minami Art Museum, Tokyo

**167 Above right**
*Ruby Lips*, 1949. Rubies, pearls and gold; 3 × 5 × 1 cm, 1⅛ × 2 × ⅜ in. Minami Art Museum, Tokyo

the body and face and certainly affronting the accepted rules of taste in this traditional area of design. His stated preference was that his jewellery should be unwearable, but if someone did have to wear a piece, it should be next to the skin and feel rough and irritating like a hair-shirt. *The Eye of Time*, from 1949, is a watch in three shades of blue enamel with diamonds and a ruby set in platinum (166). The words of popular versifiers are given form in the pearl teeth and ruby lips of a piece from 1949 (167). Later he produced a set of objects of greater formal complexity which drew on ecclesiastical and regal themes, such as *The Royal Heart* (168). *The Angel Cross* of 1954 (169), brings together in mystic communion his interests in numerology, alchemy and Christian mysticism, as is revealed in the exotic details of its technical description:

Figure sculpted from virgin gold and then painted by Dalí in oil with liquid amber. The base, crystalized zinc sulphide from Africa, embeds twelve diamond encrusted platinum spines, each moving in its own distinctive rhythm from its own individual, hidden electrically driven motor. The structure of the gold cross rests atop a globe of lapis lazuli. The globe of 602 pennyweights was cut from a foot square block brought from Russia. The coral, rare for its size and its vivid red colour, comes from China. The flawless topaz from Brazil weighs 1,687 carats. The topaz is framed in gold and hinged to the cross to represent the gate of the tabernacle and the Gate of Heaven.

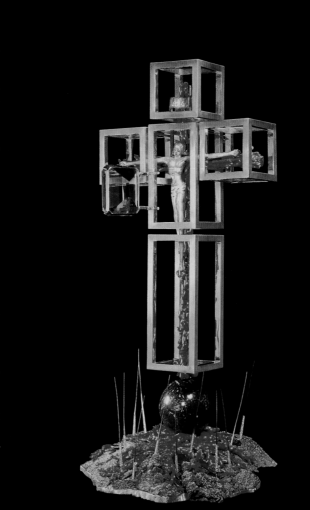

**168 Above**
*The Royal Heart*, 1951–2. Gold heart with rubies, diamonds and emeralds; h.10 cm, 3⅞ in. Minami Art Museum, Tokyo

**169 Below**
*The Angel Cross*, 1954. Gold and coral; h.76 cm, 29⅞ in. Minami Art Museum, Tokyo

**170 Right**
*Space Elephant*, 1961. Diamonds, emeralds, rubies, aquamarine and gold; h.63 cm, 24⅞ in. Minami Art Museum, Tokyo

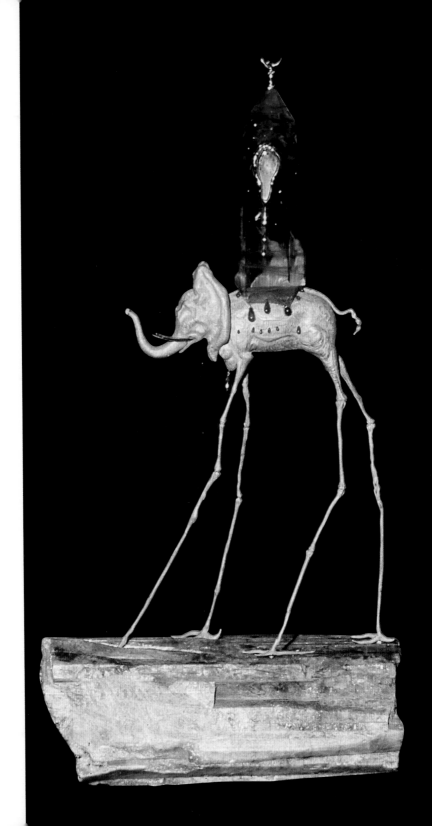

The *Space Elephant* of 1961 however, in engraved gold, emeralds, diamonds, rubies and aquamarine, is much more Dalínian in its imagery (170). It is a fantasized version of the statue of an elephant by Bernini in Rome which supports an ancient Egyptian obelisk on its back.

During this period Dalí's pictorial imagination seemed to explode in an array of disparate ideas, which, in the late 1950s and early 1960s he was still able to match with certainty and appropriateness of technique. The bizarre title of *Dionysus Spitting the Complete Image of Cadaqués on the Tip of the Tongue of a Three-Storeyed Gaudinian Woman* (171), painted in 1958-60, fittingly prepares us for a complex and disturbing visual experience, as the innocent still life with bottle and fruit disintegrates into a pair of grotesque male and female figures having either one or two heads, while the background figures seem to have strayed in from some arcadian scene from a painting by Millet. This late example of Dalí's multiple imagery, invoking a paranoiac-critical response from the viewer, stands in maximum contrast to another work from the same time, *The Discovery of America by Christopher Columbus* (172). Here the subject and mode of visual address could not, at first sight, be more accessible.

*The Discovery of America* is a large work, about $4 \times 3$ m (some $13 \times 9$ ft), and, from the ambition of its scale and historical subject, it would appear that Dalí was measuring himself against the masters of Baroque painting. The subject was no doubt clear in the mind of Huntingdon Hartford, when he commissioned it for his Museum of Modern Art in New York, but Dalí was never able to submit himself to the discipline of such a straightforward suggestion. Quite apart from the emblematic but historically dubious implication that Columbus was a Catalan, is not the dominant figure that of Gala in the pose of Bartolomé Estebán Murillo's *St Helena*, with Dalí himself, in the unlikely guise of a monk, kneeling in adoration before her image? And how seriously are we meant to take the youthful embodiment of Columbus, with his Woolworth's wig and his underpants visible beneath the drapery? Dalí's infinite capacity to bring disparate phenomena into a magical (as opposed to a logical) sympathy of rela-

tions is revealed in the curious object which dominates the lower foreground and which appears to be the objective of the whole expedition. It is, apparently, 'a celestial sea urchin', with spines removed, and Dalí is evidently associating it morphologically with the Russian Sputnik, launched in 1957, and Kennedy's promise of a moon landing within ten years. He also takes the opportunity to explore, in a playful way, representational techniques, both traditional and modern, where, for example, the illusionistically rendered figure of St Helena emerges into three-dimensional space from the banner on which she also appears in the form of a painted representation. Elsewhere in the picture, in the incorporation of the image from his *Christ of St John of the Cross*, he uses the techniques of photo-mechanical reproduction of his own day.

His delight in illusionistic effects is carried to a level of impressive virtuosity in *The Sistine Madonna* (173), painted in 1958, in which he exploits the Ben Day dot system of industrial printing (certainly in advance of its use by Roy Lichtenstein) to reveal, at one distance from the canvas, Raphael's *Sistine Madonna* (c.1512), and, at a further distance, an enormous ear – which he identifies as belonging to the Pope. An additional, supremely Dalínian complication is the *trompe l'œil* depiction of a suspended cherry and its shadow at the left of the work. This was triggered off by a photograph he had seen of Matisse in old age, which appeared to show an exposed button of the great man's trouser flies; predictably Dalí was able to read considerable Freudian symbolism into this. *The Sistine Madonna* displays the proximity of Dalí's work at this stage to the newly emerging forms of American Pop Art.

Dalí's enthusiasm for the energies of the present day and for the promises of science in the age of space flight and the decoding of DNA ensured his survival during the optimistic years of the 1960s. Indeed, his reputation soared during this time as he was discovered by a new generation of young followers who found an empathy in both the art and the persona of Dalí. His pictures, which collaged together familiar elements from the art of the museums with the imagery of the contemporary mass media with unabashed irreverence, and which

171 Overleaf
*Dionysus Spitting the Complete Image of Cadaqués on the Tip of the Tongue of a Three-Storeyed Gaudinian Woman*, 1958–60.
Oil on panel; 31×23 cm, 12¼×9 in.
Salvador Dalí Museum, St Petersburg, Florida

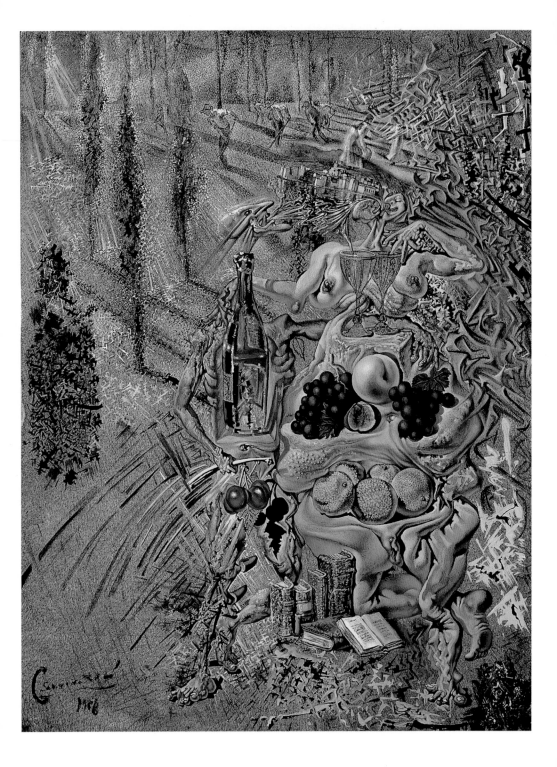

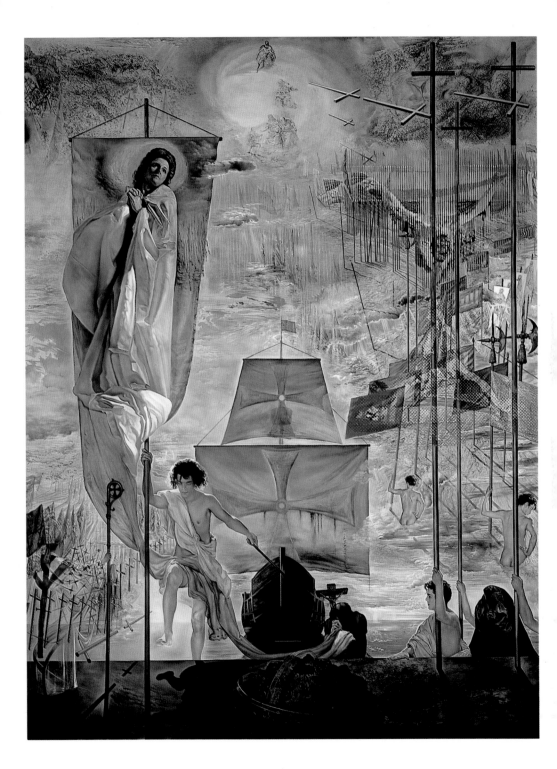

were shot through with his unique and absurd cosmological theories, were well-suited for consumption by an international youth culture which was eager for new mental and moral explorations. They complemented the often hallucinogenic reality expressed in the new popular music. The various youth cults and trends, which extended from beatniks to hippies, confidently rejected the rules of restraint, reason and austerity which had shaped the cultural structures of their parents' generation throughout America and Europe. They accused and opposed that earlier generation for its hypocrisy and its aggressive values, in political confrontations over racial segregation, over the Vietnam war and a defence policy which depended on the threat of global nuclear destruction. Instead they proclaimed and practised the values of hedonism, of aesthetic pleasure, of spiritual exploration and sexual liberation, of 'leaving home' both spiritually and physically, and they found communion and a shared means of expression through the culture of popular music which was now emerging on a world scale.

The sixty-year-old Dalí greeted these developments with joy; he was full of admiration for this young generation of 'Beautiful People' and made himself available to his new audience in the role of a dandified guru figure (Cadaqués became a recognized location on the hippie trail). He saw himself in the guise of some Renaissance prince, surrounded by an entourage of exotic courtiers – scientists and philosophers among them, but mostly selected for their physical and decorative qualities. The glamorous model Amanda Lear (174), who later wrote the book *My Life with Dalí*, was a close companion in these years. Alain Bosquet conducted some of his entertaining interviews with Dalí in the Hotel Meurice suite, in the presence of a contortionist dancer called Onda. Also in Dalí's circle of admirers was the Comtesse Isabelle de Bavière, who, better known as Ultra Violet, was later to transfer to Warhol's retinue, another reminder of the link between the two 'celebrity' artists.

When student protests broke out on the streets of Paris in May 1968, Dalí responded by issuing *My Cultural Revolution*, in the style of the political manifestos of the day. Aside from his jokes, such as the call

172 Previous page
*The Discovery of America by Christopher Columbus*, 1958-9.
Oil on canvas; 410×284 cm, 161½×111⅞in.
Salvador Dalí Museum, St Petersburg, Florida

173 Left
*The Sistine Madonna*, 1958.
Oil on canvas; 223×190 cm, 87⅞×74⅞in.
Museum of Modern Art, New York

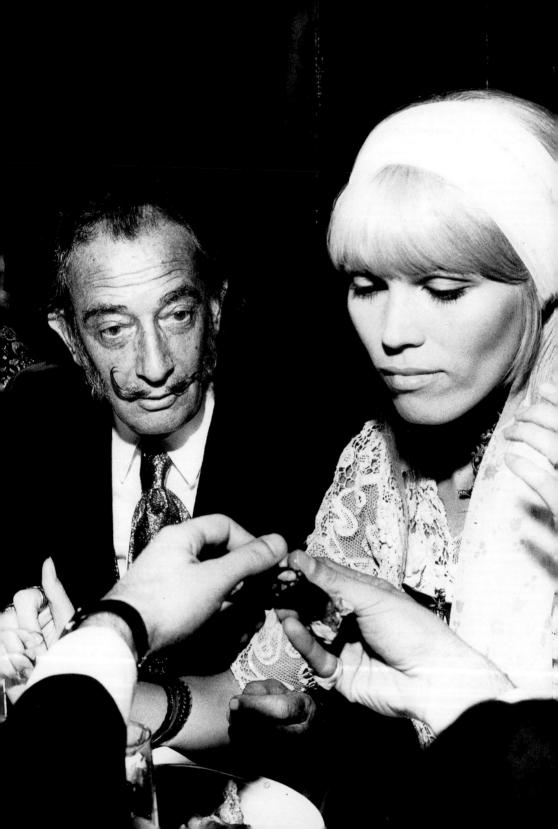

to 'make UNESCO a department of Public Cretinization', he reveals a genuine empathy with the idealism of the 1960s generation:

The colour of modern cultural revolutions is not red anymore but that of the amethyst, evoking the air and the sky and fluidity ... The era of Aquarius, which is going to determine the next thousand years, will witness the disappearance of sanguinary violence. For the time being, we have assassinated Pisces ('God is dead') and his blood colours the sea blue giving the waves that amethyst colour.

This idea evokes one of Dalí's strangest and, in its complex mixture of ingredients, one of the hardest to digest of his paintings, *Tuna Fishing* (175). This large, 3 × 4 m (about 10 × 13 ft) canvas, painted in 1966–7, is subtitled 'Homage to Meissonier'. Jean-Louis-Ernest Meissonier was a French academic painter of the nineteenth century who specialized in battle pictures, painted in precise detail. His subject matter and technique was derided by Modernist artists as *pompier* (firemen-like), but Dalí in a spirit of provocation proclaimed his admiration for it. The ghostly shades of a Meissonier battle on the horizon, however, is just one of the work's many quotations from museum art, which include antique statuary from the Pergamon frieze and a Symbolist female nude from the painter Gustave Moreau. On the other hand, the image which dominates the foreground is of a young man in a singlet which is derived from a style of photographic rendering common in the graphic design of the 1960s. Dalí deliberately created a spiralling anthology of painting styles, from the academic, through Divisionism, Abstract Expressionism, Optical Art and Pop Art. This both adds to the intense dynamics of the picture and serves as a continuation of his insistence on the value of representational art and his opposition to the high prestige of abstract art. In the spirit of his familiar theme of relating current scientific theories of the molecular structure of DNA and nuclear physics with Christian mysticism (in this case, that of Teilhard de Chardin), he explains: 'Hence the alarming energy in the painting! Because all those fish, all those tuna, and all the people busy killing them, are personifications of the finite universe, all the components of the picture ... achieve a maximum hyper-aesthetic energy in it.' In much the same way as with many of

174
Dali and
Amanda Lear,
16 April 1973

**175**
*Tuna Fishing,*
1966–7.
Oil on canvas;
304 × 404 cm,
119³⁄₄ × 159¹⁄₈ in.
Fondation Paul
Ricard, Ile de
Bandol, France

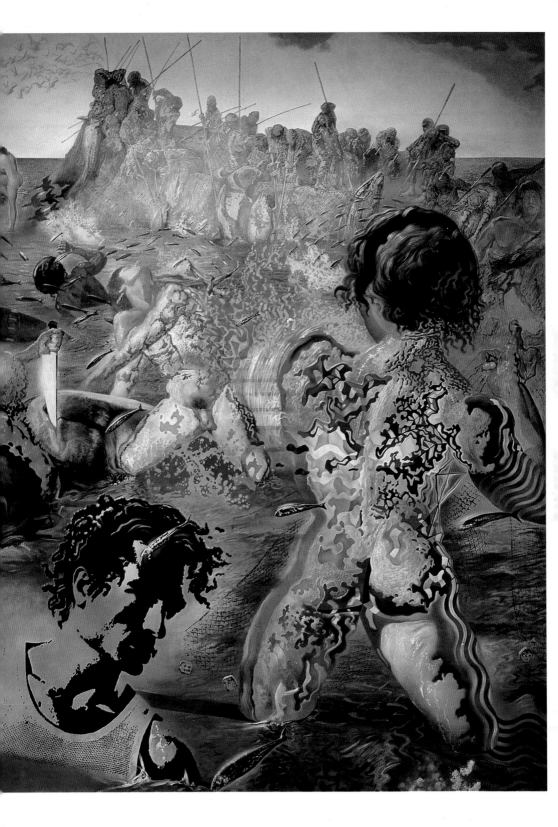

the more intensively detailed Surrealist works, we best encounter this picture by abandoning our desire for an integrated pictorial language and a harmonious compositional structure, in favour of allowing our eyes the freedom to approach and draw back from the depths of the picture and to roam across its surface, incident by incident.

A similar composite structure is employed in another major work of this time, *The Hallucinogenic Toreador* (176), though the overall effect is much more stable. Painted in 1968–70 and measuring nearly 4×3 m (almost 13×10 ft), it is replete with references to Dalí's familiar motifs and is probably one of the few works of the post-Surrealist period which has a substantial personal meaning. The young Salvador in a sailor suit gazes upward from the lower right-hand corner in contemplation of the sacred glow of Gala's face in the opposite corner. The face of the toreador emerges as a double image from the relief shading of the torso of the *Venus de Milo* – an image which had presented itself to him from the package design of a British brand of pencils. Dalí had in the past, in his quarrel with Lorca, rejected what he saw as the romanticism of Spain's obsession with the ever-present proximity of death and the necessity of tragedy in life, as represented in its traditional music, stories and customs, and most famously in the ritual conflict of the bullfight. Nevertheless he does seem to be tapping into that rich symbolic source with some authenticity in this instance. The toreador emits a tear (177) perhaps in recognition of the untimely deaths of Dalí's close friends, René Crevel and Lorca, or even that of the brother he never knew but whom he claimed had dominated his parents' attitude to his own upbringing. He was now at an age when considerations of his own mortality would be perfectly in order; his last autobiographical book, *The Unspeakable Confessions of Salvador Dalí*, published originally in 1973, leaves the reader in no doubt as to the priority of the issue for him.

I have been living with death ever since I became aware I was breathing, it has been killing me with a cold voluptuousness exceeded only by my lucid passion to outlive myself at every minute, every infinitesimal second of my consciousness of being alive. This continual, stubborn, savage, terrible tension is the whole story of my quest.

176
*The Hallucino-genic Toreador,*
1968–70.
Oil on canvas;
398·8×299·7 cm,
157⅛×118⅛ in.
Salvador Dalí
Museum, St
Petersburg,
Florida

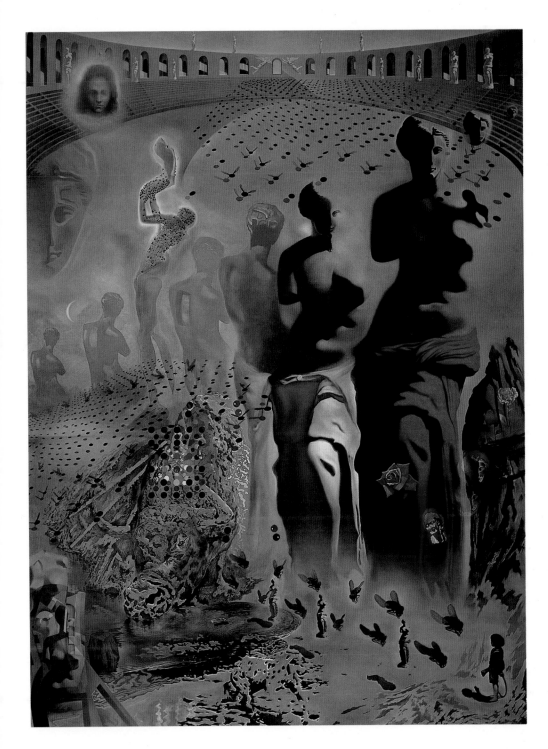

**178**
*Portrait of my
Dead Brother,*
1963.
Oil on canvas;
190 × 190 cm,
74⁷⁄₈ × 74⁷⁄₈ in.
Private
collection

My supreme game is to imagine myself dead, gnawed by worms. I close my eyes and, with unbelievable details of utter and scatological precision, see myself slowly gobbled and digested by an infernal wriggling mass of big greenish earthworms, battening on my flesh ... I find it excellent training, and have been doing this as far back as I can remember.

**He seemed to protect himself from the fear of bodily degeneration and death through a half-serious belief that developments in cryo-genic preservation would advance sufficiently in time to allow him to 'hibernate', as he put it. Dalí's fascination with death is further rein-forced by his obsession with his brother who died before Dalí was born (178).**

**Both Gala and Dalí liked money very much, but more for its magical properties – he would exclaim with apparent bemusement at his capacity to convert a minimal expenditure of effort on his part into 'the divine diarrhoea of cheques and gold'. Or perhaps there was something of a peasant anxiety that you could never have too much, since someone might one day take it all away; once, when asked to clear some of the vast array of trunks being stored for them at the Hotel Meurice, they discovered in them quantities of out-of-date cheques and currency notes which had long ceased to be in circula-tion. This unworldly concern with a standard bourgeois respect for money was not just a product of their more recent wealth but, in Dalí's case, seems to have been there since childhood: even in his hard-up days in Paris he travelled everywhere by taxi, leaving huge tips because he could never work out the change, declaring that anyone over thirty who used the metro was a loser.**

**Later on, with the advent of television, he was amazed to discover that he could be paid $10,000 for a fifteen-second commercial – what more evidence was needed of the absurdity of money and the licence it gave him to continue the 'cretinization' of those who did believe in it? It has been estimated that by 1970 his yearly income, after tax, was over $500,000 and his accumulated wealth over $10 million. While this persistent desire to make money by all available means did little harm to Dalí the celebrity, it did raise considerable problems for his artistic reputation, and this was particularly appa-**

rent with regard to the area of printmaking.

Dalí had been attracted to engraving and etching processes since the days of his first serious art tuition in Figueres, which he had received from a winner of the Prix de Rome for engraving. His father had let him set up a press at home after his suspension from art school and the Chants de Maldoror series which he made in 1934 (105) is highly prized by print enthusiasts. By the 1960s, however, the vast new public demand for prints from contemporary artists made it harder for Dalí to resist the requests from publishers for projects, even though he was not always sufficiently committed to them creatively. His mixed feelings can be judged from the following journal entry:

The Captain [his secretary, Peter Moore] brings me two copperplates for me to engrave for a Paris publisher. Every morning after breakfast I like to start my day by earning 20,000 dollars at a stroke. I hug the plates to my belly, draw up my knees, and set to work with the needle on the table thus created. It gives me real pleasure to cut into the metal as the steel point moves across it.

He undertook many projects to illustrate luxury editions of classic texts; for some, such as the *Divine Comedy* (179), the Holy Bible, the *Decameron, Alice in Wonderland* (180) and *Casanova*, he would produce watercolours which would be transferred on to the plate by engravers, though generally he would correct and rework these. Ultimately Dalí was always much more impelled by the arresting nature of an image than by aesthetic nuances of touch; he was not impressed by any sense of 'aura' that might attach to the specific presence of the artist's own hand in the production of either paintings or prints: 'I always encourage people to reproduce my paintings because I find the reproductions much better than the originals.' So he was also happy to produce books for less restricted circulation which could use ordinary commercial reproductive methods, of which the collaged illustrations to *The Wines of Gala and of God* are a fine example.

The purchaser of a limited edition print requires that it be signed by the artist as proof of its quality and scarcity of production. Publishers

179 Overleaf left
*Angel of Death from Dante's 'Divine Comedy',* 1950–2. Watercolour on paper; 41×27·5 cm, 16⅛×10⅞ in. Museo Perrot Moore, Cadaqués

180 Overleaf right
*Alice in Wonderland,* 1968. Gouache on paper; 56×40 cm, 22×15¾ in. Museo Perrot Moore, Cadaqués

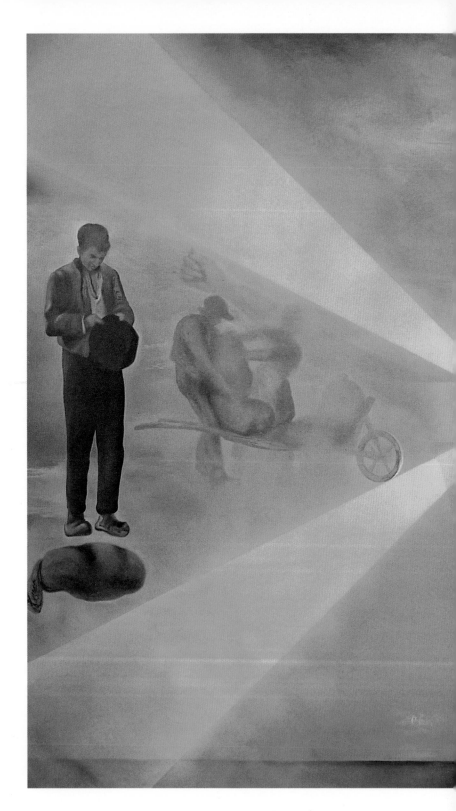

**181**
*The Railway Station at Perpignan,* 1965.
Oil on canvas; 295 × 406 cm, 116 × 160 in. Ludwig Museum, Cologne

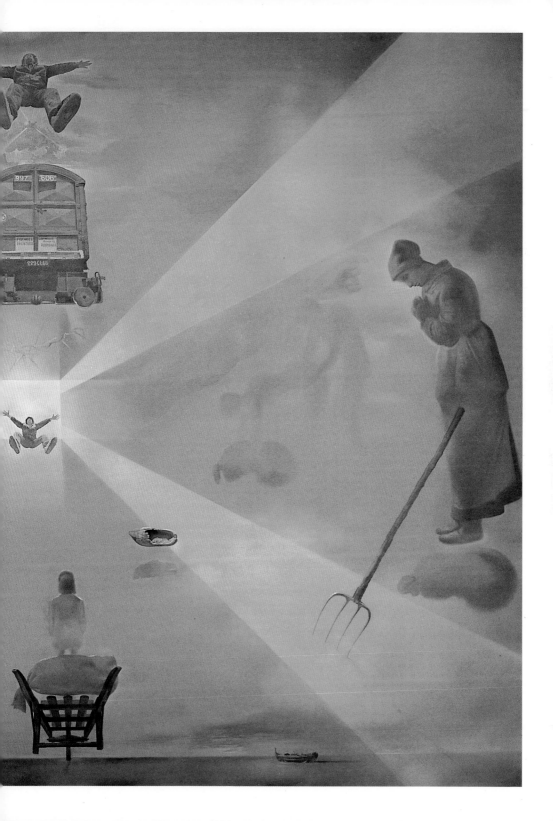

were often unsure that Dalí would be in the right place at the time that he would be needed for signing an edition, so the practice developed whereby they would ask him to sign the required number of blank sheets in advance. Unfortunately this situation was criminally exploited on a wide scale and, by the mid-1980s, large quantities of blank sheets, bearing either genuine or forged signatures, were in circulation. This led to a number of prosecutions and seizures of blank sheets and forged prints, and left a persistent cloud of doubt over the market in Dalí's graphic work.

Perpignan is the first major town encountered on crossing the border from Figueres into France. Its residents like to remind the world of their Catalan connections and it was the place from which Dalí and Gala would embark on their holiday visit to Paris after the summer's work at Port Lligat. It has a modest and efficient railway station but even the most loyal of its citizens would have difficulty relating it to

the station celebrated so grandiosely in the full title of Dalí's 1965 painting, *The Railway Station at Perpignan (Gala Watching Dalí in a State of Weightlessness above his 'Pop, Op, Yes-Yes, Kitsch' Work, where Two Awesome Figures from Millet's 'Angelus' Appear to us in an Atavistic State of Hibernation, Seen against a Sky which Can Suddenly Be Transformed into a Gigantic Maltese Cross, and at the Centre of the Railway Station at Perpignan, where the Entire Universe Converges)* (181). What he leaves for the eyes of the viewer to determine is that shadowy versions of the *Angelus* couple are enacting the 'paranoiac' scenarios alluded to by Dalí in his account of the 'Myth of the *Angelus'*. Furthermore, the megalomaniac limits of his myth of the genius – his book *The Diary of a Genius* was published in the same year as the painting – are surely reached when the central focus of the work is carefully examined, for it is purposefully ambivalent as to whether the crucified figure bearing the crown of thorns and the bleeding wound is that of Christ or Dalí.

In terms of his own Dalínian myth, the painting does mark the beginning of his last major project, the development of representational techniques which aimed at extending the illusionistic traditions of realist painting – best achieved, in his estimation, by Vermeer and Gerard Dou – into the virtual reality of three-dimensional visualization.

He was especially enthusiastic about the possibilities of holography, which was being developed in the early 1970s by Dennis Gabor. Dalí constructed six holograms, one featuring the rock singer Alice Cooper, 'the best exponent of total confusion I know', and another, *Holos! Holos! Velázquez! Gabor!* (182), not only allows the viewer to see what lay on the hidden canvas of Velázquez's *Las Meninas*, but also provides the fascinating opportunity for montaging a contemporary scene, in this case a card party taken from a beer advertisement, into the virtual space of seventeenth-century Spain. It was probably only the failure to develop a technique of true colour holography which caused him to abandon these experiments.

He then explored the potential of stereoscopic techniques, but his first efforts, using the Fresnel system familiarly used for relief-effect

182
*Holos! Holos! Velázquez! Gabor!*,
c.1972–3.
Hologram;
42 × 57 cm,
16½ × 22½ in.
Fundació Gala-Salvador Dalí, Figueres

postcards, did not translate to a larger scale. With the aid of a system of mirrors designed by Roger de Montebello, he resorted to developing the existing nineteenth-century method of stereoscopic photography. This involved painting a meticulously illusionistic image, which was then copied and repainted with slight adjustments made to positioning, tone and lighting. The two images of the picture are set up next to each other offering the viewer a real sensation of three-dimensionality, as for example in *Dalí from the Back Painting Gala from the Back Eternalized by Six Virtual Corneas Provisionally Reflected in Six Real Mirrors* (183). Dalí much admired the contemporaneous work of the American Hyperrealists of the 1970s such as Richard Estes and John de Andrea, in whose painting and sculpture he perceived a parallel set of intentions.

Further experimentation ensued, notably in techniques of computer-derived imagery, and one of the more ingenious of these returns to his constant theme of the double image, with a subject which is alternately a tiled bathroom and a portrait of President Lincoln. It was painted in 1974–5 on photographic paper and the full title reads *Gala Contemplating the Mediterranean Sea which at Twenty Metres Becomes the Portrait of Abraham Lincoln – Homage to Rothko* (184). Its effect is impressively displayed in its present location at the Theatre-Museum in Figueres.

The last years of Dalí's life were far from his happiest and their events are best related briefly and factually, to allow readers to make their own assessment of their tragic nature. In June 1982 Gala died and was buried in Púbol Castle, where Dalí took up residence. A month later he was ennobled by King Juan Carlos and given the title Marqués de Dalí de Púbol. He contracted a serious illness, probably as an attempt at suicide through dehydration, but partially recovered, though he was unable to swallow any more and for the rest of his life had to be fed through a tube, speaking only with great difficulty. He no longer painted after May 1983, and was attended by a team of four nurses and guarded by two policemen. In 1984 he was discovered in a seriously burned condition, when his bed caught fire after he had caused a short circuit by constantly switching his bedside light on and

183
*Dalí from the Back Painting Gala from the Back Eternalized by Six Virtual Corneas Provisionally Reflected in Six Real Mirrors,* c.1972–3. Oil on canvas; 60 × 60 cm, 23⅝ × 23⅝ in. Fundació Gala-Salvador Dalí, Figueres

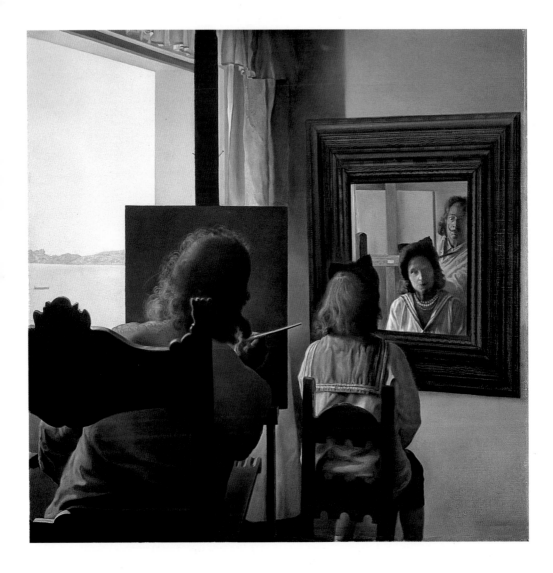

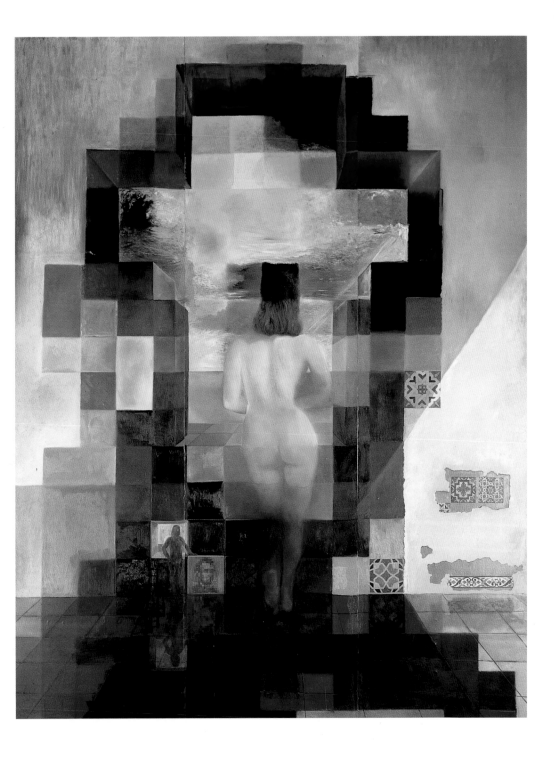

**184 Left**
*Gala
Contemplating
the
Mediterranean
Sea which at
Twenty Metres
Becomes the
Portrait of
Abraham
Lincoln -
Homage to
Rothko* (first
version),
1974–5.
Oil on
photographic
paper;
445 × 350 cm,
175 ³⁄₈ × 137 ⁷⁄₈ in.
Fundació Gala-
Salvador Dalí,
Figueres

**185**
Dalí holding a
photograph of
Gala

off. On his way to hospital, he insisted that despite his grave condition he should see the progress made on the Theatre-Museum (see Chapter 7), in particular the sculpture which incorporated Gala's boat. Following hospital treatment, he returned to live at the Torre Galatea, adjacent to the Theatre-Museum, until 23 January 1989 when he died of heart failure at the age of eighty-four. He is buried in the crypt of the Theatre-Museum.

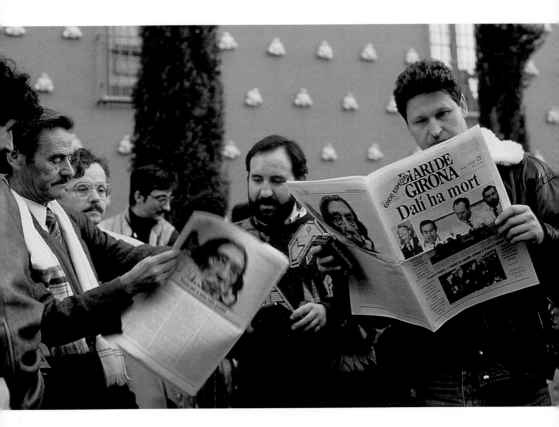

**186**
Dali's death
reported in
the
newspapers,
1989

**Spectacles and Illusions**   The Museums of Dalí

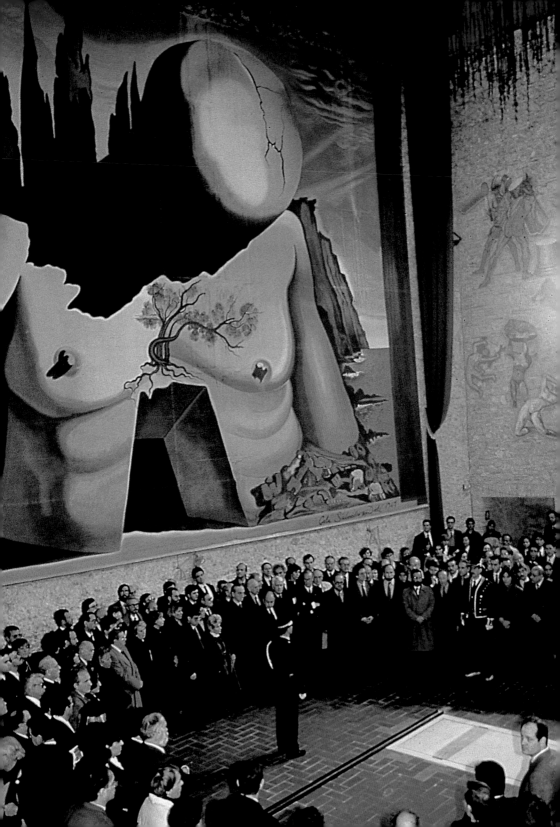

There are two major museums in the world which are devoted to Dalí's work; fittingly, one is in Europe, the other in the United States, as if to demonstrate the two cultural poles from which his art derived its dynamic energy. The Dalí Theatre-Museum in Figueres, created by the artist himself, is dedicated to the method of revelation through creative confusion, and the Salvador Dalí Museum in St Petersburg, Florida, created by his most ardent patrons, is dedicated to revelation through clarity and education.

The Theatre-Museum challenges the very concept of what an art museum should be. It acknowledges that a museum devoted to a single artist must concern itself with the obsessive ideas and the shaping influences which have driven that artist, as much as the work itself, especially in the case of Dalí who always insisted on the insepa-rability of his life and his art. It does contain the paintings and draw-ings – of the highest quality – that a visitor might conventionally expect, but there are also posters, pieces of furniture, books, carnival figures, jewellery, an automobile, a stage curtain (187), a reproduc-tion of a Renaissance interior. There are works by the artist himself, works by Old Masters or by little known or forgotten figures and a whole miscellany of installations and art objects which stretch the powers of definition. They are all thrown together in such a way as to engage the mind of the visitor by force of entertainment, rather than to suppress the imagination by imposition of curatorial authority. It has been described, a little ungraciously, as resembling 'a sumptuous flea-market', but the impression is, in fact, much more theatrical, like the space of an operatic dream, for what is important is that there is no given narrative, there is no required circulation route, so that visi-tors must rely on their own resources to compose their own preferred version of this Dalínian opera. The artist rather than the art historian has triumphed here, and the absence of dates, labels and explanatory panels – and of chronological sequence – support Dalí's contention

187
Stage curtain for *Labyrinth*, 1974 copy of 1941 original as displayed in the Fundació Gala-Salvador Dalí, Figueres

that his art is best understood in terms of the continuity of certain themes and topics throughout his work rather than in its stylistic transition over time. On the whole, the 'theatre' wins out over the 'museum', with visual surprises and incidents occurring all around; we are, of course, requested not to touch, but we can get up close to exhibits, and perhaps recapture the intensity of seeing that we experienced on childhood museum visits. The theatricality is heightened at night, when the Wagner is turned up, the drama of the architecture is revealed by the lighting and *cava* is served on the terrace.

The story of the museum project starts in 1960 when the mayor of Figueres, aware that the municipal museum possessed no work by the town's most famous artist, approached Dalí to request the donation of a piece. Dalí replied that neither a single work, nor even a whole room, would be appropriate and that Figueres should be provided with nothing less than a whole museum; furthermore, he knew exactly where it should be – in the municipal theatre, where he had first exhibited as a fourteen-year-old. It had been constructed in 1849, in a fine Neoclassical style, but, following bombardment and a fire caused by encamped troops during the civil war, it had since remained a roofless shell, partly taken over as a fish market, so this proposal for its reinstatement was readily taken up by the council.

To inaugurate the project, a *corrida* (bullfight) was arranged. Dalí had long nourished an idea for a Surrealist *corrida* to be held in Barcelona, in which the true dignity of the defeated bull's fortitude would be recognized by its ascension from the ring by means of a helicopter, to be transported to the heights of the sacred mount of Montserrat. He had not been allowed to go ahead with this in Barcelona, but now at last he did have the opportunity to provide a Surrealistic transformation of this most conservative of Spanish cultural spectacles. After a series of conventional fights, a bull, constructed by the artists Niki de Saint-Phalle and Jean Tinguely, was brought on and, following the attack from the picador, it duly exploded, releasing rockets, fireworks and an ascending dove. Dalí was presented with the civic honour of the 'Silver Fig-leaf' and the scheme was duly launched.

The national government was called on to provide the bulk of the funding and it was discovered that an old law covering the restitution of war damage could be applied to the theatre building, but progress was slow and it probably needed Dalí's personal audience with Franco in 1968 to move things along. Money was eventually released and Dalí devoted much of his time over four years planning the details, large and small, and working directly on site, to produce what must be considered his greatest and most complex work of art, the Theatre-Museum; it opened in 1974, in his seventieth year, on a day of energetic festivity.

Covering the main area of the former auditorium was a major under-taking. Dalí was attracted to the work of the American architect Buckminster Fuller, who had designed a giant, geodesic dome for the Montreal World Fair in 1967. In the event, a similar dome structure was built by the Spaniard, Pérez Pinero, which provides a memorable feature both internally and – especially when viewed from some distance – externally. The geodesic form would have appealed to Dalí through its capacity to signify, by means of a clear mathematical structure, both the macrocosmic idea of the globe and the micro-scopic reality of the faceted construction of a fly's eye, which he had studied in his experimentation in optics and spatial perception.

The old castle-like building adjacent to the theatre, where Dalí spent his last isolated years and which he named the Torre Galatea, was incorporated into the rebuilding. Its façades have been audaciously decorated in a pattern of plaster mouldings taken from a local form of triangular bread loaf, and surmounted by a row of huge, golden eggs (188–90). The museum entrance is approached across a small plaza, on which Dalí has placed several monumental 'statues' which operate on a number of levels of irony. First, there is a monument to his favourite Catalan philosopher, Francesc Pujols, in a flowing lava of kitsch forms which parodies the very genre of the public statue; next, there are three statues of Meissonier, mounted on columns of various heights, composed of tractor tyres; then, a television tower by the German artist Wolf Vostell, which displays on a screen a view of the clouds above; and finally, a bronze monument to Newton, in a hybrid,

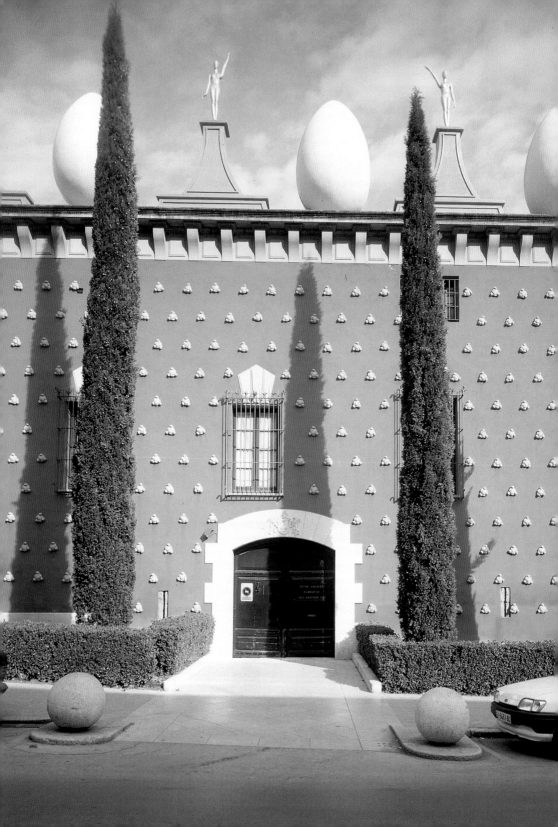

**188 Opposite**
One of the decorated façades of the Torre Galatea, Fundació Gala-Salvador Dalí, Figueres

**189 Above**
View of the Plaza Gala-Salvador Dalí with the Torre Galatea

**190 Below**
Torre Galatea, 1983. Ink on photographic paper; 28 × 37·5 cm, 11 × 14¾ in. Fundació Gala-Salvador Dalí, Figueres

**191**
Mae West
Room
showing
*Saliva Sofa*,
Fundació
Gala-Salvador
Dalí, Figueres

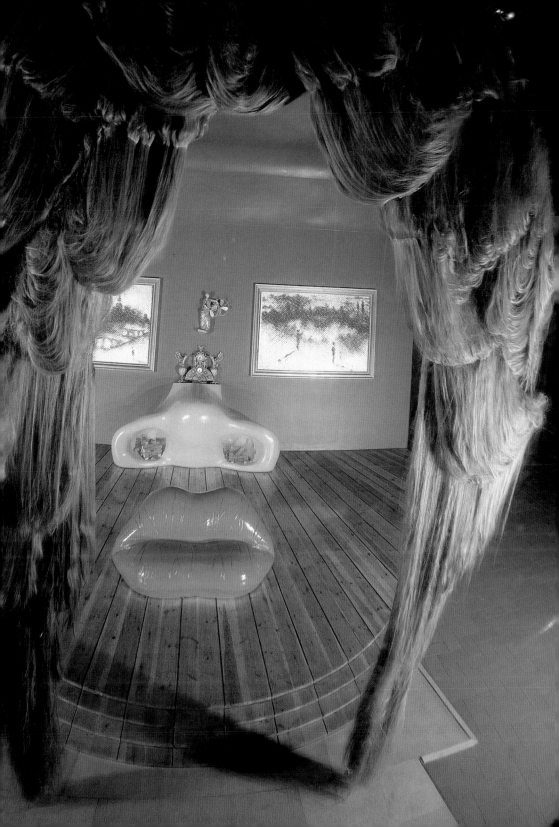

Modernist style, with hints of Pau [Pablo] Gargallo and Henry Moore. The main façade is decked out with numerous sculptural figures, with various combinations of crutches and bread loaves balanced on their heads, the centrepiece being a figure in a diving suit.

A few elements of the spectacle awaiting the visitor inside deserve particular mention. The entrance lobby exhibits two posters, one for the inauguration of the Miró Foundation in 1976 and one for the Picasso Museum in 1977, both in Barcelona: by including these images Dalí was making the point about the company he was keeping, and the major contribution that Spanish artists had made to twentieth-century art. If we climb to the top level, we come to the Room of the Masterpieces, with paintings by Dou and El Greco, the quality of which is beyond dispute, but also work by the French academic painters Meissonier and William Adolphe Bouguereau and two nineteenth-century Spanish artists, Modest Urgell and Mario Fortuny, whose work would have been generally disdained by the taste-makers of the 1970s. Pride of place is given to the sole representative of the modern period, Duchamp, with all his significant pieces neatly presented in reproduction in his 'Valise'. One suspects that Dalí fully respected this master of reserved understatement precisely because of his polar distance from his own mode of rhetorical excess and repetition. In their underlying attitudes to modern art and the delight to be obtained through 'cretinizing' its public, they had a great deal in common, especially in their mutual disdain for formalism and in their shared recognition of the centrality of the erotic impulse in art.

In 1934 Dalí came across a magazine photograph of the face of the Hollywood film star Mae West. He retouched it in gouache and converted it into an image of a *Surrealist Apartment*, later deriving from this invention the *Mae West's Lips Sofa* (113), in pink satin, for Edward James. Now, with the aid of the designer Oscar Tusquets, he had the opportunity to reverse the process by constructing an apartment (containing a new version of the sofa, the *Saliva Sofa*, in red foam rubber), which, when seen through a reducing lens, re-emerged as the face of Mae West (191).

Dalí was at last able to give form to his fantasy of the life of the great Renaissance artist by converting the three rooms of the grandly proportioned former theatre foyer into a 'studio', a 'bedroom' and a 'salon'. The studio is dedicated to the theme of 'the eternal feminine' and comprises a number of his own works alongside examples of the female nude from several nineteenth- and twentieth-century artists, offering thought-provoking juxtapositions between, for example, a Bouguereau painting and a Hyperrealist figure by De Andrea displayed in a neon-lit glass case.

To the Surrealist artist, the bedroom, the place of dreams, was certainly no less important than the studio, and a fitting array of furniture has been brought together here to induce a fertile flow of fantasy. Dalí had once pointed out the similarity between an art gallery and a bordello – essentially, they were both privileged places where one could gaze on naked women – and so it is not surprising that the pride of place is reserved for an ornate bed, supported on legs in the form of a conch shell, which, it is claimed, had previously been made to the order of Napoleon III before being passed on to a high-class Parisian brothel. Next to it, on a bedside table, stands the gilded skeleton of a gorilla (192).

The grand salon has been named the Palace of the Wind; it provided Dalí with the opportunity to paint a large ceiling mural with all the bravura and high theatricality of Baroque illusionism. The subject, of the titanic figures of Dalí and Gala distributing a rain of gold over the city of Figueres, is, in the event, a parody of the genre, as the viewer is exposed to the uninspiring vision of the soles of the feet of the 'divine' couple. It was painted in oil on a plaster ground on canvas before installation, but Dalí ensured that he was filmed completing it on site, painting with long brushes, mounted on a scaffold, in the manner of Michelangelo. His admiration for the values of a harmonious integration of thought and the senses, of order and caprice, which he considered to have been perfected in the culture of the Italian Renaissance, is reflected in the replica of the interior of Bramante's Tempietto in Rome, which is used here to display Dalí's jewellery and other objects worked in gold.

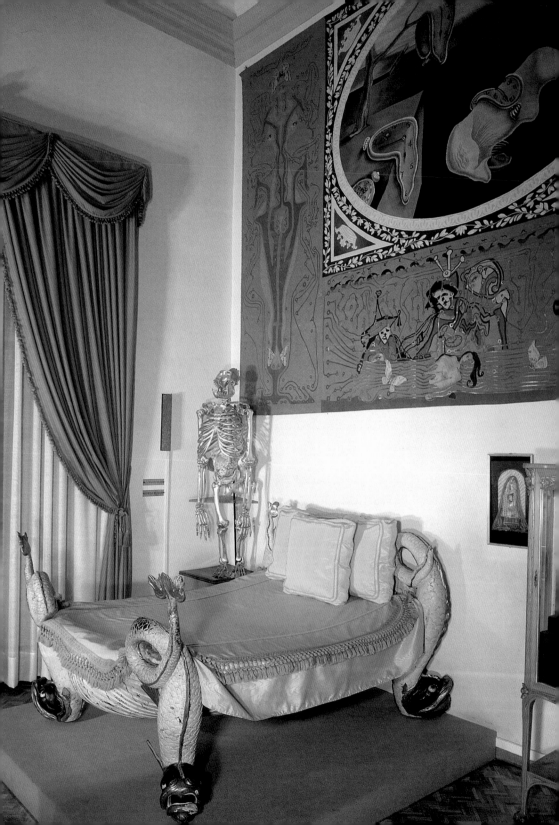

The Theatre-Museum offers the best opportunity to experience the effects of Dalí's various optical systems, since a number of the stereoscopic pieces have been set up to facilitate viewing in controlled conditions. One way in which this interest links back to its more philosophical, even magical, origins in earlier art, can be seen in the anamorphic images that are also shown here. What at first appears to be a confusion of marks, including the image of an insect, only reveal their hidden subject in their reflections on the silvered surface of a bottle placed in the centre of the lithograph of the *Harlequin* (193).

The automobile, or, to be precise, that particular peak of sensual, curvaceous form that was represented by the American automobile of the late 1940s, always held a particular fascination for Dalí. So

**192**
Bedroom with a bordello bed and a gorilla skeleton, Fundació Gala-Salvador Dalí, Figueres

**193**
*Harlequin*, 1972. Lithograph; 87 × 61·9 cm, 34¼ × 24⅜ in. Fundació Gala-Salvador Dalí, Figueres

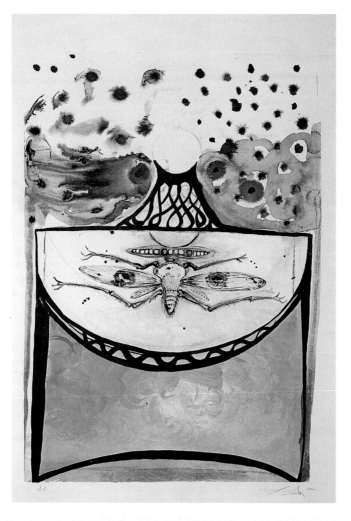

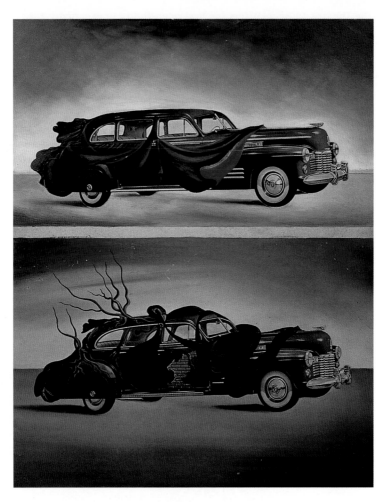

**194**
*Car Clothing*,
1941.
Oil on
cardboard;
39·5 × 27 cm,
15½ × 10⅝ in.
Fundació
Gala-Salvador
Dalí, Figueres

**195**
Courtyard
with *Rainy
Cadillac*,
Fundació
Gala-Salvador
Dalí, Figueres

apparent to him was its anthropomorphic nature that he once
designed a set of clothes to cover its indecency (194), and he was so
aware of its powers of seduction that he relished the idea of driving
through Western and Eastern Europe during the austere period of the
Cold War in such a vehicle, parking it in small towns and villages to
elicit reactions of marvel and envy from the local people. It is not
surprising, therefore, that his *Rainy Taxi*, which had first featured in
the Paris International Surrealist Exhibition in 1938, should be reborn
in the form of the *Rainy Cadillac* which dominates the inner court-
yard of the Theatre–Museum, surmounted by a 'mascot' in the form
of the bronze statue to *Queen Esther* by the Austrian artist Ernst
Fuchs (195).

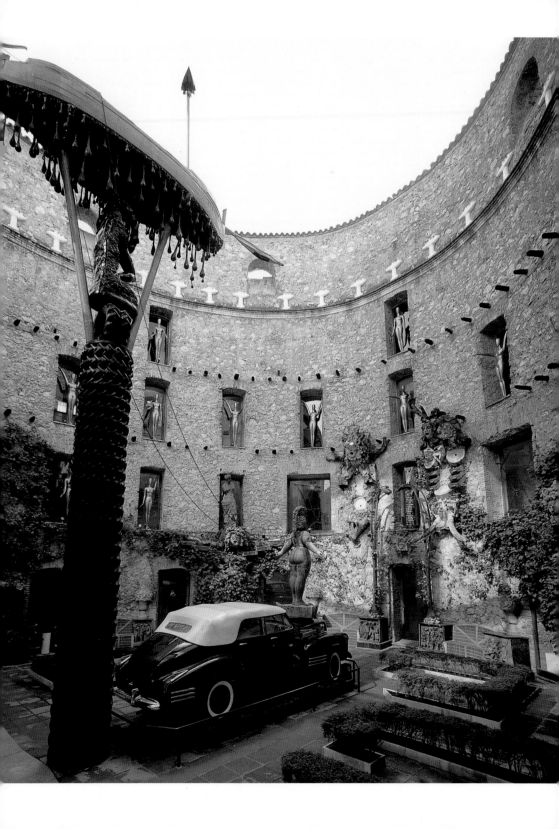

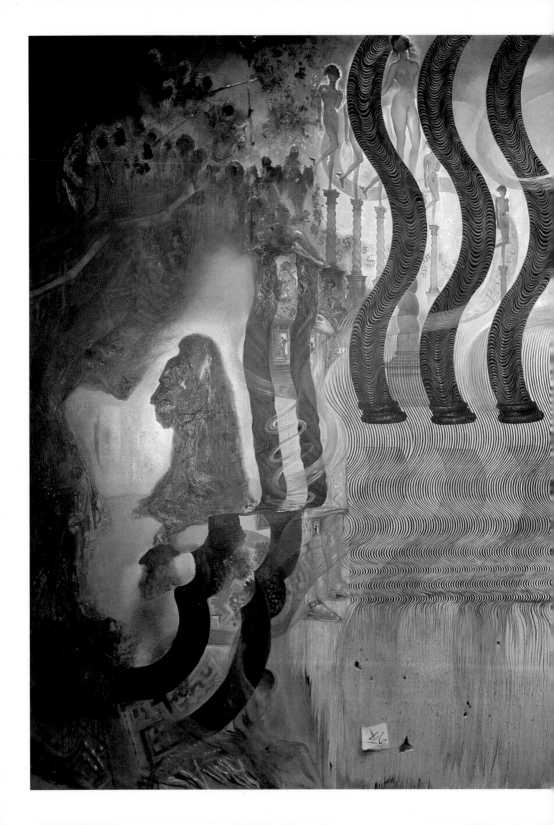

196
*The
Apotheosis of
the Dollar,*
1965.
Oil on canvas;
400 × 498 cm,
157⅝ × 196¼ in.
Fundació
Gala–Salvador
Dalí, Figueres

The museum also contains more conventionally hung rooms, and important examples of work from all periods can be found in the collection. Indeed, the new rooms which have been developed to display acquisitions made since Dalí's original ordering of the collection, do follow the familiar patterns of hanging and labelling. Prominent here is the large painting of 1965, accompanied by supporting studies, of *The Apotheosis of the Dollar* (196). 'Apotheosis' is the process of being turned into a god, and Dalí's idea here is not that of the worship of money, but rather that money can achieve a divine purpose through its conversion into art. In this, the most layered of his composite paintings, representations of his artistic heroes – historical, literary and mythical, Hermes, Velázquez, Gala, Goethe, Duchamp and Don Quixote among them – are incorporated around the serpentine columns of the baldacchino of St Peter's in Rome.

The Salvador Dalí Museum in St Petersburg, Florida stands as a revealing, and probably necessary, antithesis to the Theatre–Museum in Figueres, both in terms of its concept and its physical entity. It is housed in a coolly functional building, converted from a marine ware-

197
The Salvador
Dalí Museum,
St Petersburg,
Florida

house and situated by the waterfront, with the presence of a magnified Dalí signature as the only exterior touch of the artist's personality (197). The collection, of over ninety oil paintings, more than 100 watercolours and drawings, and around 1,300 graphic works, sculptures and art objects, is comprehensive in range, from his juvenile period, through his classicism of the 1920s, the early and mature phases of Surrealism, to the characteristic works from the 1940s and 50s, in which it is particularly rich; it includes many of the works that have been cited elsewhere in this book. The works are displayed in a coherent, chronological sequence, supplied with explanatory information and given ample space. This particularly applies to the group of important large format works such as *The Discovery of America by Christopher Columbus* (172) and *The Hallucinogenic Toreador* (176) which are granted the height of wall and length of viewing distance they demand. The collection is rich in works on paper, such as the early gouache *Saltimbanques* (198) with its almost Expressionist colour and facial features; the intensive study of *The Ants*, also in gouache, from 1936–7 (199); and the 1954 ink drawing study for *Soft Watch Exploding* (200).

Despite the appearance of art-historical inclusiveness that the present state of the collection now offers, this came about more by fortune than original intention; there is an individuality governing the selection of particular pieces, which reflects their origin as a private collection. Eleanor and A Reynolds Morse began their collection in 1943 with the purchase of *Daddy Longlegs of the Evening ... Hope!* (137) and, from there, set out on an adventurous relationship with Dalí that was to last for more than forty years. The Morses were not only good and regular customers, buying at first from his annual New York shows and, latterly, directly from the artist: it is clear that their involvement extended far beyond this, in their attempts to shape and promote the artistic reputation of Dalí in the United States, as distinct from his notoriety as a celebrity. Morse, a plastics engineer and industrialist, was attracted to Dalí's passion for intellectual and scientific inquiry and impressed by his technical skills, which he contrasted favourably with those of Picasso, whose reputation he considered excessive. He also endorsed Dalí's disparagement of the

**198**
*Saltimbanques,*
1920-1.
Gouache on
cardboard;
57 × 51 cm,
22 ½ × 20 in.
Salvador Dalí
Museum, St
Petersburg,
Florida

**199**
*The Ants,*
1936-7.
Gouache on
tinted paper;
66 × 49·5 cm,
26 × 19 ½ in.
Salvador Dalí
Museum, St
Petersburg,
Florida

**200**
Study for *Soft Watch Exploding*, 1954.
Pencil and ink on paper;
14 × 19cm,
5 ½ × 7 ½ in.
Private collection

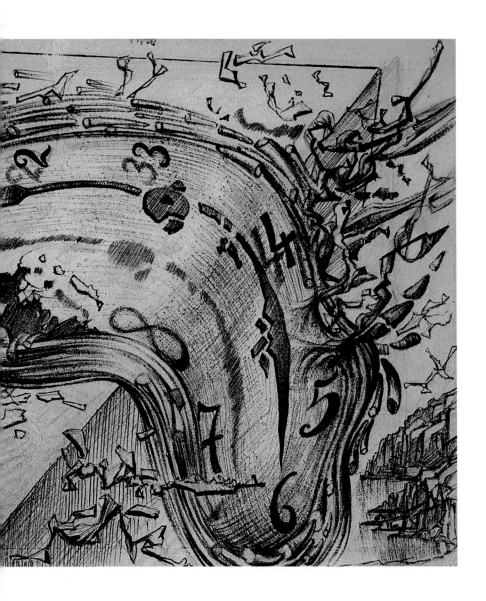

dominant place that abstract art had taken within Modernism by the 1960s: 'I believe that Salvador Dalí was also the greatest of the twentieth-century painters, precisely because he led us through the low period represented by Abstract Expressionism when art had neither content nor technique.'

In as much as anyone was admitted into the ambit of friendship with the capricious couple, the Morses could be said to have occupied that position, visiting Gala and Dalí frequently in Port Lligat and Pebble Beach. The friendship was robust enough to withstand the tough bargaining and unconventional methods of payment that Gala usually exacted: when the sale of *The Ecumenical Council* was agreed for $100,000, she further stipulated that payment should not only be in cash but in pesetas, which had to be stuffed into her personal suit-cases and mixed up with her clothing. Reynolds Morse accompanied Dalí on a lecture tour of America in 1952 as his 'interpreter'; and has written widely on the artist, producing the first detailed monographic study of him in 1958. Eleanor Morse has brought Dalí's theoretical writing to a wider readership in her translation of numerous texts, including *The Tragic Myth of Millet's Angelus*. This concern with Dalí scholarship is reflected in the incomparably complete library and archive of published books, photographs, videos, newspaper and jour-nal cuttings that the Morses assembled and which now forms an important part of the facilities at St Petersburg. During the 1970s the collection, which was housed in a specially built wing of the offices of Morse's company in Beachwood, Ohio, was made accessible to the public on request but it soon became evident that this gallery space was becoming inadequate, and the collection was also in danger of being broken up and dispersed at some stage through the imposition of estate taxes. An attractive proposal was made by the city of St Petersburg, who undertook to provide and equip a suitable building and to set up a foundation to receive and manage the Morses' dona-tion; the museum opened to the public in 1982.

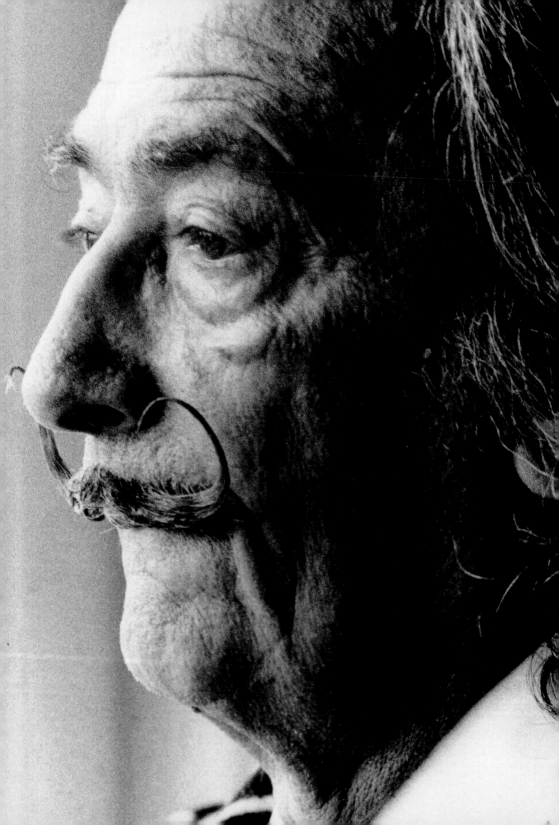

It is still inconceivable that Dalí the bad boy will ever be expelled from the pantheon of modern imagination.

Robert Hughes

Dalí's place in the history of twentieth-century art is certainly assured; visitors from all over the world are likely to be flocking to the museums dedicated to his memory as far into the future as anyone can predict. But the reasons for which he shall be celebrated and the values and meanings that shall be attributed to his contribution by future critics and historians are very far from being fixed and certain. In reappraising Dalí the artist, I want first to consider the Dalí who was the maker of images, then the Dalí who was the maker of a particular version of the myth of the artist, and finally to propose some ways in which his example might illuminate some contemporary problems about the nature and the place of art today.

The first and overriding point to emphasize about Dalí the maker of images is his immense popularity. The appeal of his work spans both culture and generation across the world, whether contact has been made with the actual paintings, or more often through reproductions, or perhaps through his influence on styles of advertising design. His art is directly accessible without prior assimilation into the particular aesthetic codes of European culture, and without specific education in the elaborate and complex history of Modernist art. The best explanation for this success is the simplest: that the imagery *does* reach directly to the subconscious awareness of the viewer; that it *does* release fantasy and the play of the imagination, by triggering normally repressed areas of response; that it *does* facilitate the contemplation of the old mysteries of sex and death and fate, as well as the new mysteries of time and space as revealed through modern scientific knowledge.

It is this self-same popularity which has rendered Dalí's art so prob-
lematic for many of the artists and critics, the educators and the
taste-makers who draw up the membership rules for entry into the
pantheon of Modernism. It is not simply that the quality of his art is
exposed to the scrutiny of objective debate, according to ideas which
might vary from one period or from one critical position to another,
but that he still, almost universally, manages to annoy and irritate
these guardians of art's purity. The battle is fought over the question
of 'authenticity'. The development of Modernist art shared the histor-
ical stage between 1900 and 1970 with the enactment of massive
ideological contests over power and democracy in Russia, Europe and
America. These contests had terrifying consequences in terms of
totalitarian repression, genocide and war. Art and artists were impli-
cated: they could not evade responsibility without recrimination;
moreover they believed that art had effects in the world, that it could
influence and even change history. When all else appeared to be
sullied by motives of economic gain and nationalist opportunity, art
was seen as one of the last bastions of disinterested truth and purity
of ideal. Nowhere was this idealism more explicit than in the circle of
Surrealism during the 1930s. Even for those many artists who felt
unable to contribute directly to these ideological contests, there
remained the morally permissible recourse of adhering to their
aesthetic programme with 'authentic' resolution. Of course few artists
lived up to this demand, either in their practice or their personal life,
but Dalí's offence was his open declaration of disbelief, his repudia-
tion of this credo, his refusal to pretend an adherence to ethical and
political values with which he instinctively disagreed.

202
Dali on a
Harley
Davidson,
December
1974

He further offended against the implicit ordinances of Modernism by
rejecting its claim of continuous evolution, the idea of a perpetual
avant-garde. He not only failed to innovate stylistically or conceptu-
ally according to the dominant tendencies of the day, but he returned
directly to the art of the museums and found much to admire in
artists against whose works the pioneer Modernists had campaigned
so violently in the first decades of the century. In other words he was
a renegade, particularly in his appreciation of technical skill in draw-
ing and painting over the Modernists' high valuation of expressiveness,

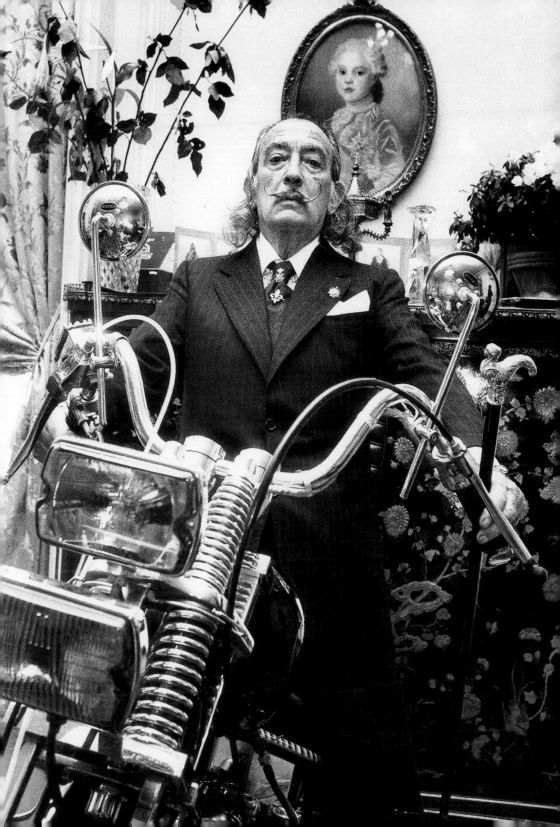

spontaneity and primitivism. He thus shared the critical fate of De Chirico, when he made his own call for a 'return to the craft', and attracted the specially vociferous recrimination which is reserved for the fallen angel. Of course, such a judgement was not passed even-handedly: so widespread was the 'Return to Order' movement in the 1920s that it involved many of the major Modernist artists, such as Derain, Matisse and Picasso, all of whom explored figure-based painting which paid homage at one level or another to the art of the past; likewise, Giacometti equally repudiated his former course of innovation in the mid-1930s and declared himself to be on the quest for figurative realism, yet escaped the disavowal of his peers.

Modernist artists and critics generally disliked the 'look' of his paintings. They found the technical precision of line and form and the eradication of brushmark offensive to an aesthetic taste which had been first initiated by the Impressionists and which persisted, at least in part, as a carrier of the values of the 'individuality' of the artist's touch. This taste supported the myth that, as if by analogy, aspects of the artist's character were revealed to the viewer through the signs of the painting's fabrication. This approach was anathema to Dalí; from his first theoretical writings in the 1920s onwards, he had consistently railed against such 'romanticism'. He rejected the claims made by painting on the emotions, on sentiment, on the route to 'the soul' through the aesthetic language of form and colour. His route of appeal was direct to the subconscious and that was to be achieved through the projection of images of a hyper-real clarity and precision, as close to the objectivity and absence of personality of a photograph as possible.

As for those Modernist tendencies which did seek to embrace the anti-Romantic values of order and objectivity, they found their most characteristic manifestation in abstraction and Minimalism, which again contrasted signally with Dalí's preference for elaboration and amplification. The end result was that, from the late 1930s onwards, Dalí's art found progressively fewer natural allies among fellow Modernist painters.

One of the most glaring paradoxes of this situation was that, precisely as the vanguard tendencies of late Modernism were becoming increasingly self-referential and confined to art's own internal concerns, through Abstract Expressionism, Colour Field painting, Optical Art, Minimalism, Conceptual Art and suchlike, Dalí was conspicuous in his efforts to be 'modern' in a wider sense, to respond to the scientific ideas of his time, to explore contemporary reproductive techniques and to seek ways of incorporating these within the content of his art.

In addition to matters of style and technique, many people also object to much of Dalí's subject matter, particularly in the case of the classic Surreal pieces, absorbed as they are with fetishized imagery of sex and excrement and putrefaction; 'an adolescent obsession!' they will exclaim, and Dalí would not deny that for a moment. *The Secret Life* devotes half of its pages to the first twenty years of his life; he described, approvingly, *Un Chien andalou* as an adolescent film and his museum also highlights his youth. A state of permanent adolescence, with all its raw egoism and extremes of passion, its insistence on the sovereignty of fantasy over reality is surely Dalí's preferred mode of address, which helps to explain both its appeal to young people and its discomfort to those of an older generation who flee from the reminder it brings of their own former adolescent confusion and vitality.

The public response to Dalí the man, or rather Dalí the maker of his own myths, raises another set of issues which divide his supporters from his detractors. Mathieu called him a magician because of his capacity to make new and potent analogies between things; indeed, this is the capacity that the philosopher William James considered as definitive of 'genius'. There is much of the enchanter and the illusionist (who tricks the eye and suspends our disbelief) in this Dalí. Some might even see in the traumatic anxiety of his early Surrealism the acts of the shaman, who aims to cure the ills of the community through exposing himself to states of delirium, but he was also always the entertainer, who adored the attention and notoriety of the public. The case to be decided is the extent to which this pose was simply

that of the clown, satisfied with just putting on a good show for his audience, and how much it was the action of a Don Quixote, a holy fool, whose actions only seem foolish to the uninitiated and the unthinking who can never reach beyond the stubborn appearances of everyday reality. As Erasmus said, 'Foolishness here is life's wisdom.' Certainly Dalí the jester was highly effective in mocking the dubious gravity with which high art tends to regard itself. He could be wickedly epigrammatic about the patriarchs of the modern movement:

Matisse: the triumph of bourgeois taste and of promiscuity.

Breton: so very much intransigence for such a small transgression!

Kandinsky? There is no escaping it: there can never be a Russian painter. Kandinsky might have made marvellous cloisonné enamel cane heads.

Henry Moore – he is an Englishman!

One of the great originating founts of energy of Modernism was the power of the avant-garde art to shock and to provoke to anger the traditional art public, who upheld the conservative values of the established order and who required a subservient, unquestioning and polite role from official culture. This subversive obligation, which the Surrealists took over from Dada, remained to nag at the conscience of Modernist artists throughout the movement's remaining duration but, as modern art gradually ceased to be a dissident movement and was more and more absorbed into the structures of the new official culture – essentially when state museums of modern art were becoming established – so this obligation to offend became frustrated and ineffectual. A certain amount of 'wild' behaviour from artists was permitted, but contained within the 'reservation' of a well-policed art world. Dalí, like Duchamp, was alerted to this reality early on and his strategy of playing the part of the jester ensured him one of the few opportunities left to provoke and annoy. It is necessary, therefore, to view the statements, actions and poses of his career after his encounter with America through the lens of irony. If you cannot conspire with him, if you do not share the joke, then you are in danger of becoming a victim of his derision.

Since the 1980s Dalí has been re-evaluated in the light of post-modern perspectives. The American critic Carter Ratcliff, for example, affirms that 'Dalí will be remembered as the allegorical figure of modernism's necessary doubts about its own good faith.' Ratcliff means by this that Dalí, by his cavalier refusal to play by the rules of Modernism, and in particular his readiness to operate habitually in commercial spheres, has threatened to erase the cultural boundaries that had hitherto protected the sanctuary of high art. We are forced to question that special claim to 'authenticity' that it had reserved for itself. We are forced to recognize that a work of art is a commodity just as much as is a car or a piece of furniture. Whether we are considering an exclusive, luxury commodity, such as a designer garment, or an accessible commodity available for mass consumption, such as a Hollywood film or a TV commercial, it remains a product, which has an economic dimension and can be defined by price. The larger part of that commodity's function might well be to feed the imagination and set free the fantasy of the user but now, in the light of post-modern reconsideration, we must seriously question whether the images and concepts produced by the artist are, in terms of their cultural use, significantly different from those created by the fashion designer or the film or TV commercial director. If we decide that the answer is 'no', then the spectre of fashion arises. Perhaps the fiercest of attacks against Dalí and what his work implies come from those who seek to defend art from what they fear as the infectious power of fashion – the very demon of 'inauthenticity'. Yet the reign of fashion is all-pervasive in contemporary culture: it determines the incessant replacement of one form of a given commodity by another, it feeds our apparent need for constant novelty, it seduces us with its alluring fantasies and it offers us opportunities to exercise aesthetic choices. The challenge is again laid down: can we claim any longer that art is – and always has been, despite its idealist protestations – exempt from the power of fashion?

The 1980s saw a revival of interest in painting, following a period dominated by conceptual approaches to art, but it was not a return to the familiar territory of painting as it was known in the confident days of Modernism. The new painting, sometimes referred to as the

204
*Bed and Two Bedside Tables Ferociously Attacking a Cello,* 1983. Oil on canvas; 130 × 140 cm, 51¼ × 55⅛ in. Fundació Gala-Salvador Dalí, Figueres

**205**
*The Swallow's Tail – Series on Catastrophes,* 1983.
Oil on canvas; 73×92·2 cm, 28³⁄₄×36³⁄₈ in.
Fundació Gala-Salvador Dalí, Figueres

New Expressionism and produced by such artists as Georg Baselitz, Julian Schnabel and David Salle, was suffused in irony, pastiche and excess. Its references often had little relationship to the inherited conventions of symbolic or representational pictorial language. Any restraint that had previously been exerted by rules of form or stylistic conformity was abandoned. The term 'bad art' became a descriptive rather than a pejorative tag. This experience has further equipped us to review in a new light much of Dalí's painting from the late 1960s onwards. The multi-layered 'sampling' techniques used in such works as *Tuna Fishing* (175) or *The Apotheosis of the Dollar* (196) can find stylistic kinship, at least, with the work of Sigmar Polke. There is an even closer connection with the New Expressionism in a work such as *Bed and Two Bedside Tables Ferociously Attacking a Cello* (204). This was one of his last paintings, from 1983, and there is every reason to suppose that, for once, in his distraught mental and failing physical state, Dalí was painting expressively out of anger and frustration. The proper note to end on, however, should be enigmatic but positive: *The Swallow's Tail – Series on Catastrophes* (205) is designated as his final painting, made in May 1983. He said about this last phase of working:

Everything I do from now on will be devoted to the phenomenon of catastrophes [the theory of René Thom]. Now it is no longer a matter of pure imagination, of my moods and dreams, of automatism. Now I am painting the meaning that derives directly from my existence, my illness or my vital memories.

# Glossary

**Abstract Expressionism** School of radical abstraction which flourished in the United States in the decade between 1945 and 1955. The term is sometimes used too widely: it is best applied to the type of gestural, informal abstraction which was also termed 'action painting'. The interest of its practitioners, notably Jackson Pollock (1912–56) and Willem de Kooning (b.1904), in freedom from conscious control and in primitivist symbols indicates influences from Surrealism.

**Anamorphosis** An illusionistic technique, popular in the mid-sixteenth century, which distorted images in such a way that their true subject could only be perceived when viewed from an oblique angle to the page or the painting. Portraits were the most common subject but the association of the technique with a hidden truth lying behind appearances also invited a metaphysical reading; hence the use of a skull as the hidden subject.

**Avant-Garde, Vanguard** Originally a military term, applied metaphorically to radical political movements, then, by the end of the nineteenth century, to advanced literary and artistic movements, while still retaining some accompanying sense of social progress. It is a defining feature of Modernism with its essential faith in progress, in an evolutionary direction of stylistic development and in the privileged capacity of certain artists to foresee the future pattern of cultural development. Dalí subscribed to this Modernist optimism during his twenties, but was renouncing its claims by 1940 as he looked for ways of reinstating the qualities of Renaissance art.

**Cubism** Arguably the most influential of twentieth-century avant-garde movements, developing in Paris around 1907, with Georges Braque (1882–1963) and **Pablo Picasso** as prominent instigators. Objects and figures are represented by faceted planes and simplified signs which suggest a number of simultaneous viewing positions. A distinction is generally made between the rigorous Analytic phase of 1907–12 and the more decorative Synthetic phase of 1912–21 in which collaged elements are often incorporated.

**Dada** A movement (c.1916–c.1923) which emerged in various centres, notably Zurich, Cologne, Paris, New York and Berlin, in response to the moral and cultural disintegration experienced during the First World War. It was determinedly provocative in its activities, challenging accepted notions of the forms and functions of art. Its typical modes were cabaret performance, magazines and ephemeral artworks of low material or aesthetic value. Its principal activists included **Marcel Duchamp**, **Francis Picabia**, Kurt Schwitters (1887–1948) and Tristan Tzara (1896–1963).

**Futurism** A movement (c.1909–c.1918) inaugurated by Italian artists including Umberto Boccioni (1882–1916), Carlo Carrà (1881–1966) and Gino Severini (1883–1966). Its influence quickly spread through the European art centres, promoted by a series of energetically written manifestos. The original Futurist Manifesto, released by the poet Filippo Tommaso Marinetti (1876–1944), vehemently contrasted the excitement of modern experience with the dullness of historical art. The painting and sculptural techniques of Futurism aimed at incorporating the sense of motion and the subjective feelings of the viewer.

**Golden Section** A mathematical division of either vertical or horizontal space into two parts which results in an aesthetically satisfying and harmonic proportional relationship. It corresponds to an approximate ratio of 8:13. This aspect of 'Divine Proportion', known to Classical Greek (it is thought to have originated in the circle of Pythagoras in the 6th century BC) and Renaissance artists and architects, supported the existence of a rational basis to the concept of beauty as the reflection of a divine order governing the universe.

**Hyperrealism, Superrealism** A largely American movement (c.1965–c.1972) in which images of apparently insignificant aspects of contemporary urban life were rendered with a photographic or waxwork precision. Painters included Chuck Close (b.1940) and Richard Estes (b.1932); sculptors included John de Andrea (b.1941) and Duane Hanson (1925–96).

**Impressionism** A form of Realist painting originating around 1860 in Paris, which reacted against academic conventions by taking its subjects from contemporary urban and rural life and rendering these in a painting manner which emphasized heightened hues and exposed brushmarks. Works were frequently painted directly on site to capture the immediacy of a specific moment. Principal exponents included Claude Monet (1840–1926), Camille Pissarro (1830–1903) and Pierre-Auguste Renoir (1841–1919).

**Machine Aesthetic** Term coined by **Fernand Léger** in 1923 to demonstrate what painters working in late Cubist and Purist styles could learn from the geometrical forms and bright, unmodulated colours used in engineering. He maintained that their aesthetic qualities stemmed from the adherence of engineers to the principles of reason, precision and economy which were essentially classical values.

**Metaphysical Art, Scuola Metafisica** Term largely associated with the painting of **Giorgio de Chirico**, Carlo Carrà and Giorgio Morandi (1890–1964) between 1917 and 1921. The mysterious and troubling essence of certain objects was displayed in extended perspective and dramatic lighting. Writing associated with this position appeared in the magazine *Valori plastici*.

**Modernism** See **Avant-Garde**

**Montage** Term derived from the French word for 'assemble', and applied to the making of photographic collages known as 'photomontages' or to an editing method in film-making. The essential feature is that the sequence of images is abrupt and evident rather than seamless and disguised, to produce the intentional effect of forcing the viewer to make conscious (or in the case of Surrealist films, subconscious) sense of often disturbing juxtapositions of images.

**Neoclassicism** A general term, originally applied to a late eighteenth-century revival of interest in Classical style. It also covers a number of movements and tendencies within the work of individual artists between c.1900 and c.1940 which, while not rejecting the need for modern art to reflect the vitality and scientific advance of contemporary life, asserted a 'call to order' to resist the more extreme and individualist excesses of the avant-garde by recalling the values of restraint, clarity and objectivity associated with the classical tradition of art.

**Noucentisme** A Catalan movement (meaning 'of the twentieth century') in painting, sculpture, architecture and literature which aimed (c.1910–c.1920) to return to the formal restraints of the classical tradition but interpreting this within the spirit of contemporary life. Painters such as Joaquin Sunyer (1874–1956) invoked the structural order of Paul Cézanne (1839–1906).

**Pop Art** A movement (c.1950–c.1970) in painting and sculpture having independent origins in Britain and America. It took its content from popular and mass media culture. Artists such as Roy Lichtenstein (b.1923) and Andy Warhol (1928–87) appropriated the forms of fashionable graphic design and produced a widely popular brand of modern art which could be read as a reaction to the esoteric and subjective language of **Abstract Expressionism**.

**Purism** A Paris-based tendency of painting and theory (1918–25), linked to the **Machine Aesthetic** and to **Neoclassicism**. Its proponents were Amédée Ozenfant (1886–1966) and Charles-Édouard Jeanneret (Le Corbusier, 1887–1965) through magazines such as *L'Esprit nouveau*.

**Realism** A general term with various inflections depending on period and context but indicating a direct and illusionistic representation of the material world. Implicit is the rejection of idealized forms of beauty and subjectivity, thereby revealing some profound, underlying truth.

**Romanticism** Either a general term, with a small 'r', emphasizing the emotional perceptions of an individual artist in contrast to the objectivity of classicism, or, with a capital 'R', specifically referring to the art movement of the late eighteenth and early nineteenth centuries. The themes of heightened mental experience, even amounting to madness, nostalgia for distant times and exotic locations and the sublimity of nature find expression in the literature, music and visual art of the period.

**St Sebastian** Christian martyr, condemned to death by the Roman emperor Diocletian by being shot with arrows, from which he miraculously survived. This provided a favourite male nude subject for Renaissance artists, whose depictions, varying between pathos and sadism, resulted in imagery which sometimes permits a homoerotic interpretation.

**Louis Aragon** (1897–1982) French novelist, poet and critic. Member of the Surrealist group from 1924 to 1932, and subsequently a member of the Communist Party, which brought his views into aggressive opposition to those of Dalí.

**Jean [Hans] Arp** (1887–1960) German, later French, poet, sculptor and painter. Founder, with Tristan Tzara, of the Zurich **Dada** movement in 1916. Member of the Surrealist group from 1930. Dalí was briefly indebted to his organic, abstract forms around 1927–8.

**André Breton** (1896–1966) French poet, novelist, essayist, theorist and promoter of Surrealism, writing its three manifestos (1924, 1930 and 1942). His experimentation in automatic writing with Philippe Soupault produced *Les Champs magnetiques* (1921). His theoretical essays included 'Surrealism and Painting' (1928) and 'What is Surrealism?' (1934); significant creative writing included the novel *Nadja* (1932) and the poetic essay 'Mad Love' (1937). His attempts to give a revolutionary direction to the movement led to his membership of the Communist Party between 1927 and 1935.

**Luis Buñuel** (1900–83) Spanish film-maker, one of the founders of Surrealist cinema. A fellow student of Dalí at the Residencia in Madrid, he collaborated with Dalí on *Un Chien andalou* (1929) and *L'Age d'or* (1930). He combined elements of Surrealist invention and social satire in such later films as *The Discreet Charm of the Bourgeoisie* (1973) and *The Phantom of Liberty* (1974).

**Giorgio de Chirico** (1888–1978) Italian painter and author of the novel *Hebdomeros* (1929). The enigmatic and melancholic imagery of his paintings from 1912 to 1916 and the *'Metaphysical'* period from 1917 to 1922 were highly valued by the Surrealists, and Dalí adopted many of his techniques of spatial distortion in his classic Surrealist period. De Chirico's subsequent **Neoclassicism** and 'return to the craft' of Renaissance and Baroque painting were aggressively renounced by the group.

**René Crevel** (1900–35) French novelist and essayist. A close friend of Dalí within the Surrealist movement, Crevel wrote the first critical study of his work, *Dalí or Antiobscurantism* (1931). His failure to reconcile his artistic and his political ideals led to his suicide.

**Marcel Duchamp** (1887–1968) Artist, curator and theorist, one of the original proponents of **Dada**. He first gained notice as a Symbolist and then a Cubo-Futurist painter, *eg* with *Nude Descending a Staircase* (1911–12) but soon turned to work which radically questioned the nature of originality and aestheticism in art when he exhibited 'ready-made' found objects, such as a bottle-rack and a urinal. A major work, encased between two sheets of glass and entitled *The Bride Stripped Bare by her Bachelors, Even* (1915–23), was unique in terms of its conceptual complexity. He appeared to have ceased working as an artist but secretly worked on a paradoxically explicit version of the same theme, *Etant Donnés* between 1946 and 1966. He shared with Dalí a constant awareness of the centrality of eroticism in art and the need for irony in the conduct of the artist.

**Gala Éluard [Helena Deluvina Diakonoff]** (c.1894–1982) Dalí's model, wife and 'muse'. Born in Kazan, Russia, she married **Paul Éluard** in 1917 and had liaisons with **Ernst, De Chirico** and others before meeting Dalí in 1929. They were married by civil ceremony in 1934 and by a religious ceremony in 1958. Leonor Fini was impressed by her view that 'every instant had to represent a revenge, a conquest or an advantage'.

**Paul Éluard** (1895–1952) French poet and leading member of the Surrealist group. He was motivated more by the revolutionary function of the movement than by its techniques of automatism. Dalí painted a Surrealist portrait of him in 1929.

**Max Ernst** (1881–1976) German painter, collagist and poet. Having studied philosophy, prior to war service, Ernst was leader of the Cologne **Dada** movement in 1919 before coming to Paris in 1922 and joining the Surrealists between 1924 and 1938. His paintings drew on childhood memories and dream imagery, but their forms were often triggered by automatic techniques for which he invented names such as 'frottage' and 'decalcomania'. His Surrealist practice also included the manipulation of banal images found in old illustrated books. He took refuge in America during the Second World War and engaged in Surrealist activities there.

**Sigmund Freud** (1856–1939) Austrian psychologist and leading exponent of psychoanalysis. In *The Interpretation of Dreams* (1900) he demonstrated through case studies how the process of unravelling

the hidden nature of patients' dreams could cure their neurotic behaviour. Dalí shared with the Surrealists a devoted attachment to his theory of the subconscious and the significance of sexual repression within society. They extended it to form the basis of their own theory of the imagination and various strategies of creative release.

**Federico García Lorca** (1898–1936) Spanish poet and playwright. His first successfully received collection was *Romancero gitano* (*Gypsy Ballads*, 1928) which added surreal elements to the language and content of traditional Andalucian song. He travelled to New York in 1929 and celebrated the life of Harlem in *The Poet in New York* (1940). His plays include *Mariana Pineda* (1925), of which the first performance had sets designed by Dalí, *Blood Wedding* (1933) and *The House of Bernada Alba* (1936). He met Dalí at the Residencia in Madrid, which resulted in a close personal friendship and a fertile, artistic exchange. He was killed in the Spanish Civil War by a Fascist faction.

**Jacques Lacan** (1901–81) French practising and theoretical psychoanalyst. In 1933 both he and Dalí wrote on paranoia in *Minotaure*, reflecting a cross-fertilization of ideas. His considerable influence in a wide range of intellectual fields from the 1950s onwards stems from his reinterpretation of Freudian theory in the light of structural linguistics. His work is usefully collected in *Writings* (1966).

**Le Comte de Lautréamont [pen name of Isidore Lucien Ducasse]** (1846–70) French poet. He published his first work, *Les Chants de Maldoror* in 1868; its despair, violence and savagery won him high respect from the Surrealists who regarded him as a forerunner of their movement.

**Fernand Léger** (1881–1955) French painter. He trained as an architectural draughtsman before working with the Cubists. His war experience encouraged both an awareness of the social role of art and an enthusiasm for the modernity of the mechanized environment. He collaborated with Amédée Ozenfant and Le Corbusier in the projects and writings of **Purism**, which influenced Dalí in his own theoretical embrace of modernity and anti-Romanticism in the late 1920s.

**René Magritte** (1898–1967) Belgian painter and theorist, and founding member of the Belgian Surrealist group in 1924. While living in Paris and in close liaison with the Surrealists between 1927 and 1930, he met Dalí who became aware of their shared indebtedness to **De Chirico** and their interest in disturbing visual ambiguities. After 1933 he contributed to Parisian Surrealist publications and explored, through his painting, philosophical issues raised by the process of pictorial representation.

**Harpo Marx [Adolph Arthur]** (1888–1964) American comic film actor, one of four brothers alongside Chico, Groucho and Zeppo. Their humour in such films as *Animal Crackers* (1930) and *Duck Soup* (1933) was neither satirical nor slapstick but represented a private oasis of anarchy within the desert of the rational world around them. Dalí discerned in their films much in common with his view of the effects of Surrealism and he was particularly attracted to the personality of Harpo, who played a dumb musician.

**Karl Marx** (1818–83) German socialist, political theorist, economist and historian. Together with Friedrich Engels, he proposed the theory of Dialectic Materialism, essentially the argument that major historical developments are determined by the relations of economic forces within society. In such works as *The Communist Manifesto* (1848) and *Das Kapital* (1867–94) he demonstrated that the injustices of Capitalism could only be overcome by political revolution rather than reform. Marxism continued to be the most influential idea for radical change well into the twentieth century and was fully embraced by orthodox Surrealism.

**Georges Mathieu** (b.1921) French painter who studied law, philosophy and English before starting painting in 1942. He developed a lyrical abstract style derived from a method of intensive, direct and gestural painting conducted at great speed, often as a public performance. A friendship with Dalí in the 1950s led to an exchange of ideas and methods.

**Jean-Louis-Ernest Meissonier** (1815–91) French portraitist and history painter. Celebrated for his energetic and realist battle pictures, carried out with a miniaturist attention to detail, Meissonier represents the kind of popular, academic art of the nineteenth century which was challenged by the Impressionists and subsequent avant-garde groups.

**Jean-François Millet** (1814–75) A member of the Barbizon school of French painters, he was known principally for his large-scale depictions of the hardships of peasant life, which after the uprising of 1848 acquired a political meaning. *The Angelus* was a widely reproduced image and Dalí concocted a complex paranoiac-critical interpretation of the work. Millet had previously painted erotic subjects, which further supported Dalí's analysis.

**Joan Miró** (1893–1983) Spanish painter and sculptor. His first mature style, influenced by Cubism (c.1919), was followed by precisely delineated but symbolically charged representations of Catalan village scenes. He moved to Paris in 1920 where he developed his typical form of Surrealist abstraction. Dalí was influenced by Miró's style (c.1927–8) and knew him when he first arrived in Paris.

**A Reynolds Morse** (b.1914) American plastics engineer and entrepreneur. Together with his wife, Eleanor, he built up the largest private collection of Dalí's work, which was donated to form the basis of the Salvador Dalí Museum, St Petersburg, Florida. He has written and lectured widely on the life and work of Dalí.

**Friedrich Nietzsche** (1844–1900) German philosopher, classical scholar and poet, best known for his theory of the *Ubermensch* (Superman) which he developed in *Thus Spake Zarathustra* (1883–5). He was highly influential in shaping the ideas of the early generations of Modernist writers and artists, such as **De Chirico** and Dalí, in that he offered them a role to be the 'avant-garde', to be in advance of the mass of humanity who, having lost their faith in a Christian God, now looked to the artist to provide spiritual salvation.

**Francis Picabia** (1879–1973) French painter, first noted for his Impressionist painting. He came into contact with the **Duchamp** brothers in 1911 and produced radical abstract work, exhibiting at the Armory Show in New York (1913). He engaged in **Dada** activities in Barcelona and Paris and remained on the margins of Surrealism but always flouted aesthetic taste and convention while maintaining a playboy lifestyle.

**Pablo Picasso** (1881–1973) Spanish painter, printmaker and sculptor. Following an early Symbolist period, he developed the formal language of **Cubism** and became the dominating presence in Western Modernist art. His prolific output was emotionally charged, rather than following any particular doctrine. Although he was acknowledged as a leading influence on Surrealism, he remained on the margins of the group and did not subscribe to its theoretical limits. His work was a major influence on Dalí's development in the 1920s and he befriended Dalí during his early years in Paris before they became estranged due to ideological differences.

**Ramon Antonio Pichot [Girones]** (1872–1925) Painter and graphic artist who divided his time between Paris, Madrid and Barcelona. He was in the circle of **Picasso** around 1900, exhibited with the Fauves and was prominent in introducing the new manners of painting from Paris into Spain.

**Arthur Rimbaud** (1854–91) French poet, who studied occult writings, the cabbala and Buddhism as preparation for a form of Symbolist poetry concerned with mystic revelation, in such works as 'The Drunken Boat' and 'A Season in Hell', both written before his twentieth birthday. This approach to poetry, coupled with a purposefully dissolute and self-abusive lifestyle, secured him a place of honour among the Surrealists.

**Donation Alphonse François de Sade [known as the Marquis de Sade]** (1740–1814) French writer whose sexually explicit works of perverse fantasy include *120 Days of Sodom*, *Justine* and *Philosophy in the Bedroom*. He was condemned to death for sexual crimes but escaped, though he was later imprisoned in the Bastille. He died in a mental asylum.

**Alberto Savinio [Andrea de Chirico]** (1891–1952) Italian musician, writer and painter. He wrote on **Metaphysical Art** in *Valori plastici*, which came to the notice of Dalí, and after 1927 he worked as a painter. His bizarre imagery, owing something to the dream-like pictures of **De Chirico**, his brother, established him as a leading figure in Italian Surrealism.

**Elsa Schiaparelli** (1890–1973) Italian fashion designer, who studied philosophy before moving to Paris in 1920. Without formal training, she opened a fashion house there in 1928, and established a reputation for original and creative designs which were close to Surrealism, such as her use of rose-coloured cellophane as a dress material and her promotion of 'shocking pink'. She worked with a number of artists in the 1930s including Dalí, with whom she devised the 'Shoe-hat'.

**Yves Tanguy** (1900–55) French (later American) painter. Self-taught, he joined the Surrealist group in 1925 and developed a typical style of dream-like, spatially ambiguous landscapes, inhabited by indeterminate organic forms. He emigrated to the United States in 1939.

**Diego Velázquez** (1599–1660) Spanish artist of the 'Golden Age' who was the outstanding exponent of all genres of painting – religious, history, portraiture, nudes and *bodegón* (still lifes of food). As royal painter at the court of Philip IV he painted his masterpiece, *Las Meninas* (*The Maids of Honour*, 1656). He became a fantasy role model for Dalí, both for his consummate artistry and his status.

**Voltaire [Francois-Marie Arouet]** (1694–1778) French satirist, philosopher, dramatist and historian. He devoted his incisive and satirical wit to attacking the tyranny of church and state, questioning the validity of organized religion and, consequently, earning periods of imprisonment and exile. His *Philosophical Letters* were published in 1737 and *Candide* in 1764. His writings had a formative influence on the young Dalí who was later to depict him in the form of a portrait bust.

**Francisco de Zurbarán** (1598–1664) Spanish painter who was a major exponent of the tenebrist (heavily modelled with dark background) technique of Caravaggio (1571–1610). He painted depictions of saints and other religious subjects in Seville and Madrid, where Dalí would have seen his work.

## Key Dates

Numbers in square brackets refer to illustrations

### The Life and Art of Salvador Dalí

**1904** Salvador Dalí Domènech born in Figueres, Catalunya, Spain, 11 May

**1908** Ana Maria, his sister, is born

**1916** Summer vacation with the Pichot family, where he encounters modern painting

**1917** First exhibition, in the family apartment

**1919** First public exhibition in a group show at the Municipal Theatre in Figueres. First article published in college magazine

**1921** His mother dies

**1922** Enrols at the Royal Academy of San Fernando, Madrid. Lodges at the Residencia de Estudiantes

**1923** Suspended from the academy for allegedly taking a leading part in a protest

**1924** Serves a month's prison sentence – on a charge which was considered to have been a political reprisal against his father

**1925** Federico García Lorca stays with the Dalí family and a close personal and artistic friendship develops. First professional solo exhibition at Galería Dalmau in Barcelona

### A Context of Events

**1906** Death of Cézanne

**1909** The 'Tragic Week' in Barcelona, when a General Strike turns into anarchic revolt with 21 churches and 40 convents burned. Marinetti publishes the *Futurist Manifesto*

**1910** Braque and Picasso establish the Analytical phase of Cubism

**1912–13** Balkan Wars

**1913** 'Armory Show' in New York at which Duchamp exhibits *Nude Descending a Staircase*

**1914** Gaudí completes Güell Park, Barcelona

**1914–18** The First World War (in which Spain is neutral)

**1917** October Revolution in Russia leads to the formation of the first Communist state. Duchamp exhibits a 'ready-made' in the form of a urinal, in New York

**1918** Spartakist Revolt in Germany. Ozenfant and Jeanneret set out the theory of Purism in *Après le cubisme* (*After Cubism*)

**1921** First exhibition of Miró in Paris

**1922** Formation of the Union of Soviet Socialist Republics. Mussolini comes to power in Italy as leader of the Fascist party. The Surrealist Group is formed in Paris. Freud's *The Interpretation of Dreams*, originally published in 1900, is translated into Spanish

**1923** Military dictatorship set up in Spain under Miguel Primo de Rivera, Captain-General of Catalunya

**1924** Breton launches the *Manifesto of Surrealism*. Heisenberg publishes his theory of quantum mechanics

**1925** Moholy-Nagy publishes *Painting, Photography, Film*

**The Life and Art of Salvador Dalí**  **A Context of Events**

**1926** First trip to Paris and Brussels. Visits Picasso in his studio. Expelled from the Academy, following refusal to take examination

**1927** Second exhibition at Galería Dalmau. Serves eight months' military service. Theatre design, including Lorca's *Mariana Pineda*. Publishes first of several articles, 'St Sebastian', for *L'Amic de les arts*. Visited by Miró, who encourages him to establish himself in Paris

**1928** Publishes the *Yellow Manifesto* with Luis Montanyà and Sebastià Gasch. Participates in the International Exhibition, Carnegie Institute, Pittsburgh, where *The Basket of Bread* [43] is purchased

**1929** Collaborates with Luis Buñuel on *Un Chien andalou*. Meets Gala Éluard. Banished from home. Shows with *Documents* group in Zurich. First exhibition in Paris at Goemans Gallery; catalogue introduction by Breton

**1929** Collapse of the New York (Wall Street) Stock Exchange leads to a period of economic depression in the United States and western Europe

**1930** Vicomte de Noailles buys *The Old Age of William Tell* [95]. Energetically involved with the Surrealist group, designs frontispiece for the *Second Surrealist Manifesto*. Settles at Port Lligat with Gala. *L'Age d'or* screened in Paris, disrupted by Fascist demonstrators and finally banned. His theoretical position set out in *La Femme visible*

**1930** Resignation of General Miguel Primo de Rivera.
The second *Surrealist Manifesto* published. Foundation of the journal *Le Surréalisme au service de la Révolution*

**1931** Publication of *Love and Memory*. Julien Levy in New York shows *The Persistence of Memory* [93]

**1931** King Alfonso XIII goes into exile and the Second Republic is established in Spain, with Manuel Azaña as its principal leader. The Republic survives until 1936

**1932** Film script entitled *Babaouo*, which remains unrealized

**1933** Writing for the publications *Le Surréalisme au service de la révolution* and *Minotaure*. First solo show in the United States at the Julien Levy Gallery

**1933** In Germany, the leader of the National Socialist (Nazi) party, Adolf Hitler, is declared Chancellor.
The recently elected President of the United States, Franklin D Roosevelt, introduces the New Deal policy for social and economic recovery.
Publication of the magazine *Minotaure*

**1934** *The Enigma of William Tell* [97] offends the Surrealist group, and they later expel him. Civil marriage to Gala. First solo show in London at Zwemmers. *Les Chants de Maldoror* etchings. Visits New York

**1934** Right-wing riots in Paris. Growing unrest in Spain as the Azaña government falls and a reactionary coalition reverses its reforms. In the Asturias region, the workers embark on a Socialist revolution

**1935** *The Conquest of the Irrational*, concerned with the 'paranoiac-critical method', published in New York and Paris

**1936** Lecture performance in diving suit at London's International Surrealist Exhibition. Appears on the cover of *Time* magazine on the occasion of 'Fantastic Art, Dada and Surrealism' exhibition at the Museum of Modern Art, New York [127]. Paints *Autumn Cannibalism* [123] and *Soft Construction with Boiled Beans: Premonition of Civil War* [122]

**1936** Popular front coalition, opposed to Fascism, wins election in France.
In Spain, elections in February bring an alliance of Socialists, Liberals and Communists to power under Azaña. Following a revolt by Franco, the Republican (or Loyalist) forces, composed of Anarchists, Socialists and Communists, supported by an international brigade of foreign volunteers, resists the Nationalist military forces, who are supported by Hitler and Mussolini

| The Life and Art of Salvador Dalí | A Context of Events |
|---|---|
| **1937** Painting and poem entitled *The Metamorphosis of Narcissus* [117]. Meets the Marx Brothers in Hollywood and proposes collaboration. Travels to Italy as the guest of his patron Edward James. Works with the couturier Schiaparelli | **1937** Paris International Exhibition of Arts and Technology in Modern Life symbolically exposes Europe's political conflicts in the national pavilions of the Soviet Union, Germany and Spain, for which Picasso paints *Guernica* |
| **1938** Obtains interview with the ailing Sigmund Freud in London. Takes part in the Paris International Surrealist Exhibition, showing the *Rainy Taxi* | **1938** Germany annexes Austria. False peace hopes raised at the Munich conference as Czechoslovakia is forced to cede the Sudetenland |
| **1939** Finally expelled from the Surrealist group for his political idiosyncrasy. Working in New York, with window display for Bonwit Teller, *Dream of Venus* [131–3] installation at the World's Fair and ballet performance, *Bacchanale*, at the Metropolitan Opera House | **1939** In March the Nationalists are finally victorious in Spain and a period of dictatorship is established under General Franco. Beginning of the Second World War (to 1945) |
| **1940** Following the German occupation of Paris, flees to Arcachon and finally to America, where he and Gala stay until 1949, first in Virginia, then at Pebble Beach, California and the St Regis Hotel in New York | **1940** Breton, Léger, Ernst and Masson escape to the United States from occupied France |
| **1941** Retrospective exhibition, shared with Miró, at the Museum of Modern Art, New York. Libretto, costumes and sets for the ballet *Labyrinth* | **1941** Japan's attack on Pearl Harbor draws the United States into the war [135] |
| **1942** Publication of fictionalized autobiography, *The Secret Life of Salvador Dalí* | |
| **1943** Designs murals for Helena Rubenstein | |
| **1944** Publishes novel, *Hidden Faces.* Costumes and sets for *Mad Tristan* [145] | |
| **1945** Paints *Basket of Bread* [144] | **1945** Surrender of Germany. Founding of the United Nations organization. The United States drops atomic bombs on Hiroshima and Nagasaki leading to the surrender of Japan |
| **1946** Animated film project, *Destino,* for Walt Disney. Dream sequence for Alfred Hitchcock's *Spellbound* [149–150] | |
| | **1947** The United States launches the Marshall Plan for the economic recovery of Europe. Dennis Gabor invents holography [182] |
| **1948** Publication of *Fifty Secrets of Magic Craftsmanship* [159] | |
| **1949** Paints *Leda Atomica* [151] and *The Madonna of Port Lligat* [154]. Returns to Europe. Designs for Peter Brook's *Salome* | |
| **1951** Paints *Christ of St John of the Cross* [155] and writes *The Mystical Manifesto* | |
| **1954** Illustrates *The Divine Comedy* [179]. Project with the photographer Philippe Halsman, *Dalí's Moustache* [165] | **1954** Tachism movement established in Paris |
| | **1956** Jackson Pollock, exponent of Abstract Expressionism, dies |
| **1957** Illustrates *Don Quixote* with a set of lithographs | **1957** Soviet Union launches the Sputnik space satellite |

| The Life and Art of Salvador Dalí | A Context of Events |
|---|---|
| **1958** Religious marriage ceremony at Girona | |
| **1959** Paints *The Discovery of America by Christopher Columbus* [172] | |
| | **1961–73** Involvement of the United States in the Vietnam War |
| **1963** Publishes *The Tragic Myth of Millet's Angelus*. Paints *Portrait of My Dead Brother* [178] in a style which anticipates Pop Art | **1963** Assassination of the American president J F Kennedy |
| **1964** Retrospective exhibition at Seibu Museum, Tokyo. Receives Grand Cross of Isabella the Catholic | |
| **1965** Paints *The Apotheosis of the Dollar* [196]. Further version of autobiography, *Diary of a Genius* | |
| **1968** Publishes pamphlet, *My Cultural Revolution*, in Paris | **1968** Martin Luther King, the black civil rights leader, assassinated. Student and worker uprising in Paris |
| | **1969** Neil Armstrong and Edwin Aldrin land on the moon |
| **1970** Paints *The Hallucinogenic Toreador* [176–7]. Major retrospective exhibition in Rotterdam | |
| **1971** The Salvador Dalí Museum is opened in Cleveland, Ohio, around the collection of Eleanor & A Reynolds Morse. Designs issue of *Vogue* magazine | |
| **1972** Holograms exhibited at Knoedler Gallery, New York | |
| **1974** Inauguration of the Theatre-Museum, Figueres | |
| | **1975** General Franco dies, ending period of dictatorship in Spain. A constitutional monarchy is established with Juan Carlos as king |
| **1976** First stereoscopic installations [183]. *The Unspeakable Confessioins of Salvador Dalí* published in English | |
| **1979** Admitted into the Académie Française des Beaux-Arts. Major retrospective at the Centre Georges Pompidou, Paris | |
| **1982** Inauguration of Salvador Dalí Museum, St Petersburg, Florida. Death of Gala at Púbol Castle. Title of Marqués de Dalí de Púbol conferred by King Juan Carlos | |
| **1983** First major exhibition of his work in Spain, in Madrid and Barcelona. Completes his final painting [205] | |
| **1984** Requires surgery following severe burns from a bedroom fire | |
| **1989** Dalí dies of heart failure at Figueres, 23 January. He is buried in the crypt of the Theatre-Museum | |

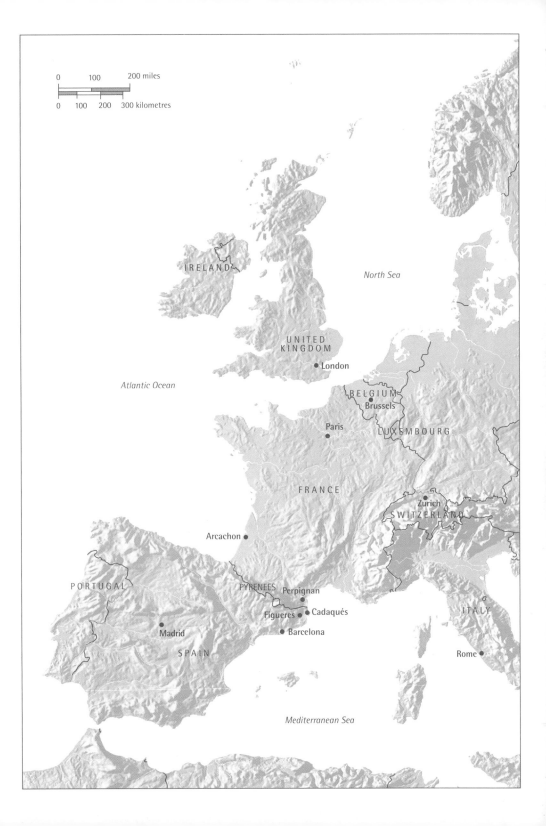

0        100        200 miles

0    100    200    300 kilometres

IRELAND

North Sea

UNITED
KINGDOM

● London

Atlantic Ocean

BELGIUM

● Brussels

● Paris

LUXEMBOURG

FRANCE

Zurich ●
SWITZERLAND

Arcachon ●

PORTUGAL

PYRENEES

Perpignan
●

Figueres ● ● Cadaqués

● Barcelona

Madrid ●

ITALY

SPAIN

Rome ●

Mediterranean Sea

# Further Reading

## Works about Dalí

Dawn Ades, *Dalí* (London, 1982)

Alain Bosquet, *Conversations with Dalí* (London, 1969)

Fleur Cowles, *The Case of Salvador Dalí* (London,1959)

Ana María Dalí, *Salvador Dalí visto por su hermana* (Barcelona, 1949, revised 1993)

Robert Descharnes, *Salvador Dalí: The Work, The Man*, trans. by Eleanor R Morse (New York, 1984)

Robert Descharnes and Gilles Neret, *Salvador Dalí 1904–1989: The Paintings*, 2 vols (Cologne, 1994)

Meredith Etherington-Smith, *Dalí* (London, 1992)

Haim Finkelstein, *Salvador Dalí's Art and Writings 1927–1942* (Cambridge, 1996)

Edouard Fornes, *Dalí and his Books* (Barcelona, 1984)

Ian Gibson, *The Shameful Life of Salvador Dalí* (London, 1997)

Robert S Lubar and A Reynolds Morse, *The Salvador Dalí Museum Collection* (New York, 1991)

A Reynolds Morse, *Salvador Dalí: A Panorama of his Art* (Cleveland, OH, 1974)

George Orwell, 'Benefit of Clergy', in *Collected Essays* (London, 1961), pp.209–19

Carter Ratcliff, 'Swallowing Dalí', *Artforum* (September 1982), pp.32–9

–, 'Dalí's Dreadful Relevance', *Artforum* (November 1982), pp.56–65

Carlos Rojas, *Salvador Dalí or the Art of Spitting on your Mother's Portrait*, trans. by A Amell (Philadelphia, 1993)

Luis Romero, *Dalí* (Secaucus, NJ, 1976)

David Vilaseca, *The Apocryphal Subject: Masochism, Identification and Paranoia in Salvador Dalí's Autobiographical Writings* (New York, 1995)

## Exhibition Catalogues

*400 obres de Salvador Dalí del 1914 al 1983* (Palau Real de Pedralbes, Barcelona, 1983)

*Dalí: Retrospective 1920–1980* (Centre Georges Pompidou, Paris, 1979–80)

*Homage to Barcelona: The City and its Art* (Hayward Gallery, London, 1985)

*Salvador Dalí* (Tate Gallery, London, 1980)

*Salvador Dalí, 1904–1989* (Staatsgalerie, Stuttgart, 1989)

*Salvador Dalí: The Early Years*, ed. Michael Raeburn (South Bank Centre, London, 1994)

*Salvador Dalí: A Mythology*, ed. Dawn Ades and Fiona Bradley (Tate Gallery Liverpool, 1998–9; Salvador Dalí Museum, St Petersburg, Florida, 1999)

## Writings by Dalí

The following texts among others are reproduced and translated in Haim Finkelstein (ed.), *The Collected Writings of Salvador Dalí* (Cambridge, 1998):
'Art Films and Anti-artistic Films', 1927
'My Pictures at the Autumn Salon', 1927
'Photography: Pure Creation of the Mind', 1927
'St Sebastian', 1927 (with Luis Montanyà and Sebastià Gasch)
'Yellow Manifesto', 1928
*La Femme visible*, 1930
*L'Amour et la mémoire*, 1931
'The Stinking Ass', 1932
'The Object as Revealed in Surrealist Experiment', 1932
'Apparitions aerodynamiques des "Etres-objects"', 1934
'I Defy Aragon', 1937
*The Conquest of the Irrational*, 1935

*The Secret Life of Salvador Dalí* (New York, 1942)

*Hidden Faces* (New York, 1944)

*Fifty Secrets of Magic Craftsmanship* (New York, 1948)

*Manifeste mystique* (Paris, 1951)

(with Philippe Halsman) *Dalí's Moustache: A Photographic Interview* (New York, 1954)

*Dalí on Modern Art: The Cuckolds of Antiquated Modern Art* (New York, 1957)

*Le Mythe tragique de l'Angelus de Millet: Interpretation paranoiac* (Paris, 1963); trans. by Eleanor R Morse (St Petersburg, Florida, 1986)

*Diary of a Genius* (New York, 1965)

*Ma Révolution culturelle*, pamphlet (Paris, 1968)

(with André Parinaud) *Comment on devient Dalí* (Paris, 1973), trans. by Harold J Salemson as *The Unspeakable Confessions of Salvador Dalí* (London, 1976)

*Salvador Dalí, Federico García Lorca, Correspondance 1925–1936*, ed. Rafael Santos Torroella (Paris, 1987)

## Historical and Cultural Background

Alfred H Barr, Jr (ed.), *Fantastic Art, Dada, Surrealism* (New York, 1936)

Dominique Bona, *Gala* (Paris, 1995)

André Breton, *Introduction au discours sur le peu de réalité* (Paris, 1924), trans. in Franklin Rosemont (ed.), *What is Surrealism?* (London, 1978)

–, *Manifeste de surréalisme* (Paris, 1924)

–, *L'Amour fou* (Paris, 1937), trans. by Mary Ann Caws as *Mad Love* (London, 1987)

Luis Buñuel, *L'Age d'or* and *Un Chien andalou* [film scripts], (London, 1968)

–, *My Last Sigh* (New York, 1983)

Raymond Carr, *Spain 1908–1975* (Oxford, 1966, 2nd edn, 1982)

Jacqueline Chenieux-Gendron, *Surrealism* (New York and Chichester, 1990)

Sigmund Freud, *The Interpretation of Dreams* (Vienna, 1900), trans. by James Strachey, (London, 1955)

Ian Gibson, *Federico García Lorca: A Life* (London, 1989)

Melsna Lewis, *The Politics of Surrealism* (New York, 1988)

Federico García Lorca, *Selected Poems*, trans. by Merryn Williams (Newcastle upon Tyne, 1992)

Malcolm Haslam, *The Real World of the Surrealists* (London, 1978)

Marcel Jean, *The History of Surrealist Painting* (London, 1960)

Tim McGirk, *Wicked Lady: Salvador Dalí's Muse* (London, 1989)

Maurice Nadeau, *The History of Surrealism* (London, 1968)

Herbert Read, *Surrealism* (London, 1936, repr. 1971)

Mark Rogerson, *The Dalí Scandal* (London, 1987)

Dickran Tashjihan, *Surrealism and the American Avant-garde* (London, 1995)

# Index

Numbers in **bold** refer to illustrations

# Acknowledgements

I would like to acknowledge the debt of
gratitude I owe to all who have helped with
advice and encouragement in my preparation
of this book. In particular I must mention
A Reynolds Morse and Eleanor Morse and
the staff at the Salvador Dalí Museum,
St Petersburg, Florida, remembering the
special assistance of Peter Tush. I also wish
to mention Felix Fanes of the Centre for
Dalinian Studies, Figueres, and my
colleagues, Brandon Taylor and Marko Daniel
for their invaluable commentary on the text.

RR

To C W

# Photographic Credits

AKG London: 11, 12, 18, 42, 46, 67, 72, 74, 87, 97, 178, 179, 180, 181; Bridgeman Art Library, London: 13, 14, 36, 53, 75, 78, 80, 90, 92, 100, 112, 115, 118, 124, 175; Burrell Collection, Glasgow Museums: 155; Jean-Loup Charmet/Bibliothèque Littéraire Jacques Doucet, Paris: 57, 89; Christie's Images, London: 116, 119; Courtauld Institute of Art, Witt Library, London: 65; Detroit Institute of Arts Founders Society: 55; Fundació Gala-Salvador Dalí, Figueres: 5, 7, 9, 10, 17, 20, 21, 22, 24, 26, 28, 29, 34, 35, 40, 95, 130, 141, 144, 145, 147, 149, 150, 151, 164, 182, 183, 184, 187, 188, 191, 192, 193, 194, 195, 196, 204, 205; Fundación Federico García Lorca, Madrid: 32, 33, 48; Fundación Thyssen-Bornemisza, Madrid: 146; Freud Museum, London: 77; Horst, Courtesy of Hamilton's Gallery, London: 132; Hulton Getty Picture Collection, London: 76, 107, 120, 135, 148, 153, 166; Indiana University Art Gallery: 66; Katz/Time Life: frontispiece, 138; Kobal Collection, London: 56, 60, 61, 62, 63, 64; Lee Miller Archives: 109; Magnum/Philippe Halsman: 152, 165, 203; Patrick and Beatrice Haggerty Museum of Art, Marquette University, Milwaukee: 154; Mountain High Maps, copyright © 1995 Digital Wisdom Inc: p.343; Musée des Beaux Arts, Ville de Nantes: 71; Musée Nationale d'Art Moderne, Centre Georges Pompidou, Paris: 98; Museo Cau Ferrat, Sitges: 8; Museo Nacional Centro de Arte Reina Sofía, Madrid: 30, 37, 39, 41, 49, 51, 79, 84, 85, 88, 106, 125, 128; Museu Nacional d'Art de Catalunya (Calveras/Sagristà): 15, 19, 38; Museum Boymans van Beuningen, Rotterdam: 136; Museum of the City of New York: 126; Museum of Modern Art, New York: 68, 83, 93, 102, 173; National Gallery of Art, Washington, DC: 157; National Gallery of Canada, Ottawa: 104; Philadelphia Museum of Art: 122; Playboy Collection, Los Angeles: 161; Rex Features, London: 2, 4, 158, 159, 167, 168, 170, 174, 185, 186, 189, 190, 201, 202; RMN, Paris: 44, 103; Roger-Viollet, Paris: 99, 121; Salvador Dalí Museum, St Petersburg, Florida (benefactors: Reynolds and Eleanor Morse): 1, 6, 16, 31, 41, 45, 50, 52, 54, 94, 96, 101, 105, 108, 134, 137, 143, 160, 162, 163, 171, 172, 176, 177, 197, 198, 199, 200; Sotheby's Fine Art Auctioneers/ Cecil Beaton Collection: 110; Tate Gallery, London: 114, 117, 123; By courtesy of the Board of Trustees of the Victoria & Albert Museum, London: 111, 113

**Phaidon Press Limited**
Regent's Wharf
All Saints Street
London N1 9PA

First published 1997
Reprinted 1998, 1999
© 1997 Phaidon Press Limited

ISBN 0 7148 3411 4

A CIP catalogue record for this book is
available from the British Library.

Typeset in Rotis Semi-sans

Printed in Singapore

**Cover illustration** *Lobster Telephone*, 1936
(see p.175)